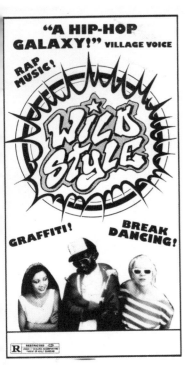

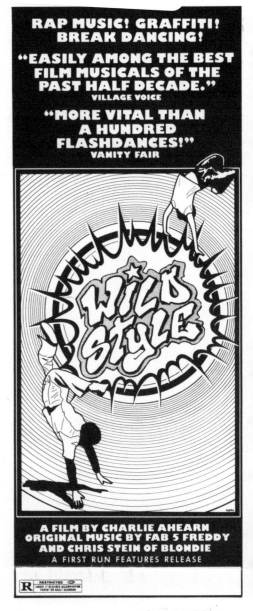

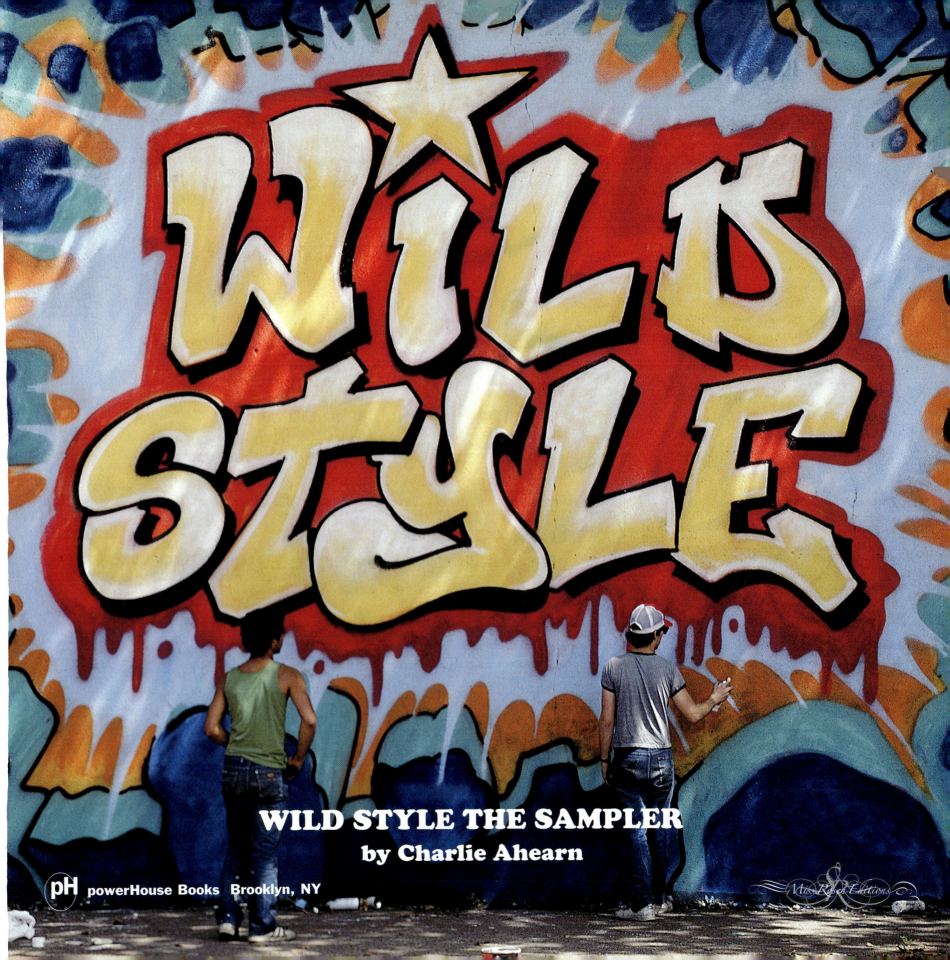

Welcome to Wild Style The Sampler

"We are all graffiti artists!" This answer yelled back by those Bronx street kids in the movie *Wild Style* could now be, "We are all hip hop artists!"—a global declaration for love. Born of African-American roots this culture has spawned a bewildering variety of crucial self-affirming subcultures around the world. No doubt, *Wild Style* helped get the party started.

If sampling is the most sincere form of flattery, then *Wild Style* has gotten plenty of love in the past 25 years: Nas, Beastie Boys, Biz Markie, Jurassic 5, the list goes on and on. Consider this book a Wild Style Sampler box full of stories, photos, graphics, and detritus from the inside—from the crazy production through the movie's hip-hop journey around the planet.

Wild Style was the first movie to capture hip-hop culture at its roots. Check the line up: Flash, Busy Bee, the Cold Crush, Fantastic, Rock Steady Crew, etc., and starring artists Lee, Pink, Zephyr, and Fab 5 Freddy. Shot on location in the South Bronx without permits or pretensions, it was first screened in 1982, broke all records in Times Square in 1983, and went on to become the cult hip-hop movie classic.

"Here's a little story that must be told..."

Charlie Ahearn, New York 2007

The Chief Rocker Busy Bee Starski, scratched slide by Charlie Ahearn, 1980

Scratched slide by Charlie Ahearn, 1980

Table of Contents

Welcome to Wild Style The Sampler 2

Part 1
Break It Down 8
Art in the Projects 10
The Times Square Hook Up 16
Style Masters 28
Masters on the Mic 41
T-Connection 44
The Webster P.A.L. 46
The Ecstasy Garage Disco 48
Celebrity Club 54
The Ritz 58
Rapture 60
Sugarhill Convention 64
In The Cipher with Rock Steady 70

Part 2
Making the Movie 72
Here's a Little Story That Must Be Told 74
Money for the Movie 80
Break Beats 82
Casting 84
Shooting 96
Lee as Movie Star 98
Locations 100
Dixie Mural 108
Stoop Rap 110
The Union Crew 112
Where's That Place We Work It Out? 114
Wild Style Theme Song 116
The Basketball Throwdown 118
The Dixie Battle 122
The Stick-Up 126
Trouble in the Yard 128
Uptown 81 132
Flash in the Kitchen 134
Rock Steady Crew 136
Lee Gets Busted 138
Painting the Amp 140
The Amp Jam 142
How To End the Movie 148
Reshoots in the Spring 149
Scratch Mixing in the Editing Room 152
The Animation 156

Part 3
The Release 162
How the Movie Got Sold 164
The Wild Style Mural 166
Tokyo Rocks 168
Times Square and Beyond 176
On and On 190
Reunion in LA 192
Amphitheater Returns 194

Sample Sale by Sacha Jenkins 199
'Til the Break of Dawn by Carlo McCormick 205

Index of Players 208
Performers 209
Cast 209
Film Credits 209
Acknowledgments 210

Animation by Zephyr, 1983

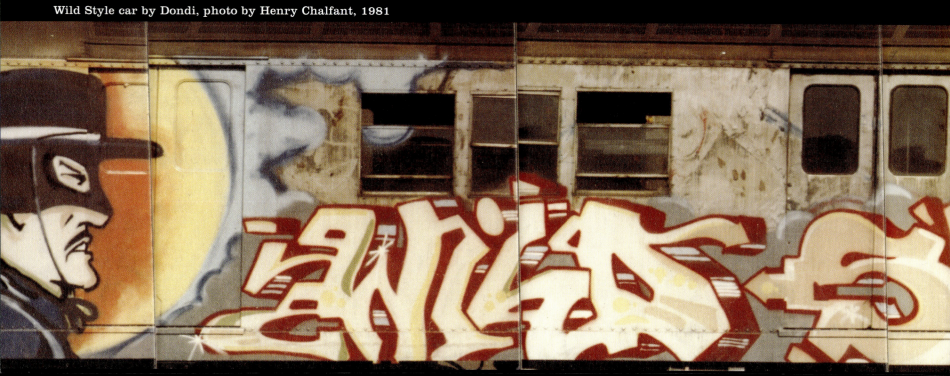
Wild Style car by Dondi, photo by Henry Chalfant, 1981

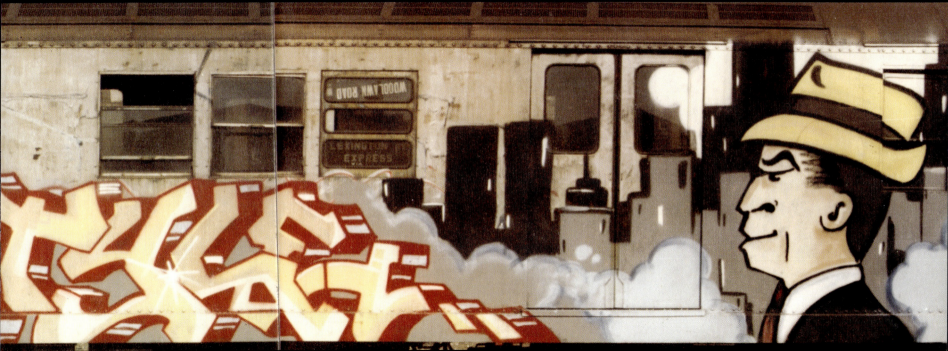

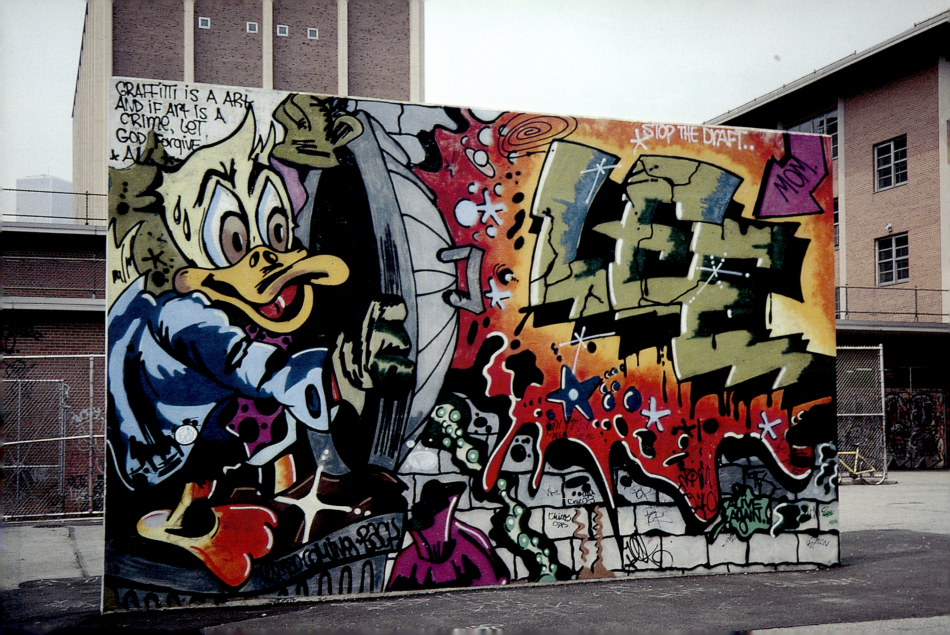

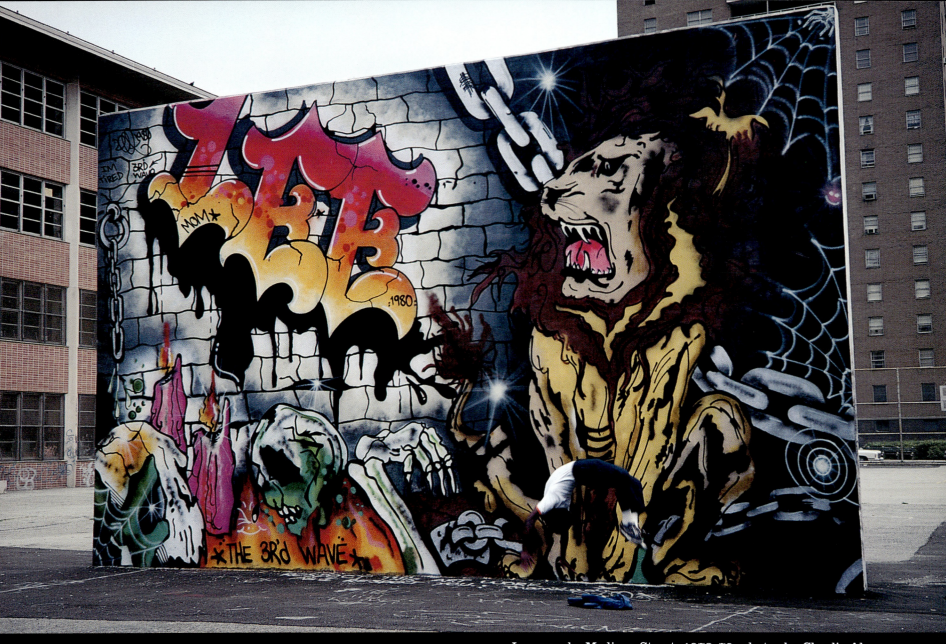

Lee murals, Madison Street, 1978–79, photos by Charlie Ahearn

Art in the Projects

11

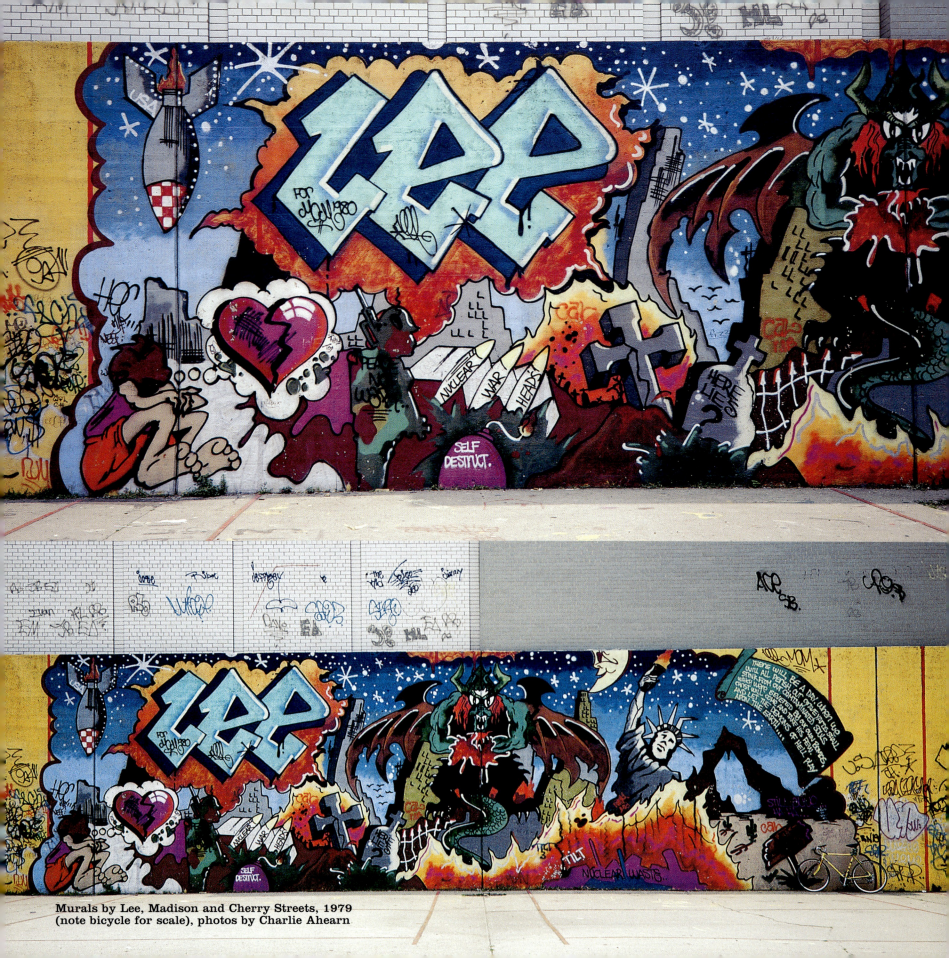

Murals by Lee, Madison and Cherry Streets, 1979 (note bicycle for scale), photos by Charlie Ahearn

In the late 70s I ventured into the Smith Projects near the Manhattan side of the Brooklyn Bridge, where there were mysterious but colorful murals spray painted on handball courts with cartoon characters and LEE in bold letters. There was a grim lion's den of death, an explosive "Howard the Duck," and a vast apocalyptic nuclear nightmare of New York City. These were among the most impressive artworks I had seen in years—but who was painting them? The local kids gushed that, of course, they knew him. He was famous. He was the most famous subway graffiti artist, but no one knew where he lived or how to get in touch with him. He was Lee Quinones.

 I had come to New York City in 1973 to be part of the art scene and fell in with a generation that had taken up film, video, and performance art and were looking for fresh audiences for their work. I was walking around the Smith Projects with my 16mm Bolex movie camera. I wandered into a jam in the local gymnasium where "Soul Power" by James Brown was deafeningly loud; guys faced off in rows, dropping back on their ankles in unison. This was 1977. I had no clue what was going on, but I returned to project the film images on the wall at the next jam.

 At one of my screenings in Smith a large group of kids stayed behind to speak with me. They were from a local martial arts school led by Nathan Ingram. They wanted me to make a movie with them to be called *The Deadly Art of Survival*. The story was to reflect Nathan's real struggle against the local drug dealers—who, in our movie version, operated from a rival karate school called the Disco Dojo. I made the film in super8 with a sound stripe to capture all the dialog and fight scenes.

 We were shooting alongside Lee's "Howard the Duck" mural when a skinny kid with a big afro rode up on his jerry-rigged scooter bike. I was floored to meet Lee Quinones and immediately asked him to be in our movie. He said sure, but he was in hurry someplace. I asked, "How will I get in touch with you?" He just shrugged and said, "I'll be around," as he took off on his bike. But he didn't come around. The next place we met was in Times Square.

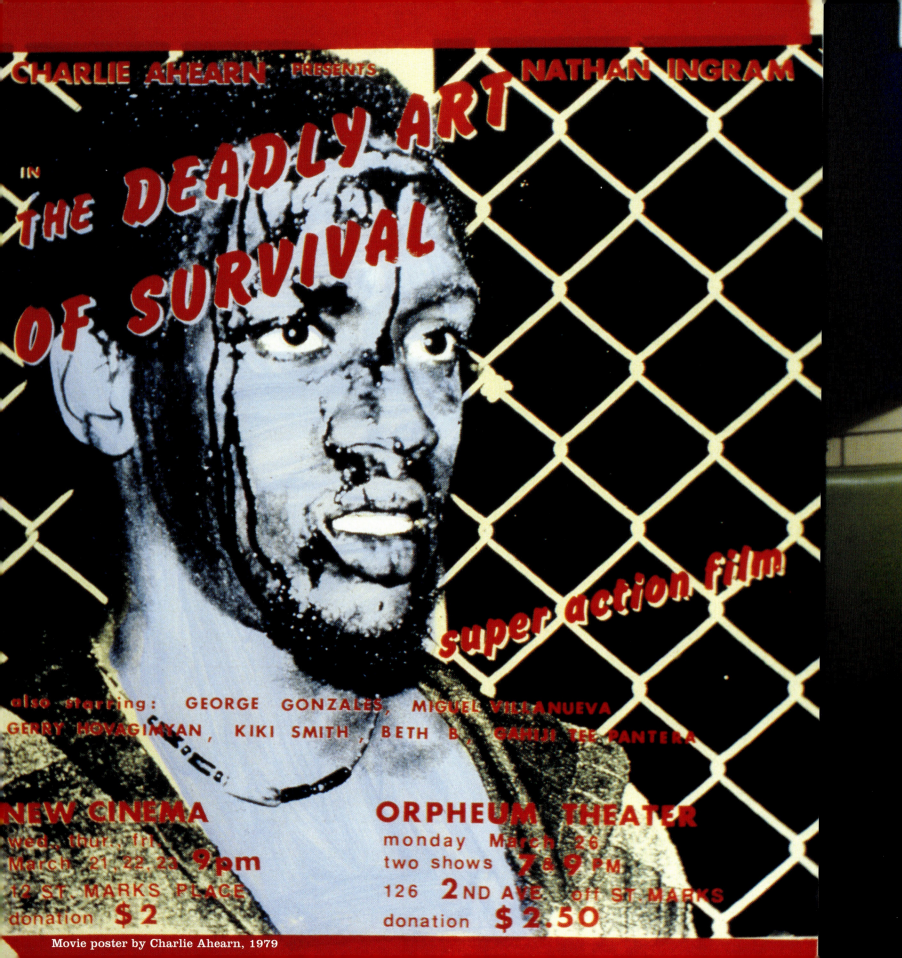

Movie poster by Charlie Ahearn, 1979

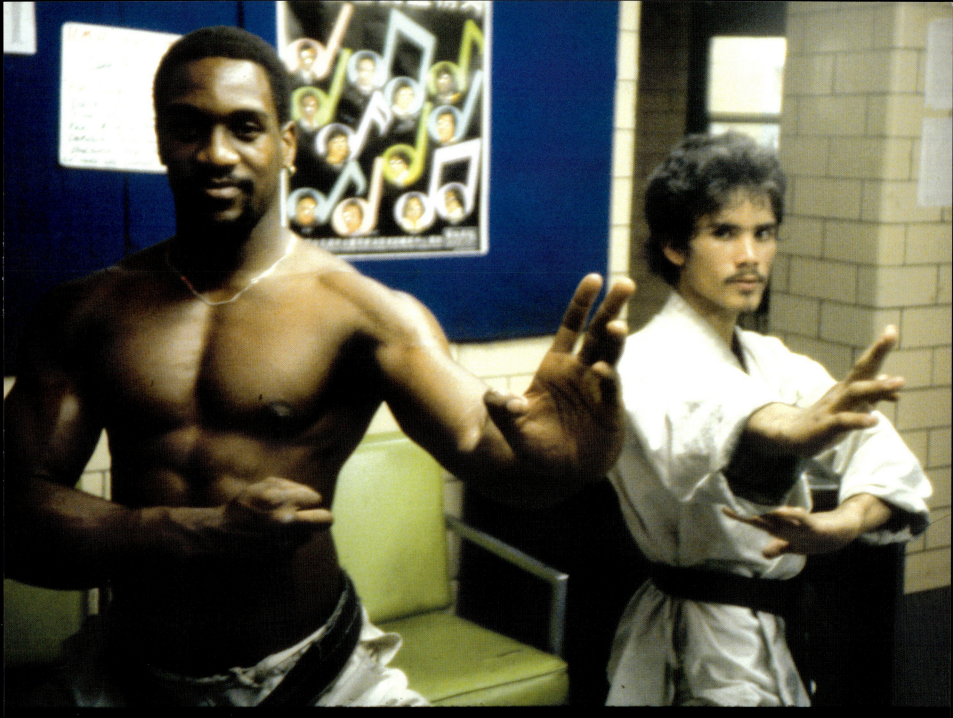

Nathan Ingram and student Raymond Diaz in the Deadly Art of Survival school, photo by Charlie Ahearn, 1978

A true-to-life action hero in the Smith Projects, Nathan Ingram sang in his parent's gospel church and founded his martial arts school called the Deadly Art of Survival in 1973. Nathan invited me to make a film with him and his students to reflect Nathan's real struggle to teach discipline and self-respect to the local kids.

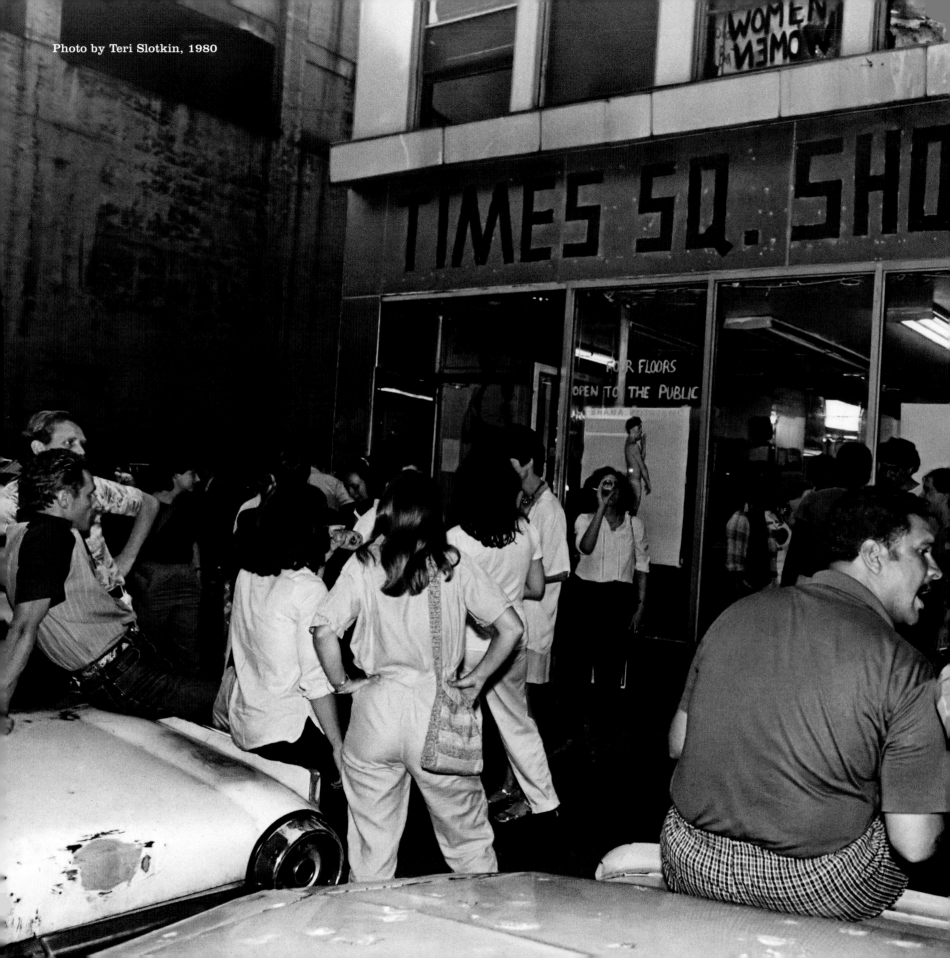
Photo by Teri Slotkin, 1980

The Times Square Hook Up

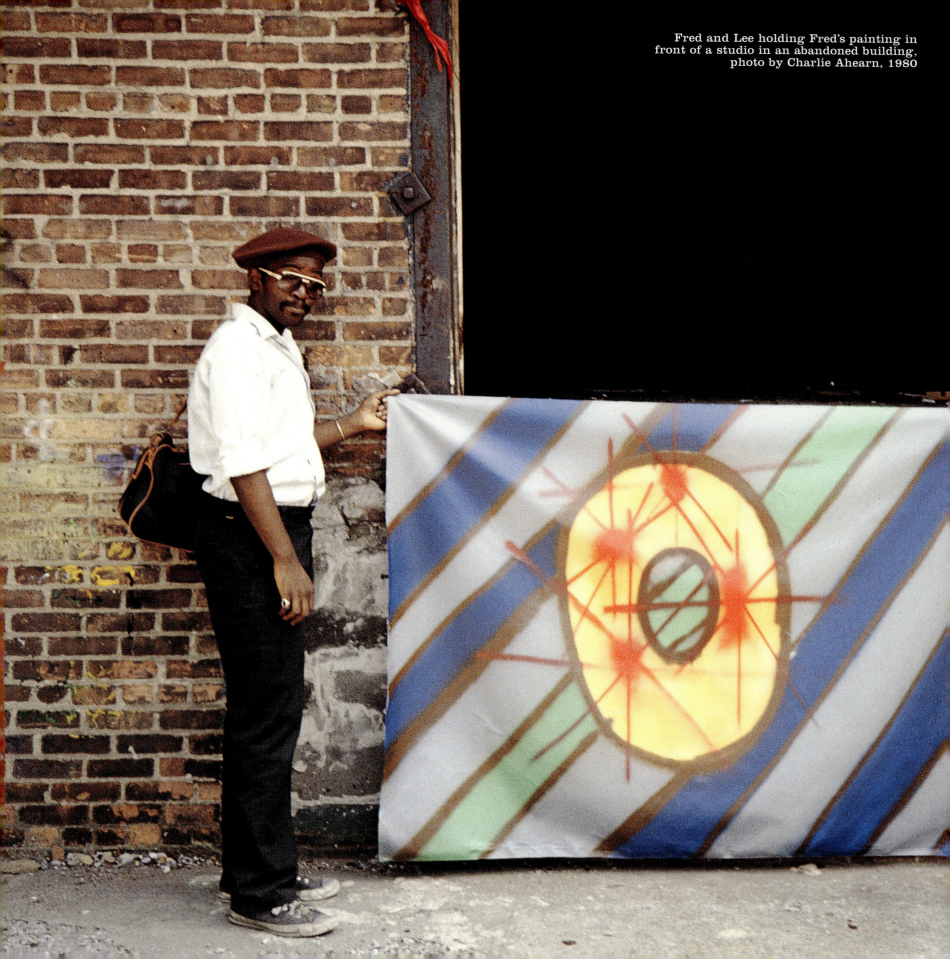

Fred and Lee holding Fred's painting in front of a studio in an abandoned building, photo by Charlie Ahearn, 1980

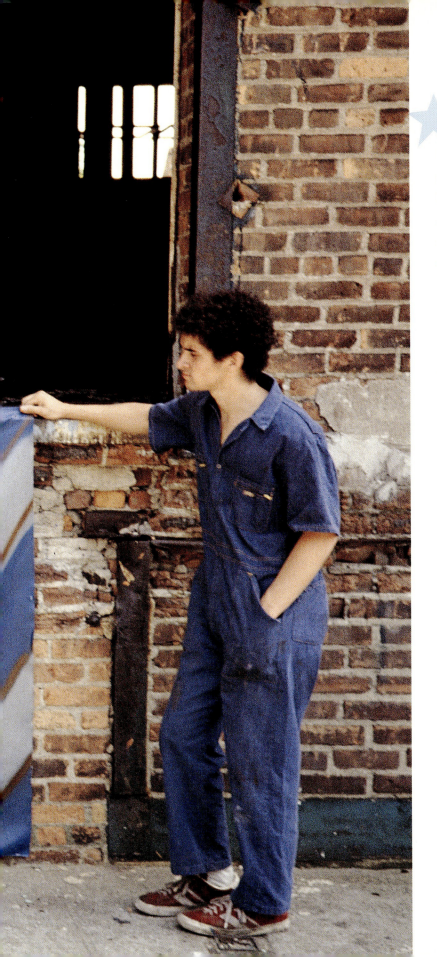

Fred

In 1979 I connected with Lee Quinones, one of the master graffiti artists of our time. I did some graffiti in Brooklyn coming up, and while I was nowhere near the artist Lee was, I had lots of ideas. We talked about the art world and we talked about us, particularly as people of color inserting ourselves, not as folk artists, not as naive artists, but as fine artists, just as smart as any of those other cats.

I began to meet people that, when I would explain some of these ideas, would say, "Yeah, I agree with you." And those people became instrumental to me—because I couldn't go to friends my age and have these kinds of conversations. Those were people like Jean-Michel Basquiat, Keith Haring, Glenn O'Brien, Chris Stein and Debbie Harry from Blondie, and my man, Charlie Ahearn.

I remember hanging out with Lee in the Lower East Side by the Catherine Projects, and seeing a poster on the wall. I recall thinking this has got to be some really grimy low-budget independent film. It was an image of a man's face, all bloodied, behind a chain link fence, and the title was *The Deadly Art of Survival*. The poster always caught my eye. I said, "Yo, Lee, what's up with that? It feels like something street." Lee said, "That guy on the poster lives around here. He's into martial arts."

It went along with these ideas I had. If we could put this stuff into a movie, we could present it like a real culture.

Some of Lee's work in the Smith gymnasium was in *The Deadly Art of Survival*. I remember seeing the film and saying, "Look, there's some of Lee's work!" I was looking for the guy who made the movie.

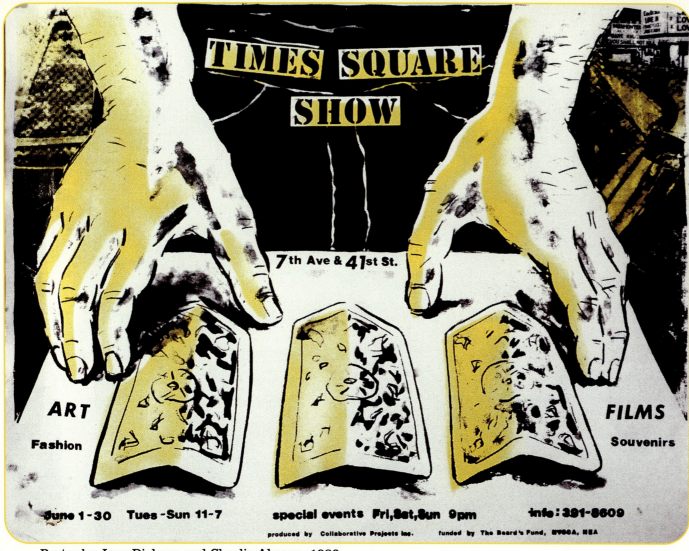

Poster by Jane Dickson and Charlie Ahearn, 1980

Co-lab, short for Collaborative Projects, was a group of artists who came together in the late 70s to exhibit art in raw spaces, to publish magazines (such as *X*), and to create film and video programs for public television. In June 1980 Co-lab and other artists descended in droves on an abandoned massage parlor in Times Square to mount a show that helped spark dozens of art careers as well as *Wild Style*.

 It was a beautiful mess strewn over four floors. My twin brother John Ahearn cast passersby out on the street. Tom Otterness painted Coney Island—like come on signs for the show. Davis Hammons smashed Night Train bottles and poured the broken glass down the stairs. Debbie Davis piled mashed potatoes in unusable toilet bowls in the men's room. David Wells' James Brown did the "funky chicken" in the lobby. Kenny Scharf customized the architecture with his toy soldiers and his School of Visual Arts mate Keith Haring pasted pre-Radiant Child xeroxes on the walls. Jean-Michel Basquiat sprayed the words FREE SEX over the entrance to the Times Square Show. Rock bands, art performances, and weird movies played in the lobby every night.

20

Lee

I remember Fred telling me about this upcoming show with various artists; I think he mentioned Kenny Scharf, Keith, and Jean-Michel. All this art was hanging everywhere and I was like, "What's this?" All this art being done by all these notorious characters in the hipster scene was being lumped together like we were on the subways. I felt that I was a part of a new wave of great art that was coming in at a very bland time.

Fred

I met Diego Cortez, a pretty well-known downtown art curator, very connected to the punk and new wave scenes. We went up to the *Times Square Show*. I think that was the week a big article had come out in the *Village Voice*, "The First Radical Art Show of the '80s." I think it was by Richard Goldstein. Charlie Ahearn's brother John was on the cover. It was very exciting because the timing was perfect: me trying to insert myself into the art world, feeling this energy, and here's this radical art show. Well, shit, I'm doing graffiti; we should be part of this show.

We walked into the show and on one of the walls I saw a poster for *The Deadly Art of Survival*. I said to Diego, "Who did this?" And he said, "That's Charlie Ahearn. He's the brother of the guy on the *Voice* cover." Diego introduced us and we began to talk right there. I told him I was working with Lee Quinones and right away Charlie knew who he was. He said, "Lee! He's the one who does the handball courts. Bring Lee up here, and you guys should do something."

By the way massage parlors are long gone now but they were another name for whorehouses. Times Square was littered with these places back then.

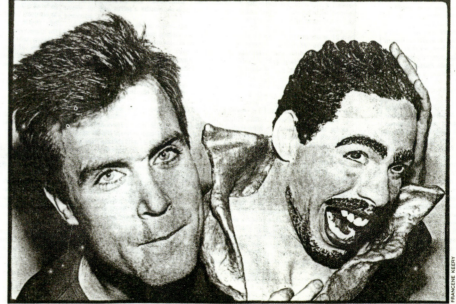

Village Voice, June 1980

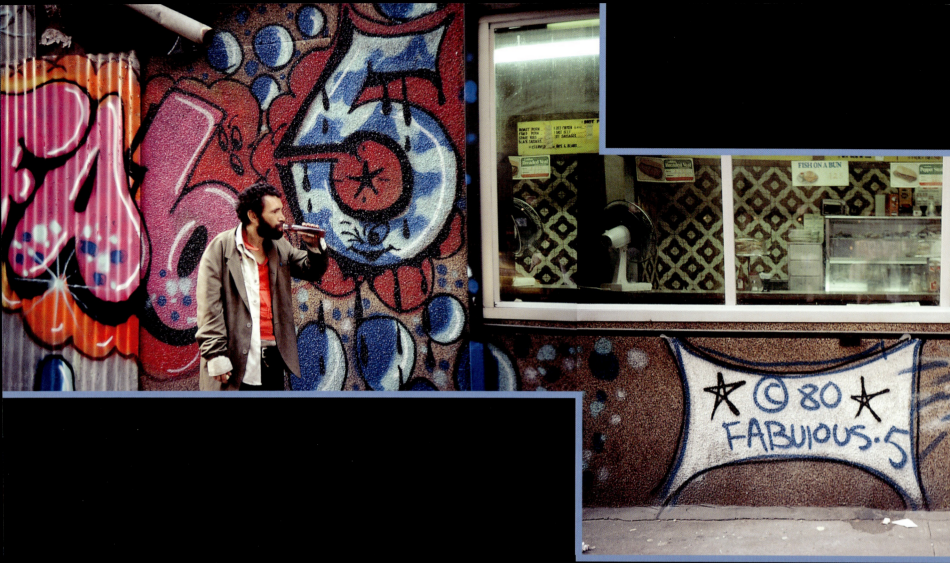

One night at the *Times Square Show*, I was approached by this very cool guy wearing dark Ray Bans. It's surprising, considering the time we both spent at downtown spots like the Mudd Club, that we didn't already know each other. He said that he'd seen my *DAS* posters around the Smith while he was hanging out with Lee Quinones. His name was Fred Brathwaite (aka Fab 5 Freddy), and he had a very interesting proposition: to make a movie combining rap music with graffiti.

I was focused on only one detail—to hook up with Lee Quinones—so I modestly proposed that if he and Lee were to come by, I would give them $50 for spray paint to make a piece on the wall outside. The next morning Fred and Lee were busy spraying a crude but colorful FAB 5 piece on 41st Street as if the world was ours and cops didn't come to Times Square. The three of us bonded that morning with the dream that we were going to make this movie together. We joked about it playing in the nearby Deuce grind houses where crews mobbed to see flicks like *The Seven Grand Masters* and *The 36 Chambers* or *Mad Monkey Kung Fu*.

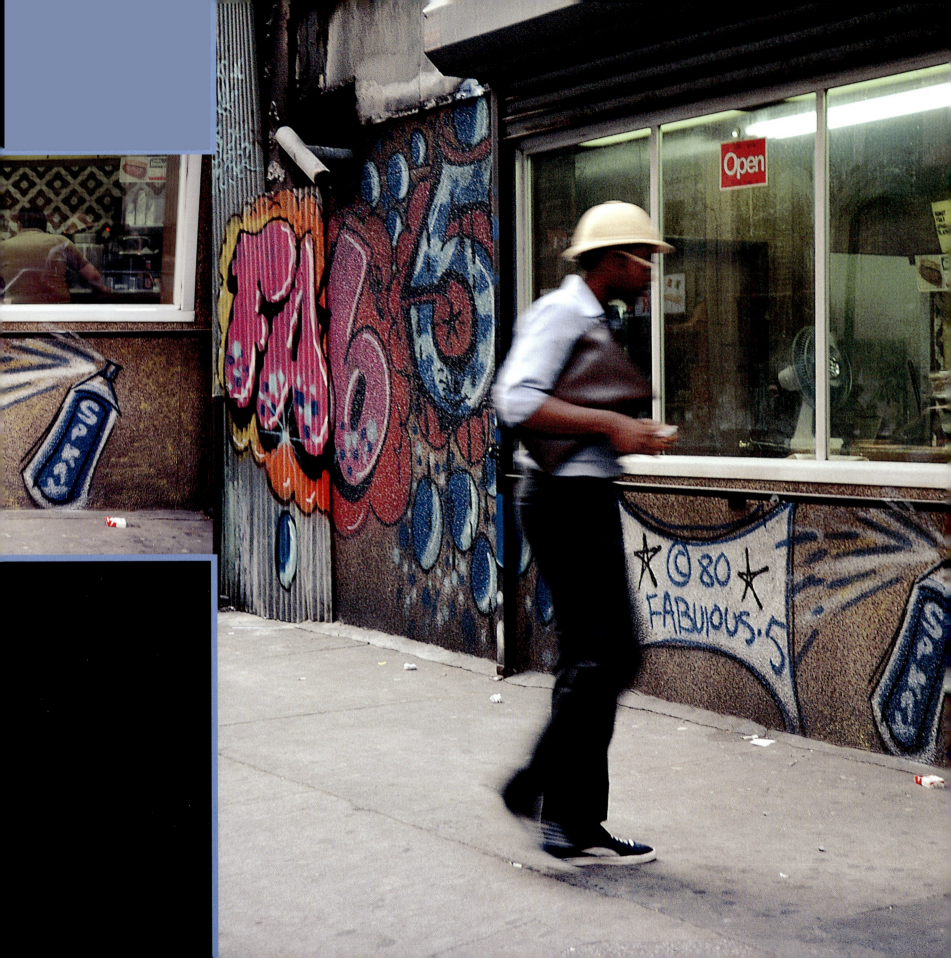

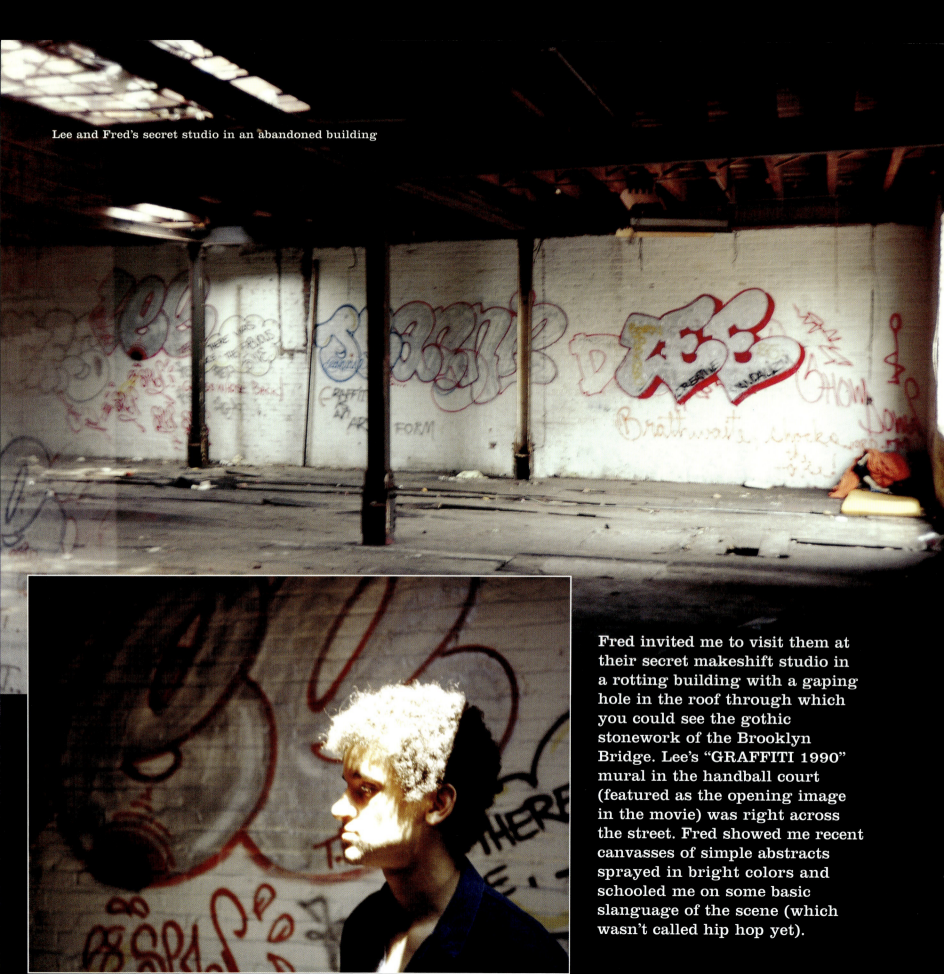

Lee and Fred's secret studio in an abandoned building

Fred invited me to visit them at their secret makeshift studio in a rotting building with a gaping hole in the roof through which you could see the gothic stonework of the Brooklyn Bridge. Lee's "GRAFFITI 1990" mural in the handball court (featured as the opening image in the movie) was right across the street. Fred showed me recent canvasses of simple abstracts sprayed in bright colors and schooled me on some basic slanguage of the scene (which wasn't called hip hop yet).

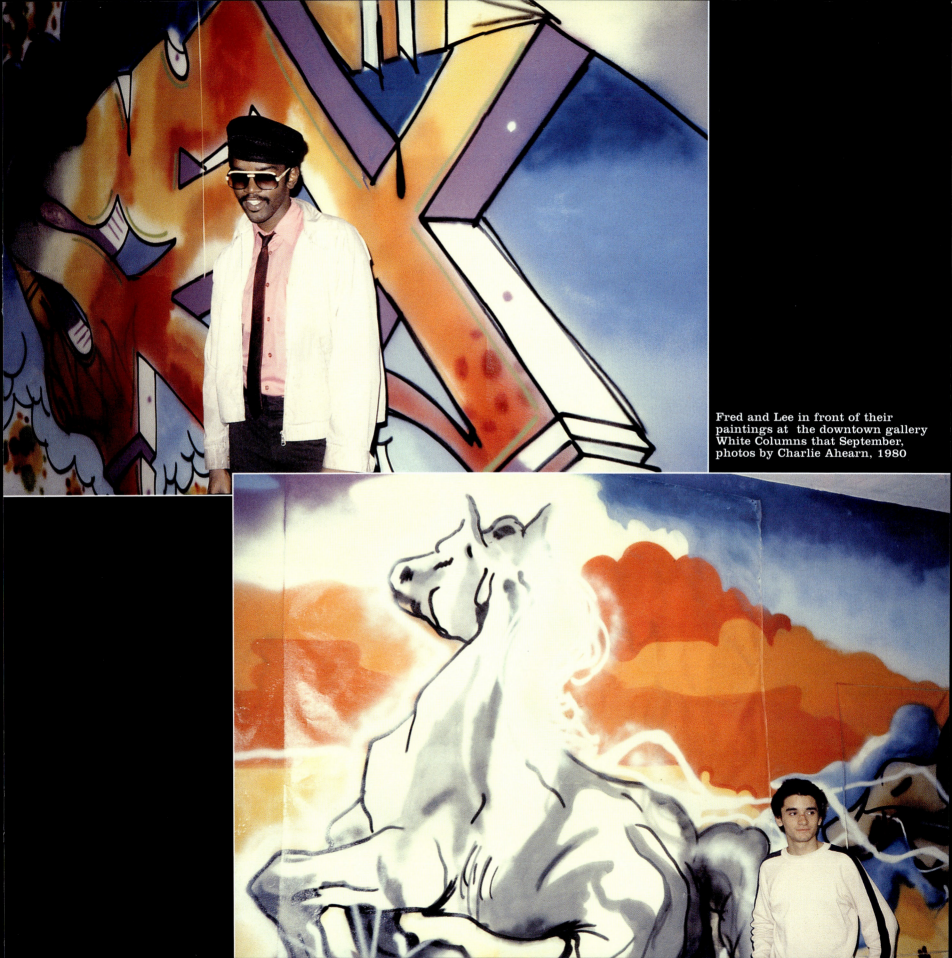

Fred and Lee in front of their paintings at the downtown gallery White Columns that September, photos by Charlie Ahearn, 1980

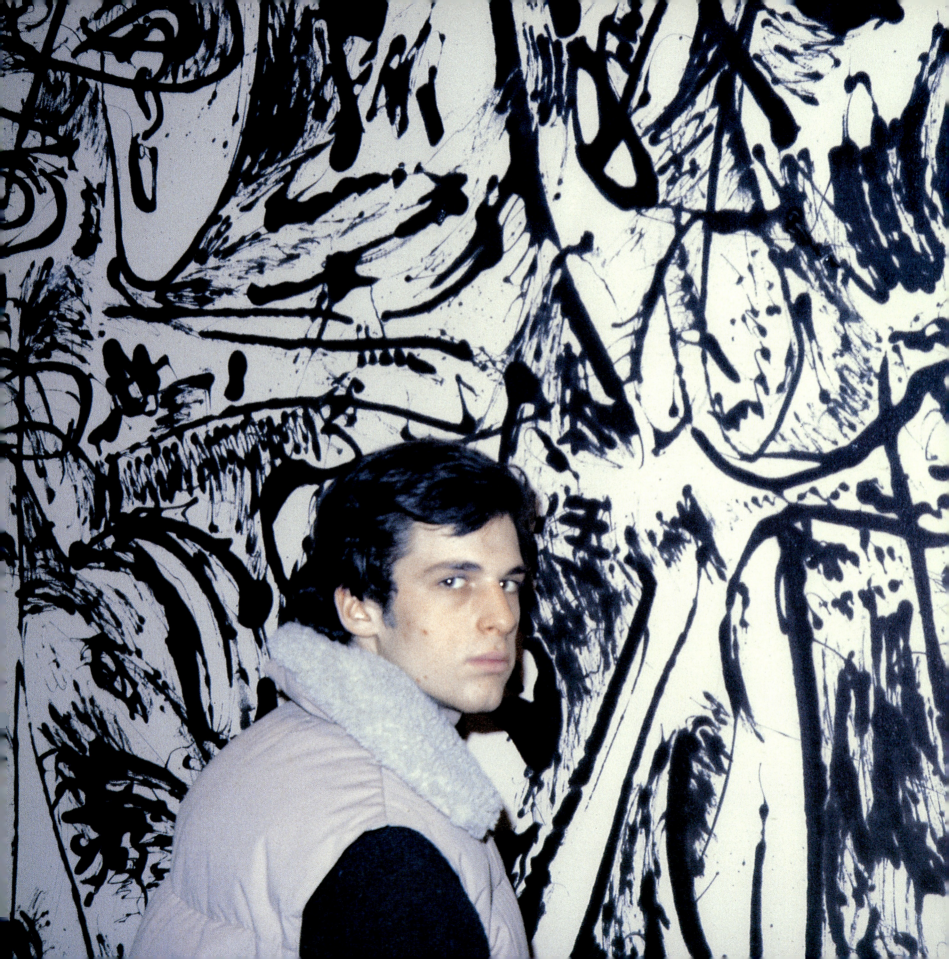

Riding the subway, Fred and I would study the dripping calligraphy covering the insides of the moving gallery, trying to decipher the secret code in words like PRESWEET, VOICE OF THE GHETTO, CRIME79, and REVOLT. We imagined how much Jackson Pollock would have felt right at home on the MTA. We went to the art houses to watch old movies like The *Harder They Come* and *Black Orpheus*, with their stirring dramas and documentary-like settings in Trenchtown and Rio—and most impressive was the evocative soundtracks.

But what could I do? I hadn't gone to film school and I had no real experience writing a script or directing a movie—and I had no budget. None of this mattered. The movie seemed destined to happen, but every question was open-ended. Was this going to be a documentary on graffiti and the rap scene? Or would this be a "real movie" that could play in Times Square? That question would follow us through every decision.

Fred

In the late 70s, graffiti was still a full-out assault on everything that a young kid would want to put his name on. Surfaces were covered. They were blitzed. They were saturated with markers with tags, with scrolls, with paintings—some good, some bad—but basically covered with an energy, covered with a voice that a segment of the city wanted to be heard in on our own terms. It was an uprising, baby. Spontaneous. That angst that aggression, those other ways that we sometimes feel, that sometimes represent those times that we lived.

I understood that when Pop Art was jumping off in the 60s it was a reflection of popular culture, of the musical sensibility, the Beatles and the Rolling Stones, that whole thing was going on. I connected with that. I also saw Abstract Expressionism having a connection to jazz. Some of these artists had a calligraphic style to their work. I said, damn, that reminds me of the energy of graffiti. You could see this next to a Jackson Pollock, and say, hey wait a minute. There's something similar here. To some people this was the ugliest side of graffiti, but from an artistic point of view you could see a connection.

Zephyr before a Jackson Pollock at the Museum of Modern Art, photos by Charlie Ahearn, 1981

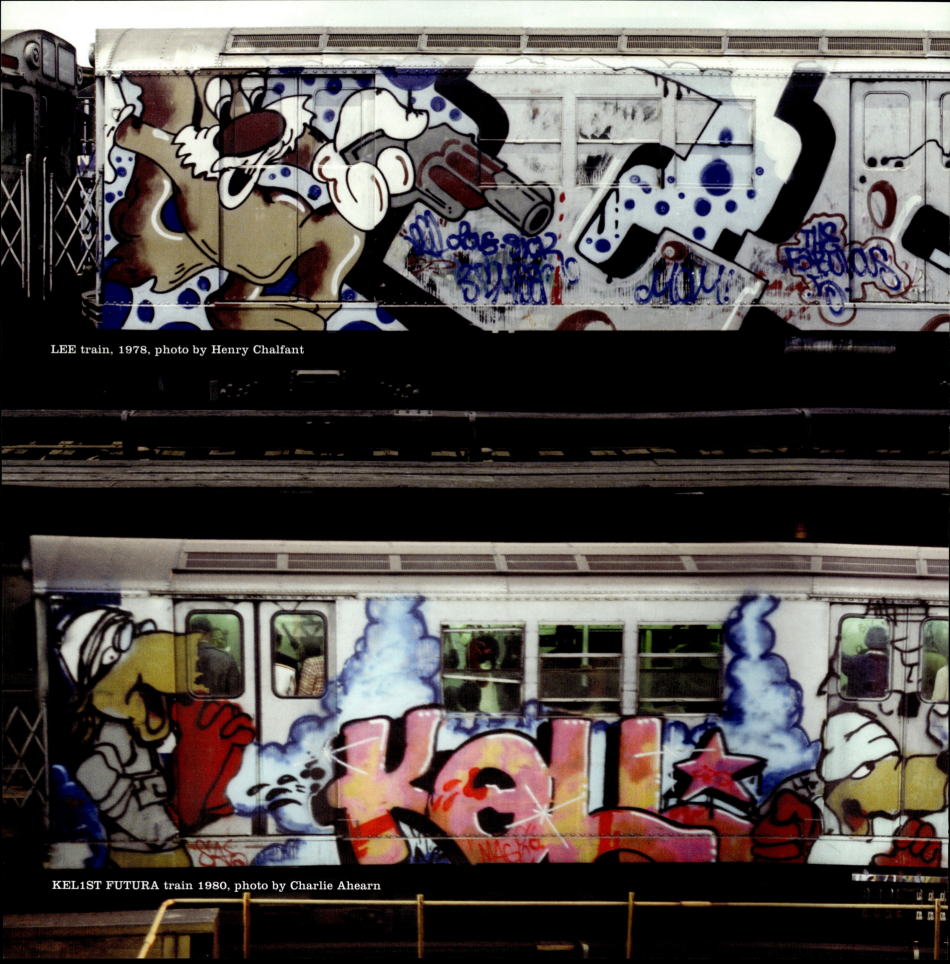

LEE train, 1978, photo by Henry Chalfant

KEL1ST FUTURA train 1980, photo by Charlie Ahearn

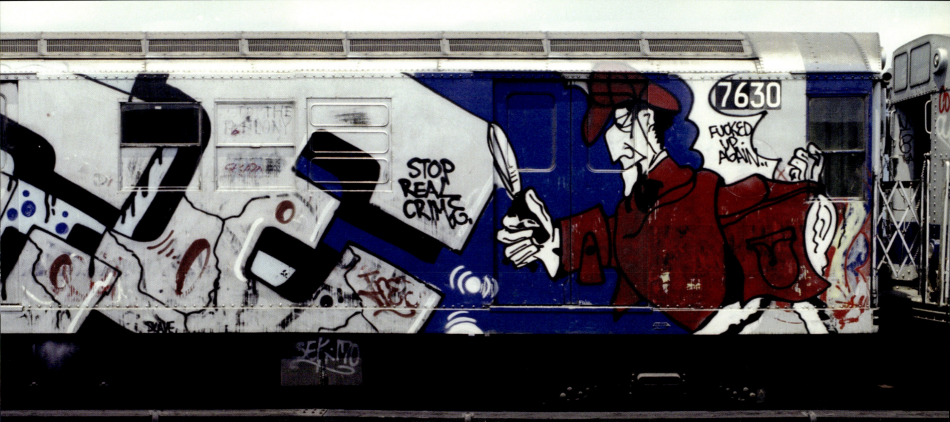

Style Masters

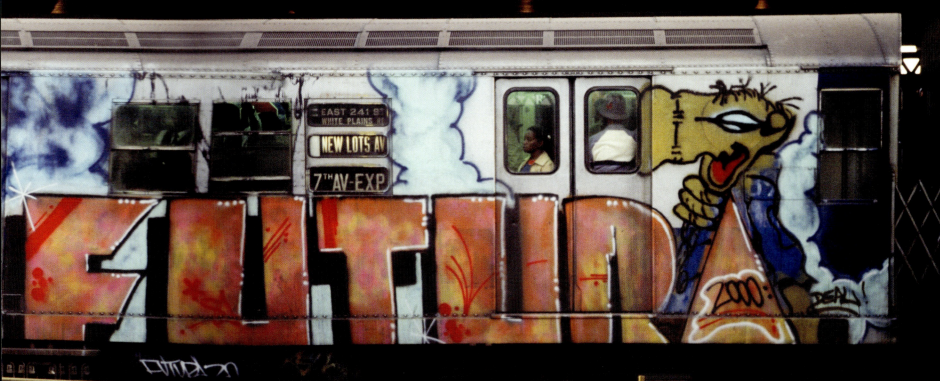

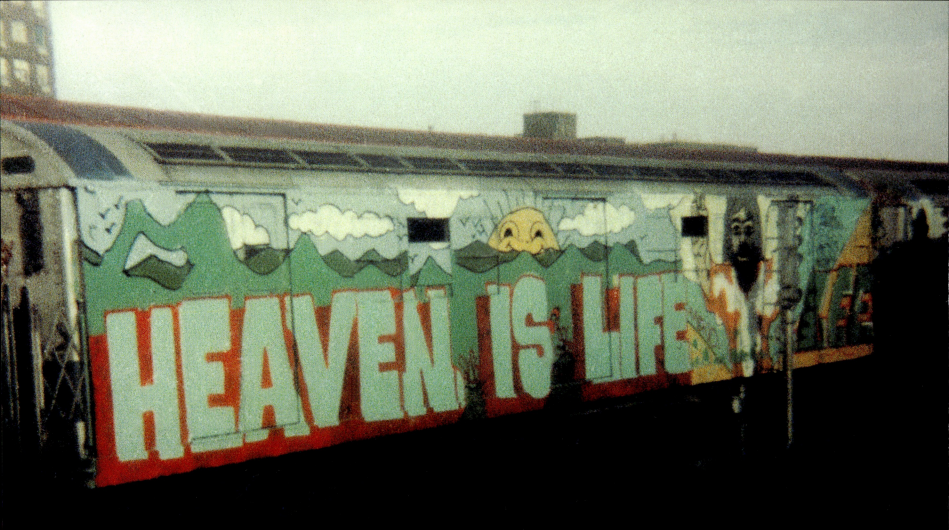

⭐ Lee

When I started painting trains in 1974 I said to my mom, "Don't try to stop me from doing this. I know what I'm doing." My mom was so worried. "Mom, I'm going bombing tonight. I'm doing a whole car!" "OK. Be careful. God be with you." By 1975 I wanted to do a whole car every night. It was a big stress on me. I started failing in school. I was cutting school to go watching trains or stealing paint. I never slept. I'd go watch trains from 7:00 AM to late afternoon.

The murals came in early spring 1978. The first one, the "Howard the Duck" wall, was down on Madison. I did that without knowing it was so monumental. At that time I was pulling off whole cars, a dime a dozen, back-to-back sometimes. That wall wasn't that huge a feat to me, other than, can I do this out in the open without getting caught?

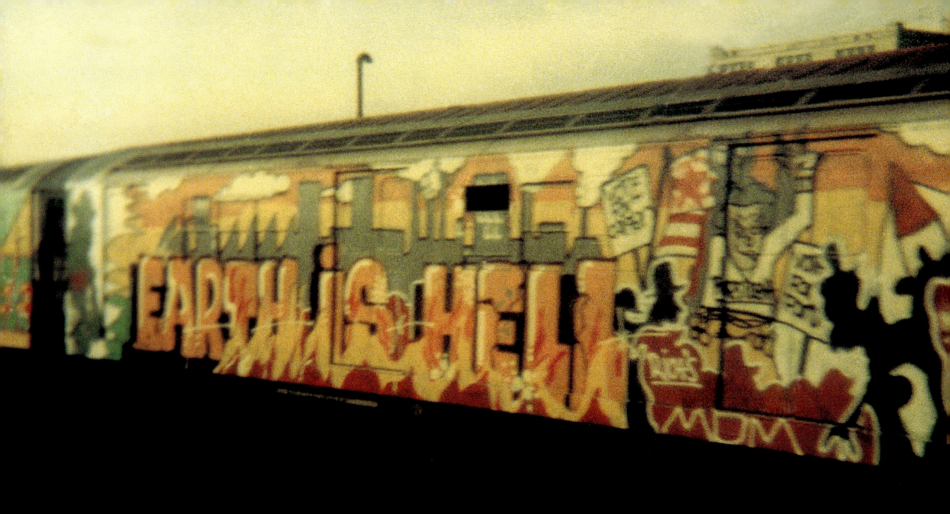

These two cars, painted one night in 1977, were a "married couple," which means the trains were linked. photos by Lee Quinones

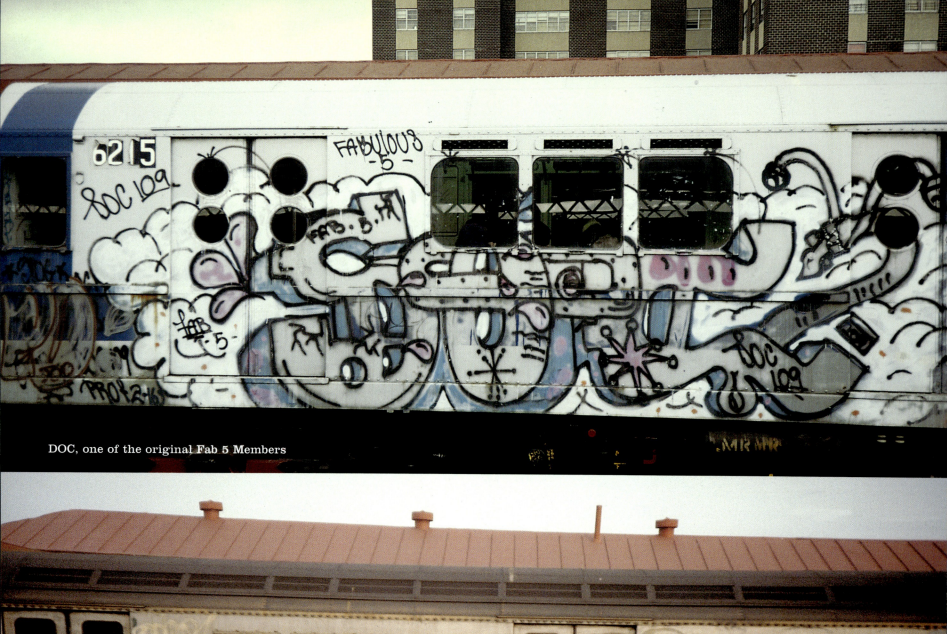

DOC, one of the original Fab 5 Members

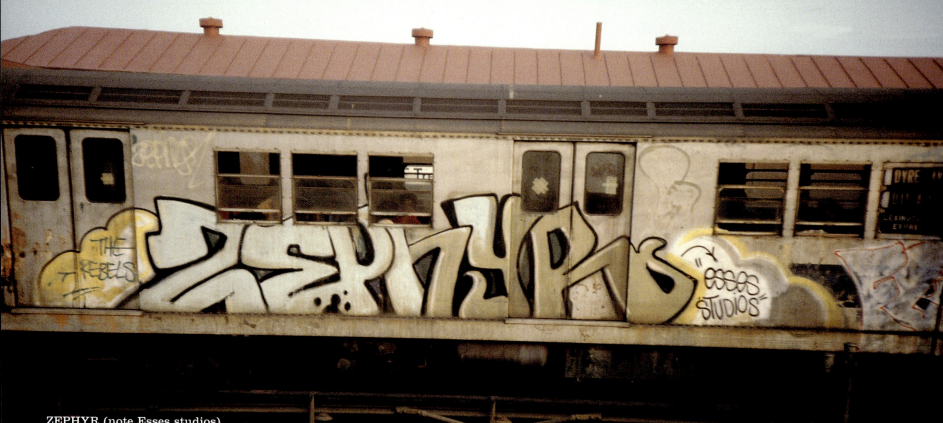

ZEPHYR (note Esses studios)

Writers were identified with the lines that they hit. The 2s and 5s on the IRT were among the most hotly contested, partly because of the way the trains emerged into sunlight in the Bronx. In the movie Lee and Zephyr gaze at the rolling art gallery, appreciating the fresh competition. The summer of 1980 was an amazing moment for burners, from Blade's wildly swinging letters and Lee's final blockbusters to Futura's break abstraction. It seemed endless then. Shocking new masterpieces appeared every week, but because of the toxic chemicals of "The Buff Machine," you had to look fast before everything disappeared. Two of the titans of the IRT grew up alongside opposing train yards; Dondi was literally at home at the infamous New Lots in Brooklyn and Seen played as a child among the vast field of slumbering IRTs in the North Bronx.

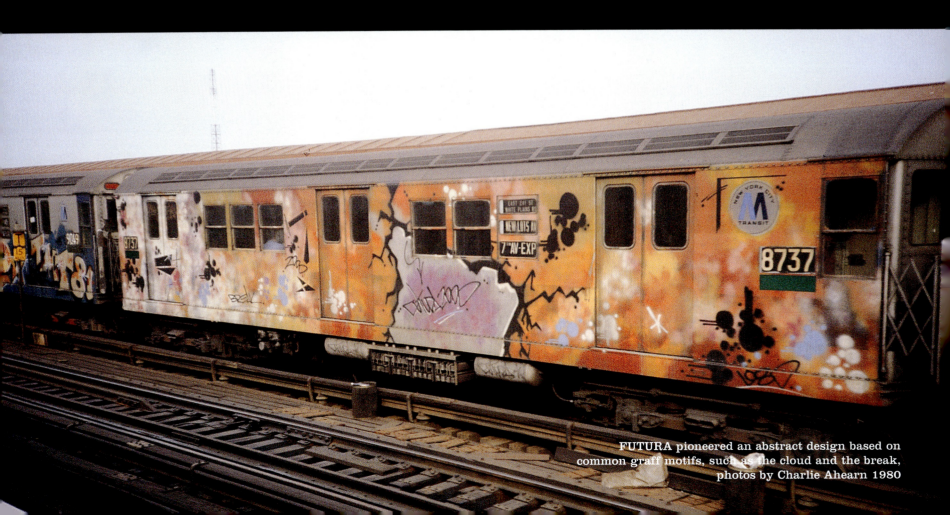

FUTURA pioneered an abstract design based on common graff motifs, such as the cloud and the break, photos by Charlie Ahearn 1980

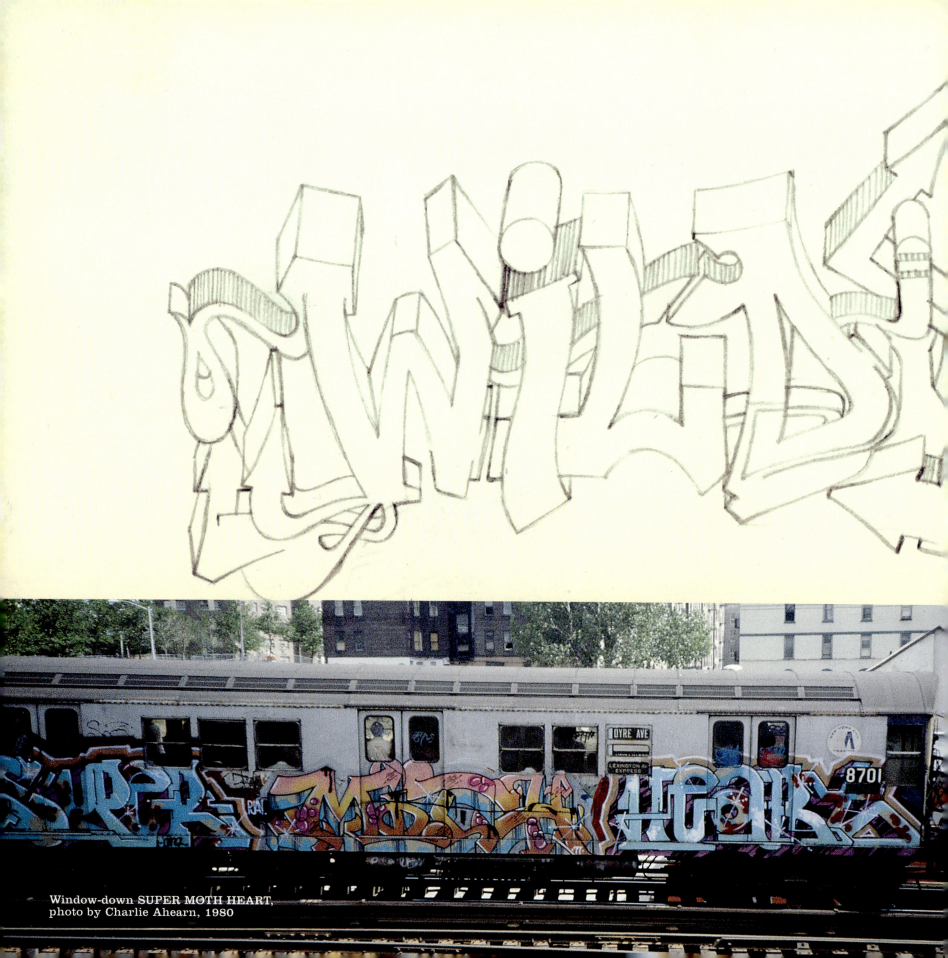

Window-down SUPER MOTH HEART,
photo by Charlie Ahearn, 1980

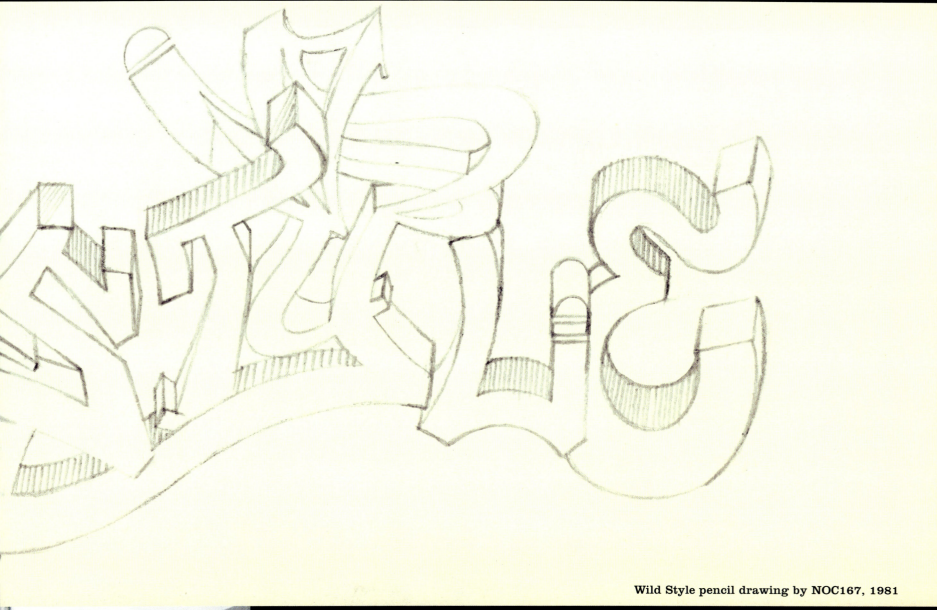

Wild Style pencil drawing by NOC167, 1981

That summer all the writers were talking about "wildstyle," referring to the most advanced but indecipherable letter style: smoothly interlocking, aerodynamic forms that seemed ready to sprout wings and fly off the trains. Their letters were moving like the trains they embellished. Zephyr often talked how Dondi's letters danced. And Rammellzee's letters were ready for war. "Wild Style" seemed like the perfect title for a movie about hip hop creativity coming out of the streets. I later heard about and met the legendary writer Tracy168 who tagged wildstyle after his name, and who led the respected wildstyle crew with Peanut2, King2, and Billy167 throughout the mid-70s.

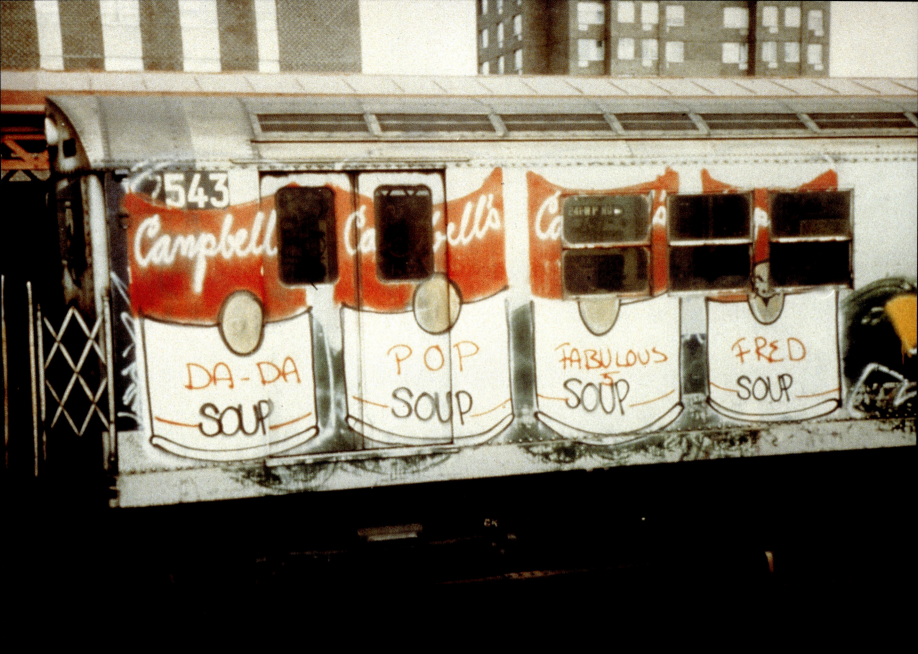

Fred Soup Train

I saw Pop Art as being influenced by the same things that we as graffiti writers and artists were inspired by—popular culture. I was a fan of Andy Warhol. One of the things he was famous for paintings of Campbell's Soup cans, and I said to Lee that I thought it would be really interesting to put this on a train as an homage to Andy. We were going to do was two whole cars together. I was going to do Campbell's

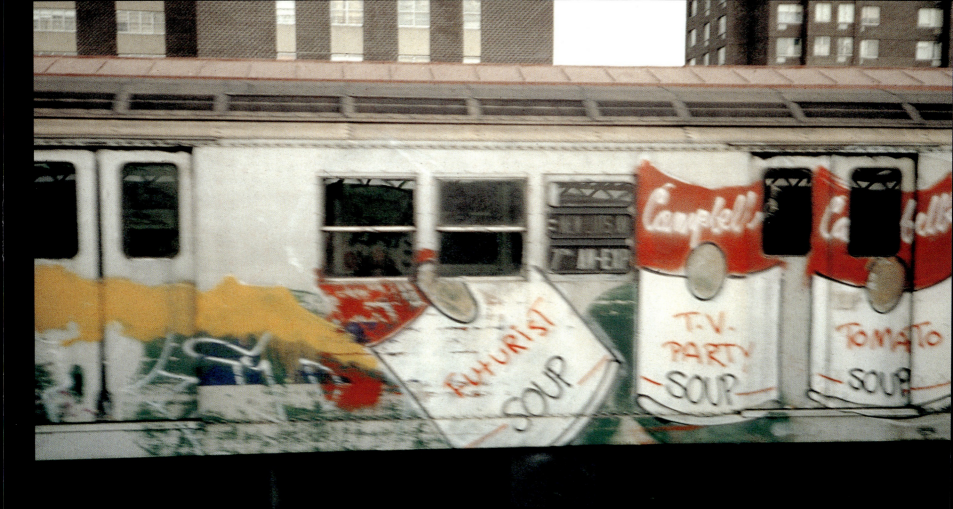

Photos by Charlie Ahearn, 1980

Soup cans and Lee was going to do a whole train that was a loaf of Wonderbread. I went to do the Campbell's Soup, and Lee did a typical top-to-bottom whole car himself. It was really cold that night and we weren't able to get the trains open to turn the engines on and warm up the paint. I wasn't able to finish my piece. It was going to be three or four cans on either side then a window-down FRED.

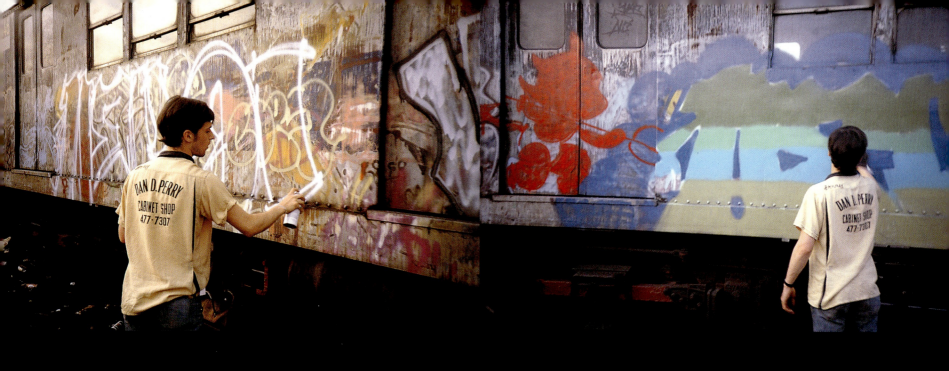
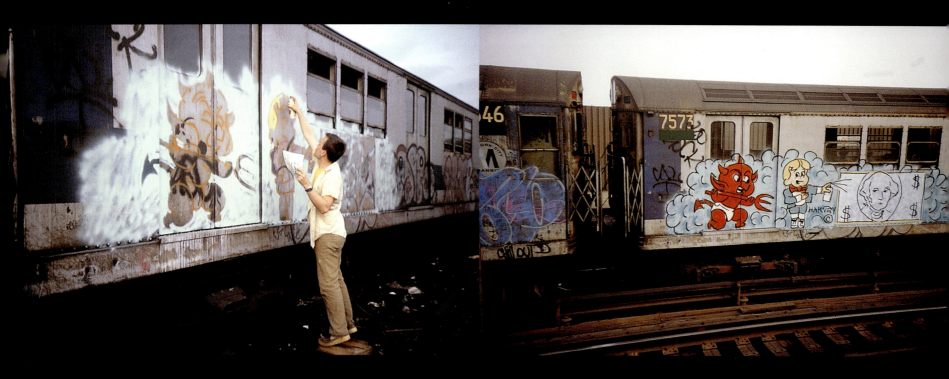

Zephyr (top left and right) and Charlie (bottom left), photos by Charlie Ahearn, 1981

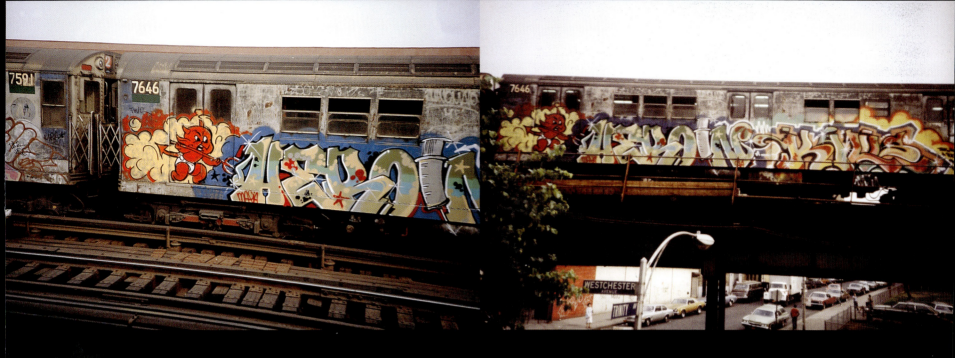

Zephyr In The Yard with Dondi and Charlie

Trips to subway yards were always dangerous. While I functioned under the false premise that going to the yard was a "piece of cake," the truth was that with every trip came the real possibility that things could go very wrong, very fast. So when Charlie A. announced that he wanted to join Dondi and me on our next painting mission, I tried hard to convince him that it was a poor idea. But Charlie was determined to gain some first-hand train painting experience, and wasn't taking "no" for an answer.

Forced into the awkward role of go-between, I adopted my "Hey Dondi, get a load of this shit" voice when I broached the subject. But to my surprise, Dondi liked the idea. So we painted with Charlie in the New Lots yard on a Sunday afternoon. I came with a big plan. I had with me the necessary paint and an outline for a huge cautionary message, "Heroin Kills." The idea came because of a situation one of my best friends was going through with the drug. Dondi thought my concept would be a great thing for all of us to do together. So I painted the word "Heroin," Dondi painted the word "Kills," and Charlie did the little devil from Harvey Comics.

Charlie was new to working with spray paint, and certainly new to enlarging a sketch onto a train (he had come prepared with sketches). But what I witnessed that afternoon was amazing. Charlie's execution was extraordinary, given his level of experience, or lack of. Dondi and I were blown away, and maybe even a little jealous, since we expected "Chuck" to fall on his face. While Charlie's devil on the "Heroin Kills" car, and the subsequent "Richie Rich painting a dollar bill" (that he painted on another car) may have had some drips, to this day I give Charlie credit for being the best "newbie" I ever painted graffiti with.

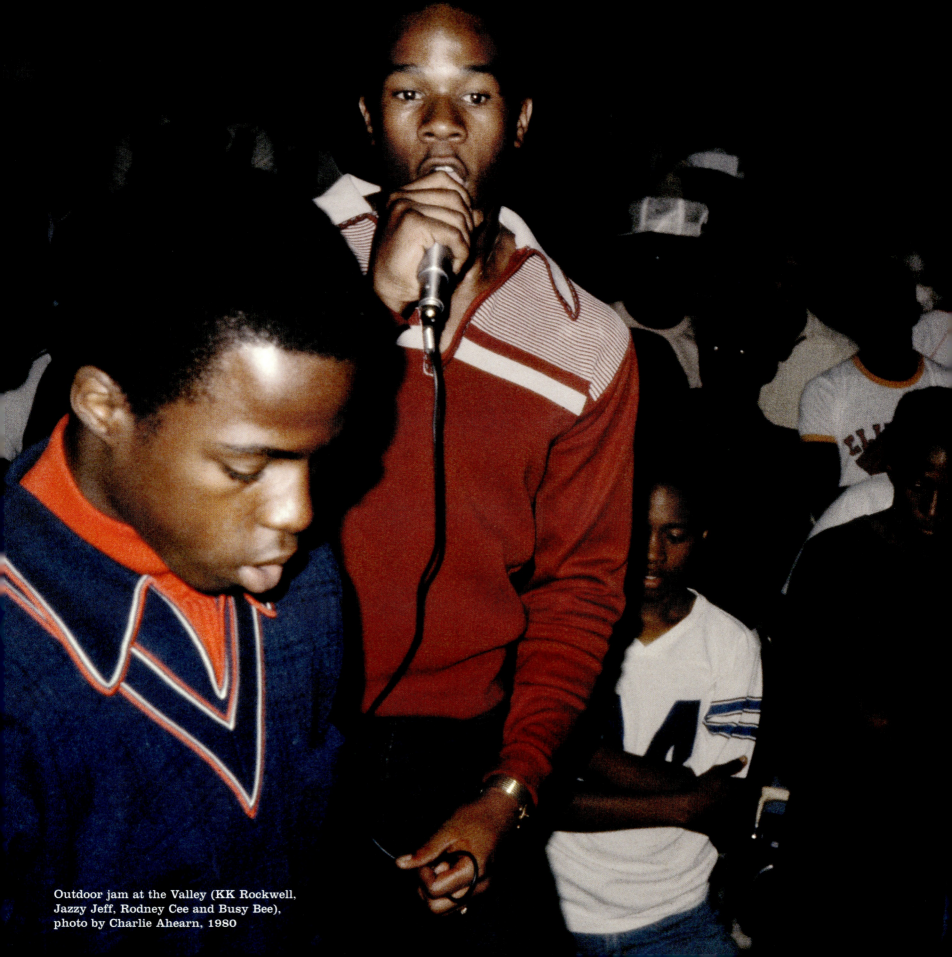

Outdoor jam at the Valley (KK Rockwell, Jazzy Jeff, Rodney Cee and Busy Bee), photo by Charlie Ahearn, 1980

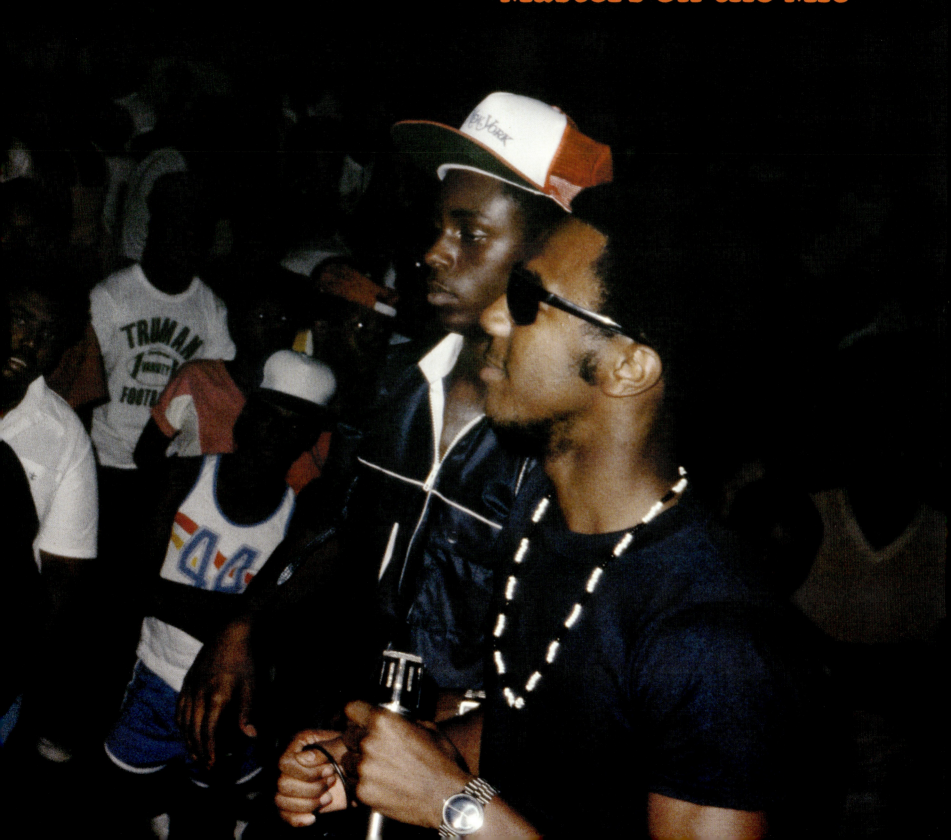

Masters on the Mic

Fred had heard that there was going to be an outdoor jam at a place called the Valley in the North Bronx. It was dark when we arrived at this wide open space. I remember hearing heavy dub music blasting out from one end of the park and James Brown music coming from the other end; we headed towards the James Brown. The place was like a miniature version of the Amphitheater in *Wild Style*. The Funky Four were on a tiny stage, exhorting the crowd of about fifty people to wave their hands in the air.

The man I was to soon know as the Chief Rocker Busy Bee Starski saw me and he was "sweating bullets" because he thought I was a cop about to bust him for the smoking joint in his hand. He asked me, "What's up?" and I introduced myself saying that I wanted to make a movie about the rap scene. Busy then immediately took me by the hand and led me out to the microphone on the stage. He put his arm around me and announced to everybody, "This here's Charlie Ahearn, my film producer and we're making a movie about the rap scene."

Busy Bee

For those of you who have never seen Charlie Ahearn, if he walks up on you, you swear you was in trouble, because he looks like The Feds coming at you. He came up like, "Where's Busy Bee?" And I was nervous and scared to death. "No, no, I ain't seen Busy Bee. I don't know where Busy Bee's at." And then he told me, "I love what you do. I want to do this movie with you." And I said, "Huh? You a movie man?" And I just relaxed, grabbed the mic, and said, "Listen this is my man Charlie Ahearn and Fab 5 Freddy. They're going to do a movie on me." It was crazy. But me and Charlie have been friends since then.

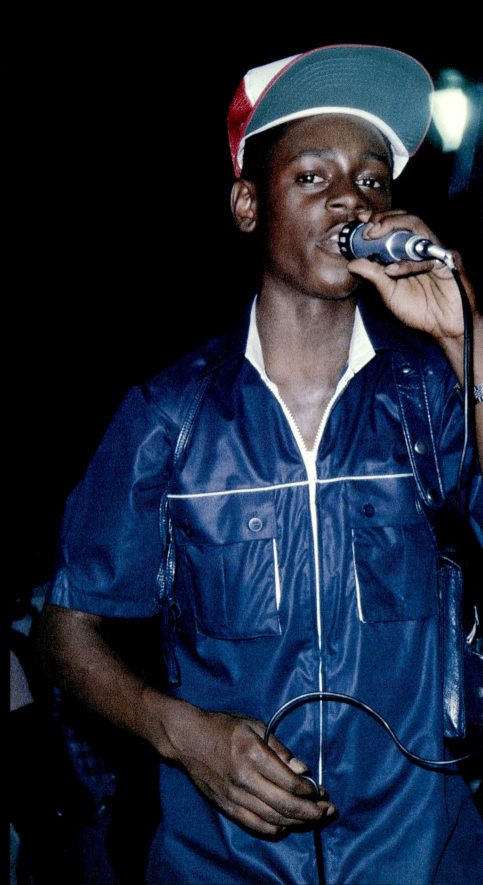

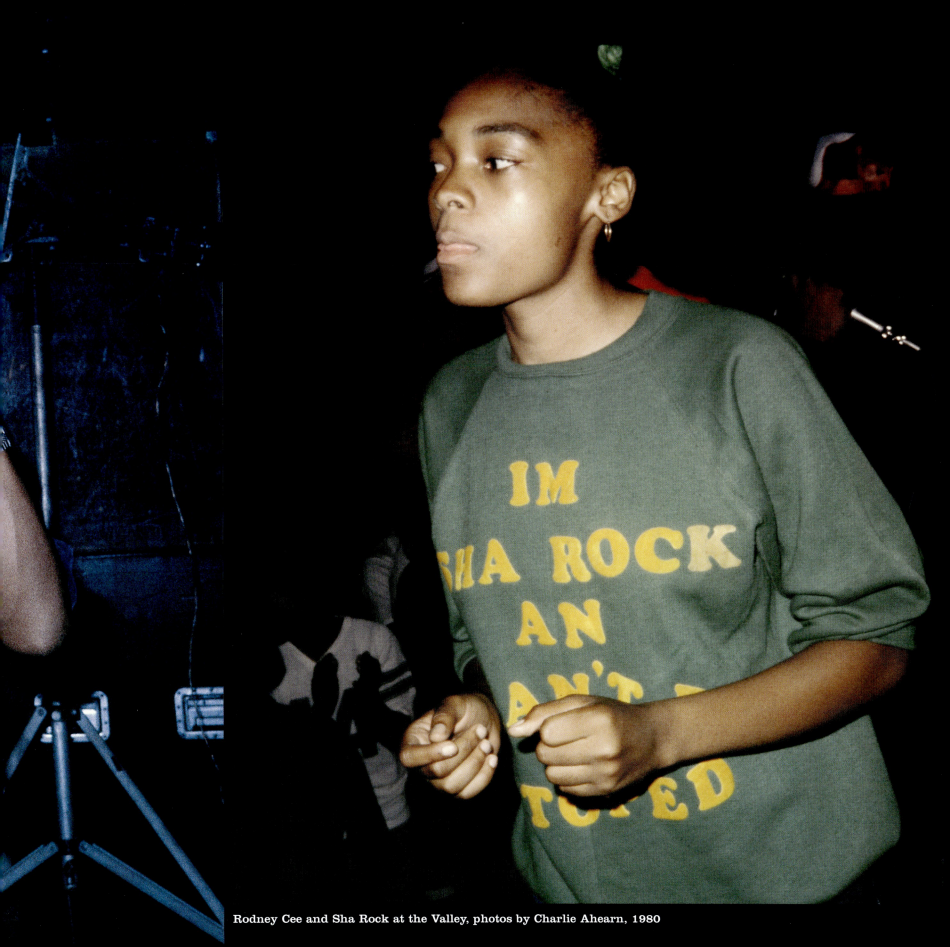

Rodney Cee and Sha Rock at the Valley, photos by Charlie Ahearn, 1980

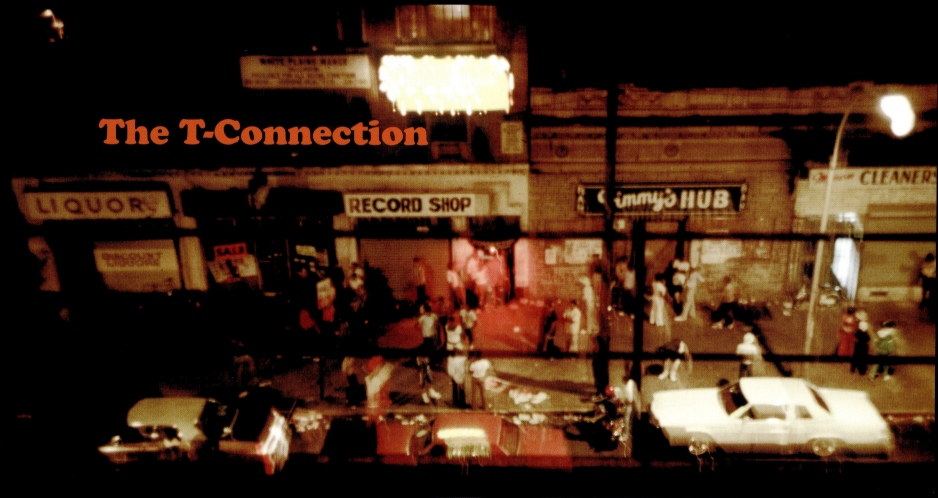

The T-Connection

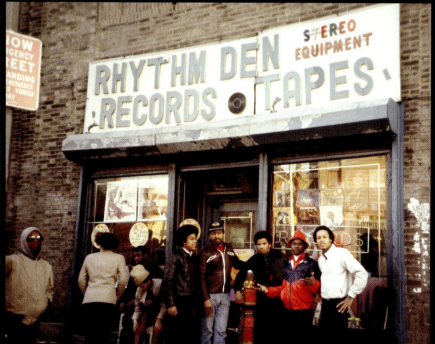

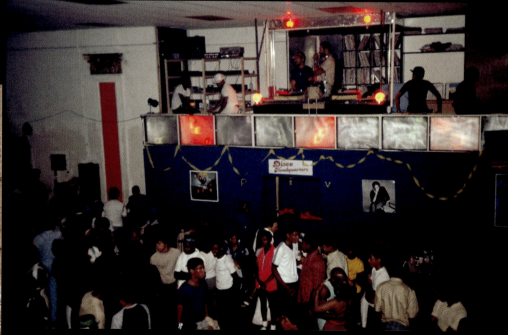

DJ Kool Herc (with mic)

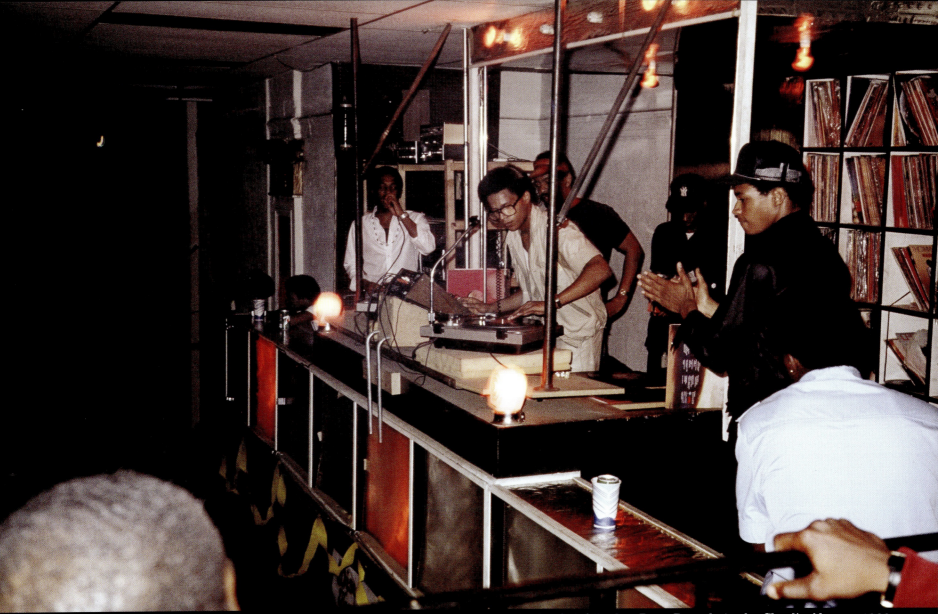
Herc's partner DJ Clark Kent rocking the decks for Chief Rocker Busy Bee, photos by Charlie Ahearn, 1980

The summer of 1980 Fred and I were going up to the clubs in the Bronx twice a week. At about midnight if you took the IRT to Gun Hill Road, and peered over the railing, you could check out the crowd trying to get into the T-Connection. You had to walk up three flights of rickety wooden stairs to get into a large open gymnasium with a generous stage and a professional DJ booth with panels of disco lights. This was the home of Richie T (RIP), a pioneer DJ and the owner of the Rhythm Den on Tremont Avenue, where you could purchase $5 cassettes of Zulu Nation, Cold Crush, and Flash party tapes from any year.

Charlie Ahearn,
photo by Fred Brathwaite, 1980

The Webster P.A.L.

Fred

Back then the streets were a lot more polarized along racial lines. You just didn't go into other neighborhoods unless you really knew people or were with people that could guarantee your safety. Obviously I'm black and Charlie is white and every time we would go, I would say to myself, "Man, I just hope nothing happens," because we were going into the jungle, baby! It was crazy out there in those streets!

There was one night at a Cold Crush/Fantastic jam at the infamous Webster P.A.L. (Police Athletic League) in the Bronx. The music was bumping, clouds of pungent weed and angel dust smoke wafted through the air as hundreds of kids "spanked" and "Patty Duked" to the music. We were enjoying the festivities and taking notes. Charlie was snapping pictures with his trusty camera.

There was a tall, menacing looking, extremely well-chiseled black guy swaggering thuggishly through the crowd, shirtless. His facial expression was like a snarling pit bull and he seemed to be carrying on a running conversation with himself. It was like he had smoked a bit too much and was completely damaged and "dusted." As he stalked around the party, everyone was sure to get out of his way. I noticed him several times and hoped he wouldn't come our way.

Charlie had just snapped a shot of Busy Bee and some others. We retreated to a back wall to reload the camera. When we both looked up, the Pit Bull spotted us from across the room. He began to move in for the kill. As he got closer, he walked slowly and deliberately right towards Charlie, starring menacingly. The closer he got, the worse it seemed until he stopped a few feet directly in front of him. Other people near us watched. It played like a scene in a horror film where you wonder, "Why don't they just run!" I felt like at any moment he was going to do something ugly. Charlie looked at me and said, loud enough for him to hear, "Fred, I think he wants me to take his picture." Then Charlie looked back at him with a calm Irish Spring smile on his face as the Pit Bull continued to stare, then he turned, seemingly dumbfounded, and slowly walked away.

The Ecstasy Garage Disco

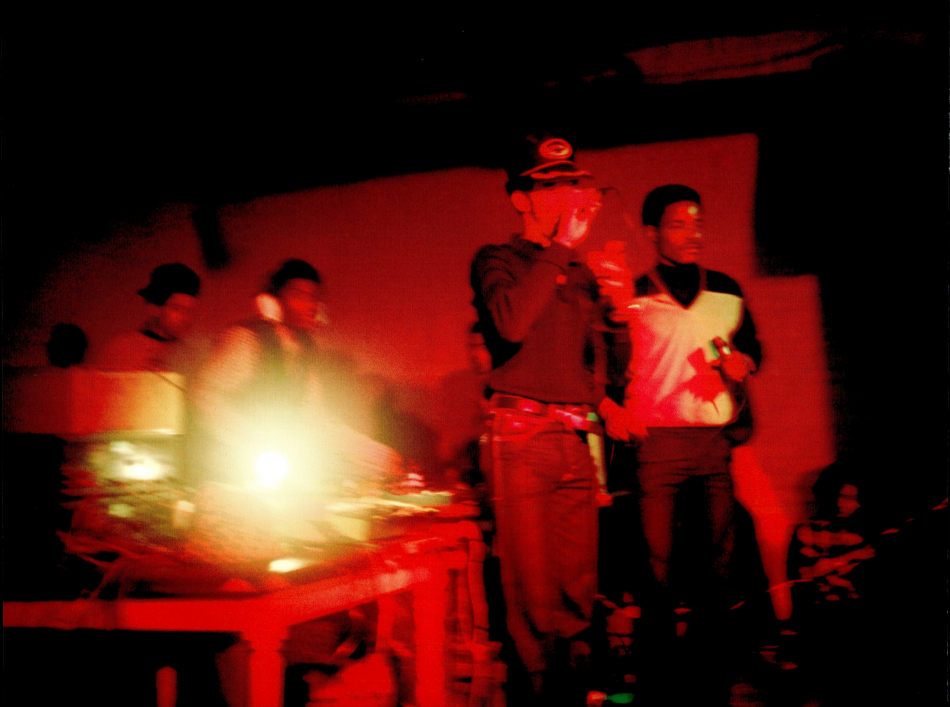

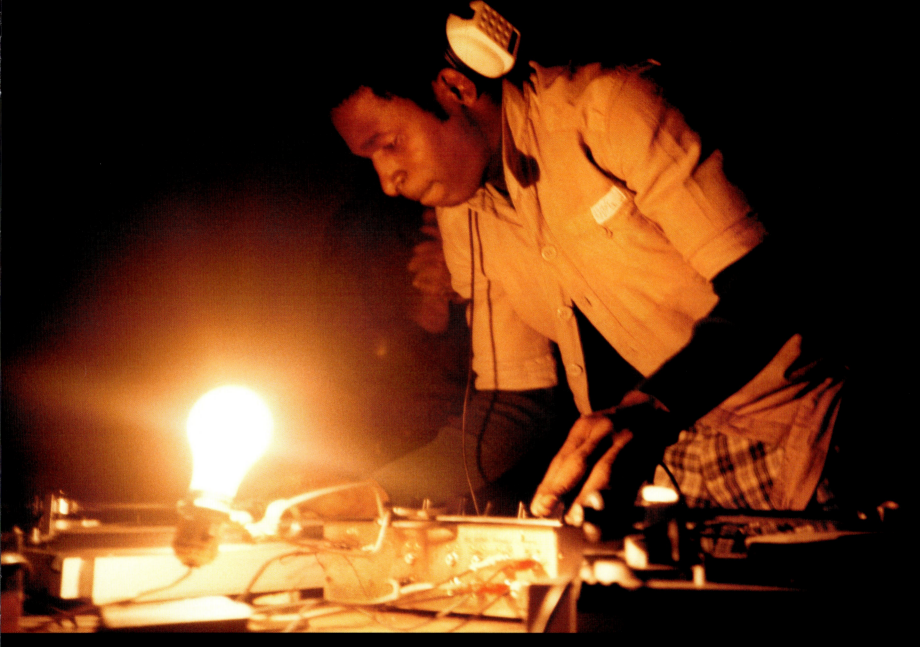

DJ AJ, photos by Charlie Ahearn, 1980

Slide Show, Ecstasy Garage

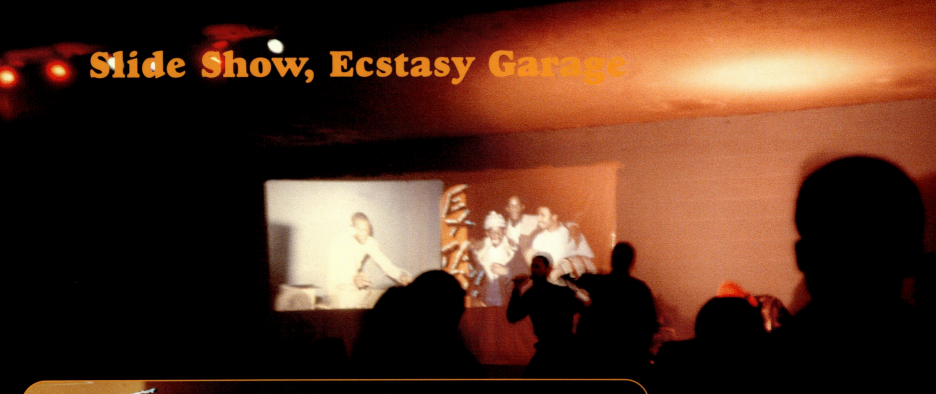

top: Busy Bee rocks the slide show

bottom: Phase2 and friends

top right: DJ AJ and Busy Bee

bottom right: Fantastic 5 at the Ecstasy, photos and scratched slides by Charlie Ahearn, 1980

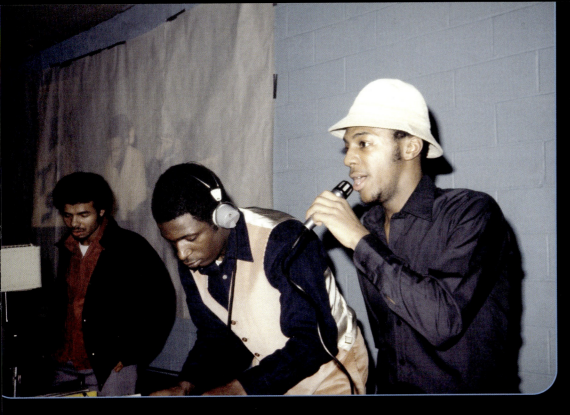

The Ecstasy Garage was located over by Kool Herc's West Bronx on McCombs off Jerome Avenue, only a few blocks from where my brother John had his casting studio and home on 172nd Street. I would hang out at John's place checking out his recent sculptures of his neighbors until it was midnight and time for the Ecstasy. The large cinderblock space lit only by a single bulb over the turntables would be jammed with teenagers drinking Old English malt liquor in quarts, listening to DJ AJ or Grand Wizzard Theodore playing "Heaven and Hell is on Earth," "Johnny the Fox Meets Jimmy the Weed," or "Rock It in the Pocket." Then the Fantastic would grab the mics, and they'd go for hours.

Later I would bring two sheets and hang them on the wall behind the DJ and project slides that I was snapping in the yards and the clubs. I would edit them like a storyboard, adding some shots taken the week before at the Ecstasy. It was like projecting a rough version of the movie. Busy Bee would be on the mic. He'd see himself up huge on the screen and would get the crowd to yell, "Hey Busy Bee, ho!" One night Phase2, who was an originator of early subway art and was designing the most beautiful party flyers, brought some slides from the early 70s of his incredible train pieces and of him posing in front of some of his bubble-style paintings. I popped them into the carousel and they became part "of the movie." That led me to think we should offer him a part in the film, and I asked to come down to our office in Times Square, but it never worked out. So when Fred was creating his role we fused his name with Phase and came up with Phade, the subway legend, party promoter, and scene catalyst.

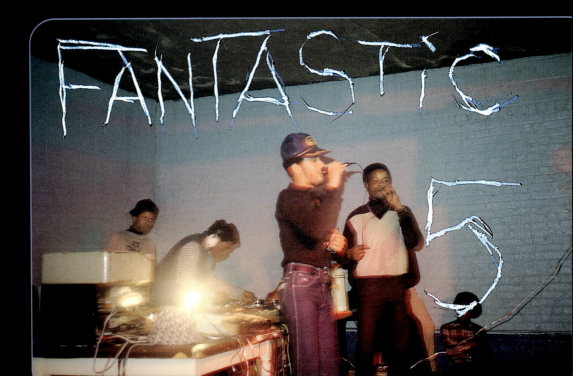

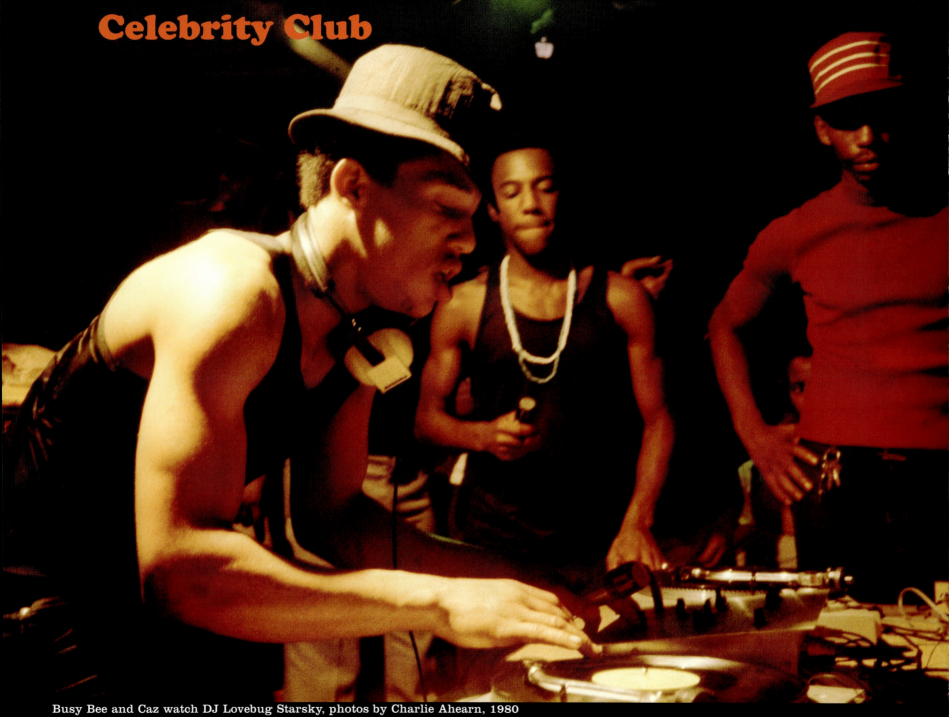

Celebrity Club

Busy Bee and Caz watch DJ Lovebug Starsky, photos by Charlie Ahearn, 1980

The night of the New York City Hip Hop Convention at the Celebrity Club in Harlem was being hyped by DJ AJ as the biggest rap battle bar none. His flyer boasted the names of every MC you wanted to see: Melle Mel was mellow in the house. Kool Moe Dee was coolin' in the house. Lovebug Starsky was doing his unique DJ/MC style. Busy Bee Starski was doing his funny shit and when he said, "I don't know but I been told," the whole crowd knew the response: "Eskimo pussy is mighty cold!" You couldn't believe the groups there—the Treacherous Three vs the Crash Crew! The Cold Crush were there in strength, but had decided to compete as single MCs for the cash prize. Among the competition were Busy Bee, Caz, Kay Gee, JDL, and others. The battle was on, but just when the winner was to be announced, there was a gun shot. The room cleared in an instant—leaving only broken tables and discarded shoes. Later I heard grumbles that DJ AJ set it up to leave him and Busy Bee with the money.

 I never believed it, but it inspired me to end the battle scene at the Dixie with Rodney complaining that it was a fix, leaving him with the hope of getting his revenge at the Amphitheater.

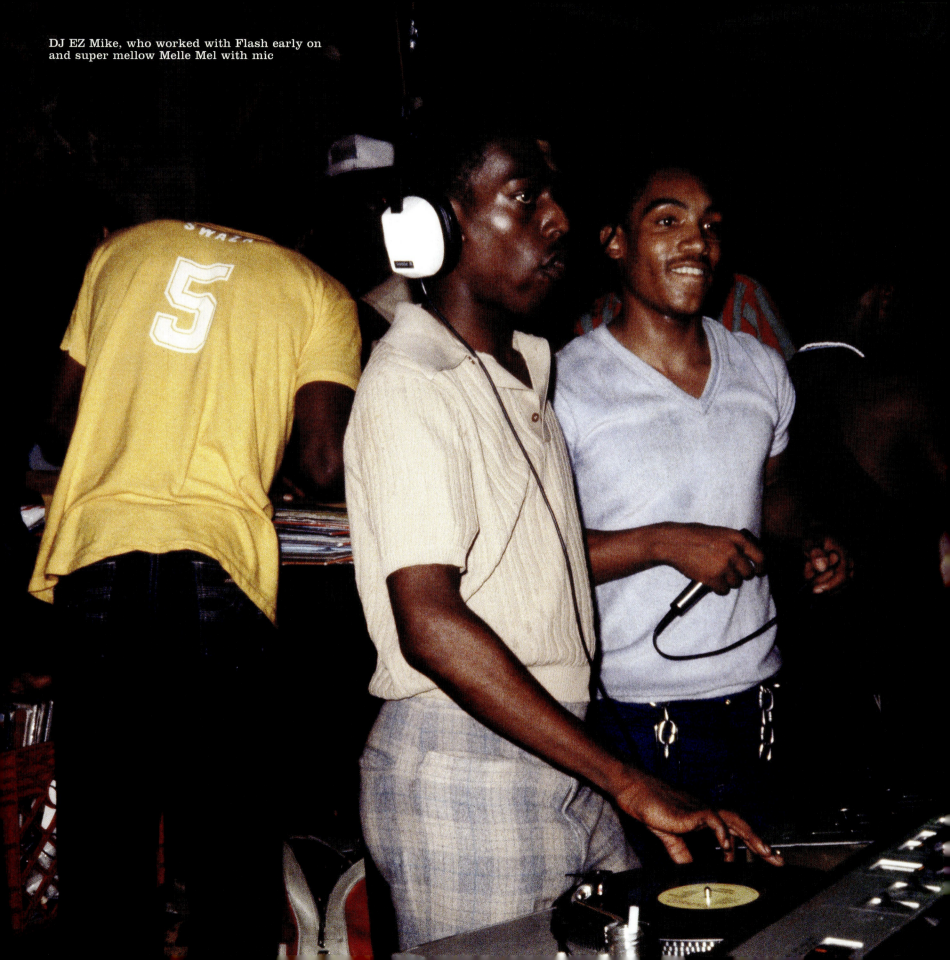

DJ EZ Mike, who worked with Flash early on and super mellow Melle Mel with mic

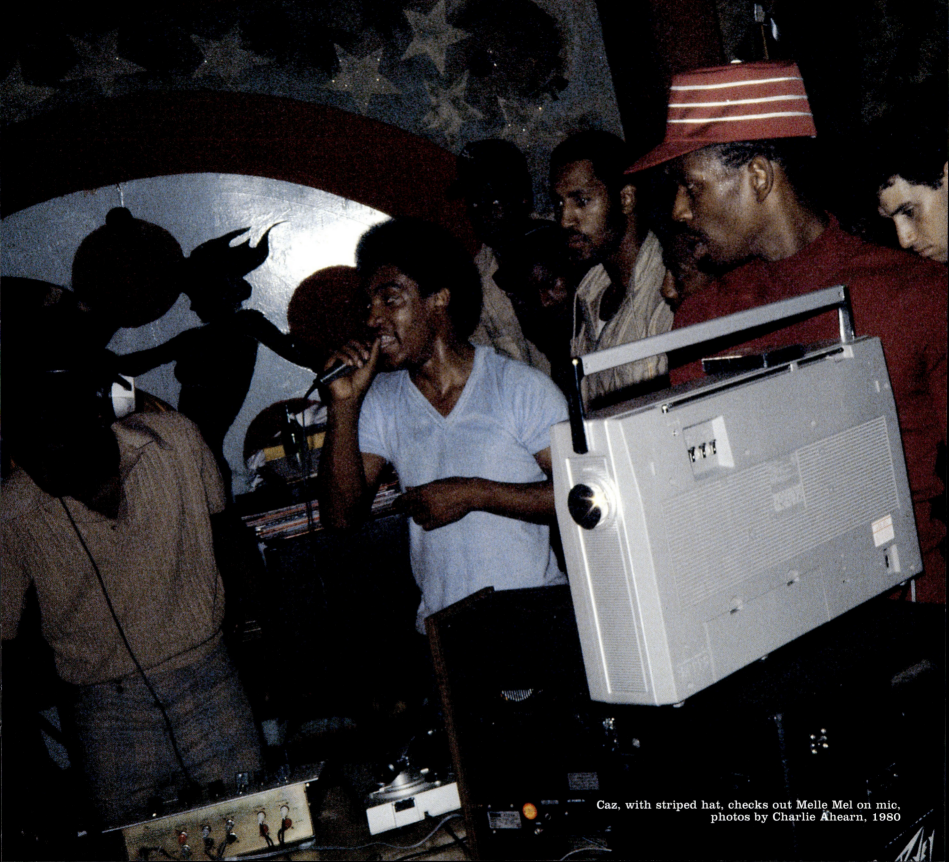

Caz, with striped hat, checks out Melle Mel on mic,
photos by Charlie Ahearn, 1980

The Ritz

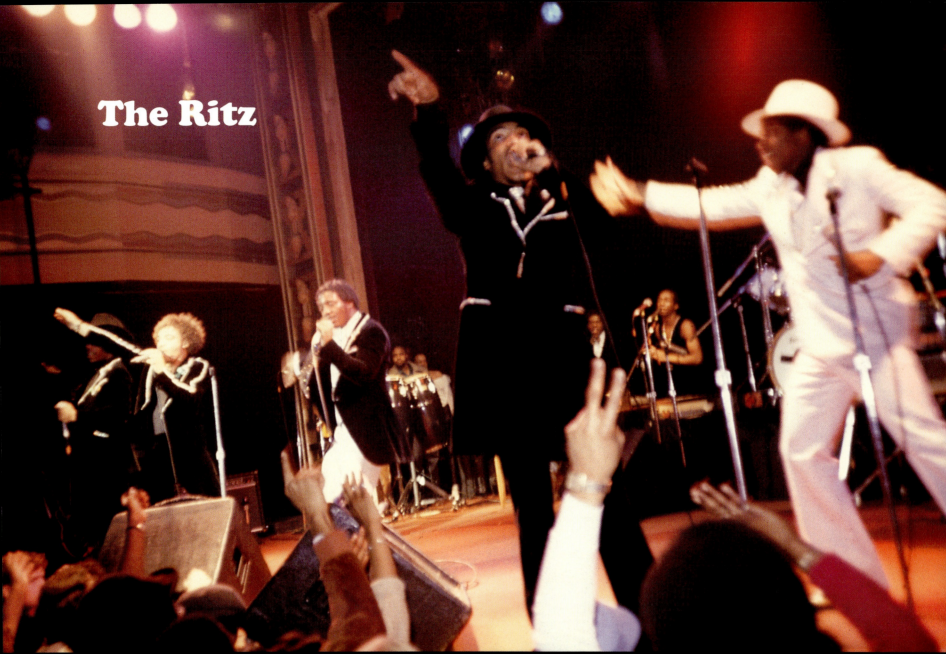

GrandMaster Flash and the Furious Five

When GrandMaster Flash and the Furious Five appeared downtown at the Ritz in 1981, they had already graduated from Enjoy to Sugarhill Records. Being the premier MC crew from the Bronx, they were too busy touring with Sugarhill to play their homebase.

Melle Mel

We did the Temptations and all that. Scorp had on the white velvet and it was nasty. That was our original crossover move, going down there to the Ritz. That was our downtown white crowd. We used to look out behind the curtains like, "Anybody got any cheese?"

"No why?"

"'Cause there's a whole lot a crackers in that muthafucka tonight!"

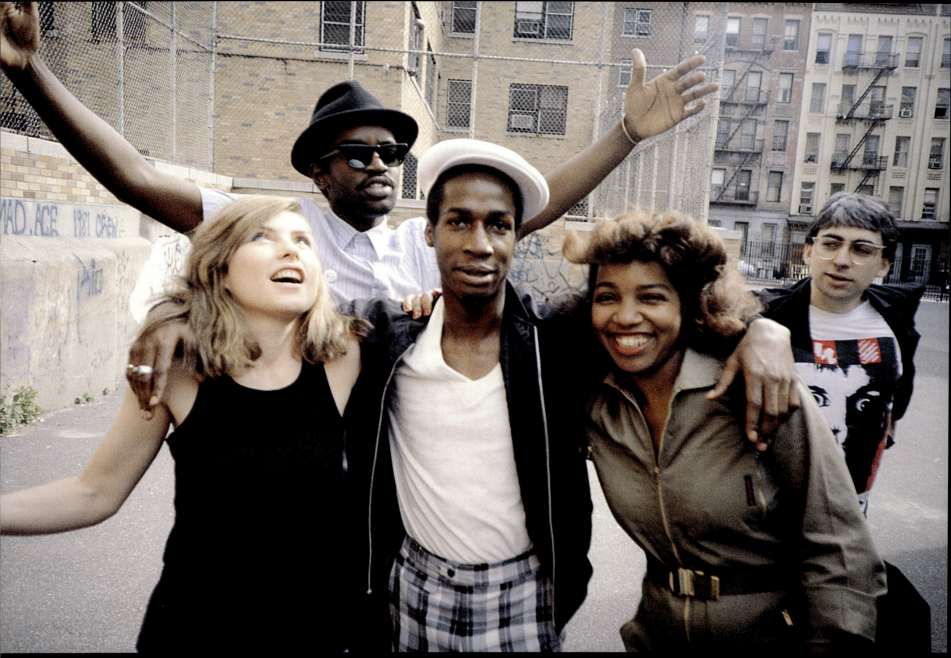

Debbie Harry, Fred, Flash, friend and Chris Stein, photos by Charlie Ahearn, 1981

Blondie expressed their respect for GrandMaster Flash in the number one hit "Rapture," the first rap song many people heard, along with its famous line: "Flash is fast, Flash is cool." Ironically "Rapture" came out a year before the Furious struck gold with "The Message."

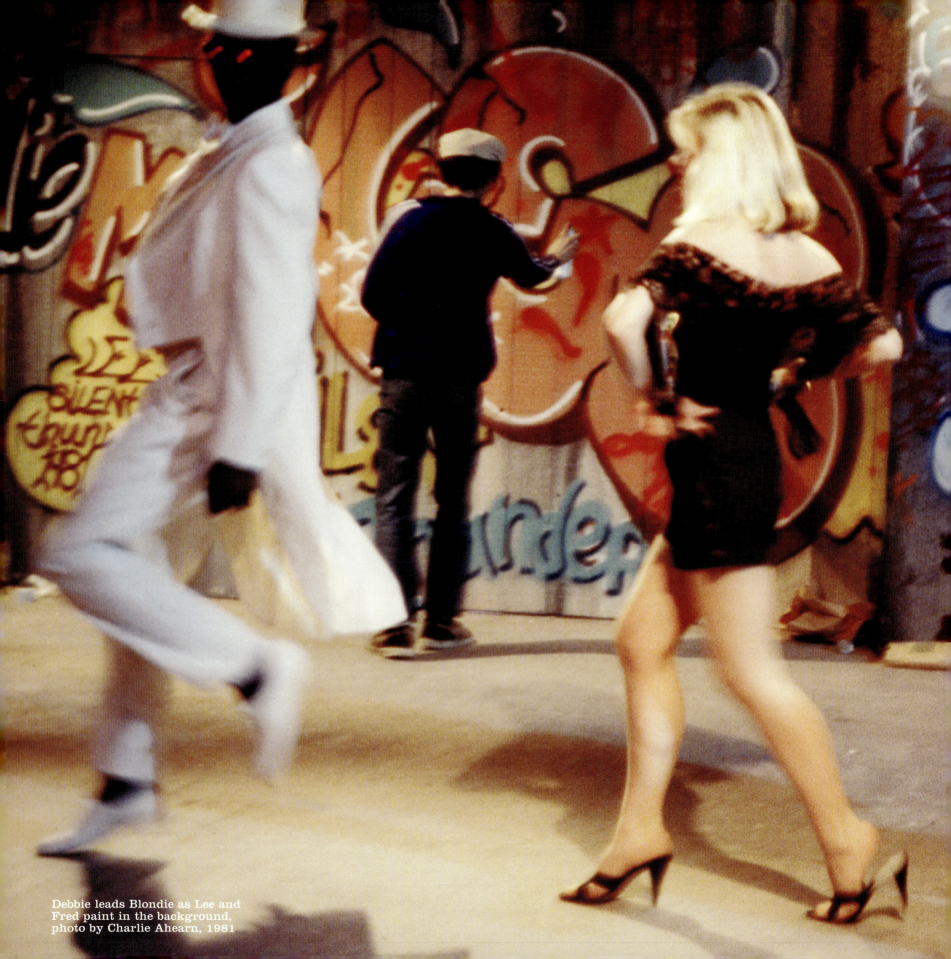

Debbie leads Blondie as Lee and Fred paint in the background, photo by Charlie Ahearn, 1981

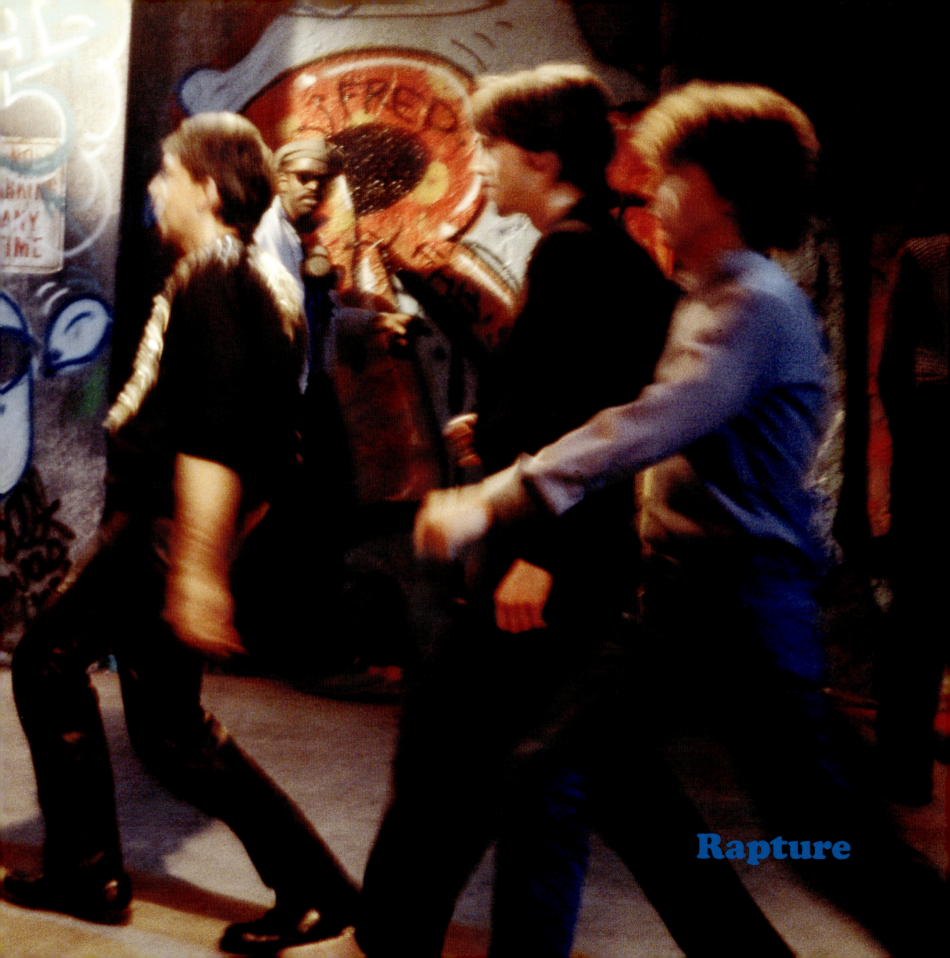

I had been invited to join Glenn O'Brien's *TV Party*, a public access TV program. I was the operator on the show and was meeting all these people on the punk/new wave scene. One of the strong connections I made was Chris Stein and Debbie Harry from Blondie. They were also a big part of *TV Party*.

I arranged to take Debbie, Chris, Glenn, and a bunch of people from the *TV Party* scene to the Webster P.A.L. Ray Chandler, who organized some of the first parties with Flash at the Black Door, took us to this little balcony where we could sit and look down on the stage. We saw the Mercedes Ladies, the Cold Crush Brothers, and DJs like AJ and Flash.

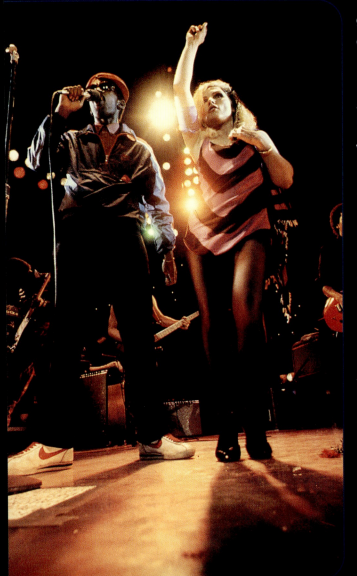

Fred rocks with Blondie at the Meadowlands, photo by Jonathan Wenk, 1982

Debbie was totally enthralled. Chris was super energized. That got things sparking in their heads and later led them to make a song called "Rapture."

They invited me to their house. They were really excited and wanted me to hear some of the things that they did. I was still living in Brooklyn at the time, so I hopped on a train up to 58th Street where they were living. They put on one song and I heard this really funky beat. Debbie was singing and then went into this rap: "Fab 5 Freddy told me everybody's fly." I smiled and thought, that's so sweet of them, they made a special version and put this little rap on it as a novelty thing.

Later I was in Italy for my art show. By this time Charlie and I were seriously working on the development of *Wild Style*. Charlie had made a connection with these guys from a German TV station, ZDF, and he said to me, "Look, you're going to be in Italy. I want you to fly over to Germany to meet the head of ZDF." Charlie wanted me to show him our movie proposal. It was such a flimsy package! Charlie would make color xeroxes and put them in a folder, and I'd make nice little tags on the cover.

I flew from Milan, Italy, to Mainz, Germany, and showed the guy the package. Then I decided to go to Paris. The Talking Heads and the B-52s happened to be on tour there and I had met them through my association with Glenn. I'll never forget zipping around Paris in a cab with Chris and Tina from the Talking Heads, when on French radio, I heard this song. "*Excusez-moi* driver. Turn the music up!" It was "Rapture." Debbie went into her rap with "Fab 5 Freddy" and I was sitting there going, wait a minute, I thought this was a joke! I didn't know they were going to release this record!

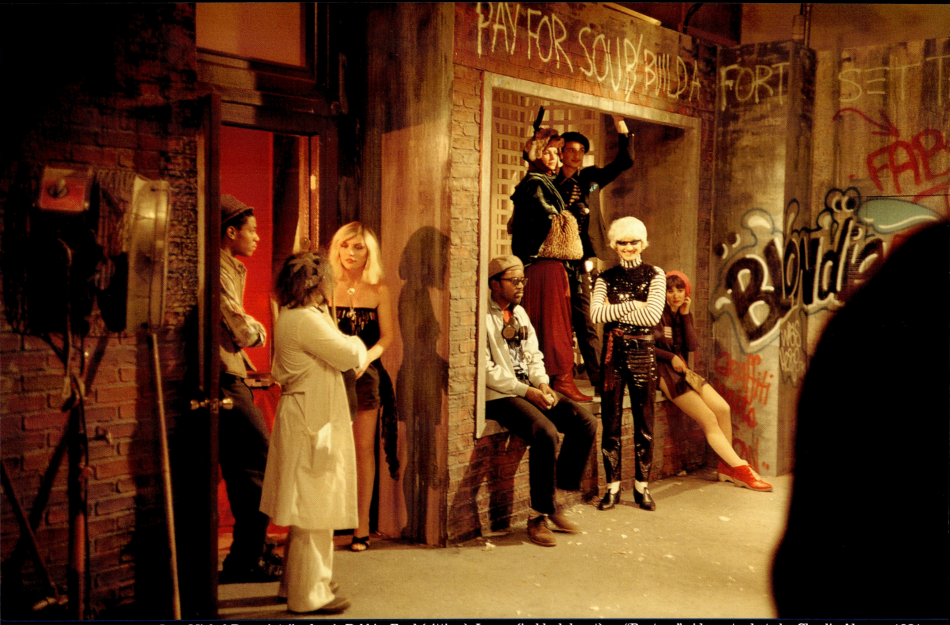

Jean-Michel Basquiat (in door), Debbie, Fred (sitting), Lenny (in black beret) on "Rapture" video set, photo by Charlie Ahearn, 1981

I joined Fred when they were shooting the "Rapture" video. I knew some of the people including Lenny Ferraro, who was later to be the drummer on our break beats album. The set was a New York City block and looked like the set on *Sesame Street*. Lee was on one corner doing a LEE piece and Fred on the other doing a FRED. And Jean-Michel Basquiat had spray painted the words PAY FOR SOUP, BUILD A FORT, SET IT ON FIRE over the top edge of the set, but you couldn't see it in the video. When Debbie sang, "Flash is fast, Flash is cool," Flash was supposed to be there behind the turntables, but he didn't show up, so they got Jean-Michel to be him. The high point was the parade led by the high stepper in top hat and tails followed by the ballerina girl with the goat, Debbie, Chris, and the rest of Blondie dancing across the stage. The song became a number one hit.

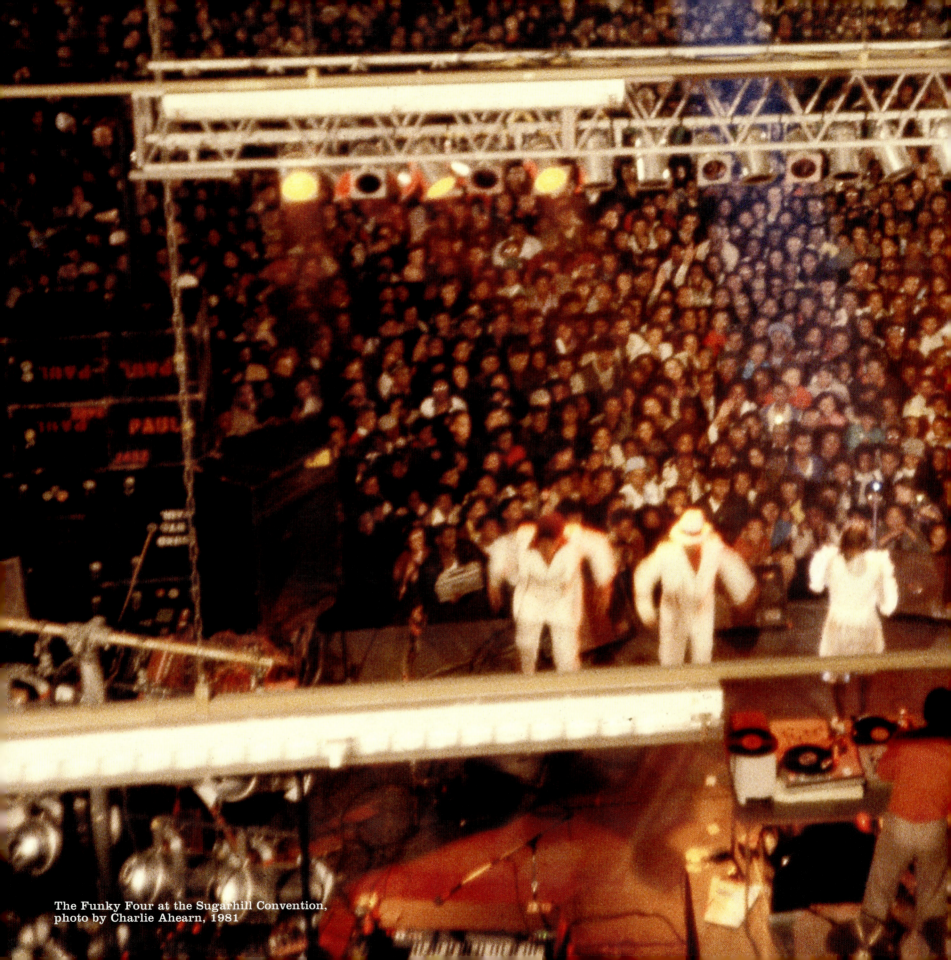
The Funky Four at the Sugarhill Convention, photo by Charlie Ahearn, 1981

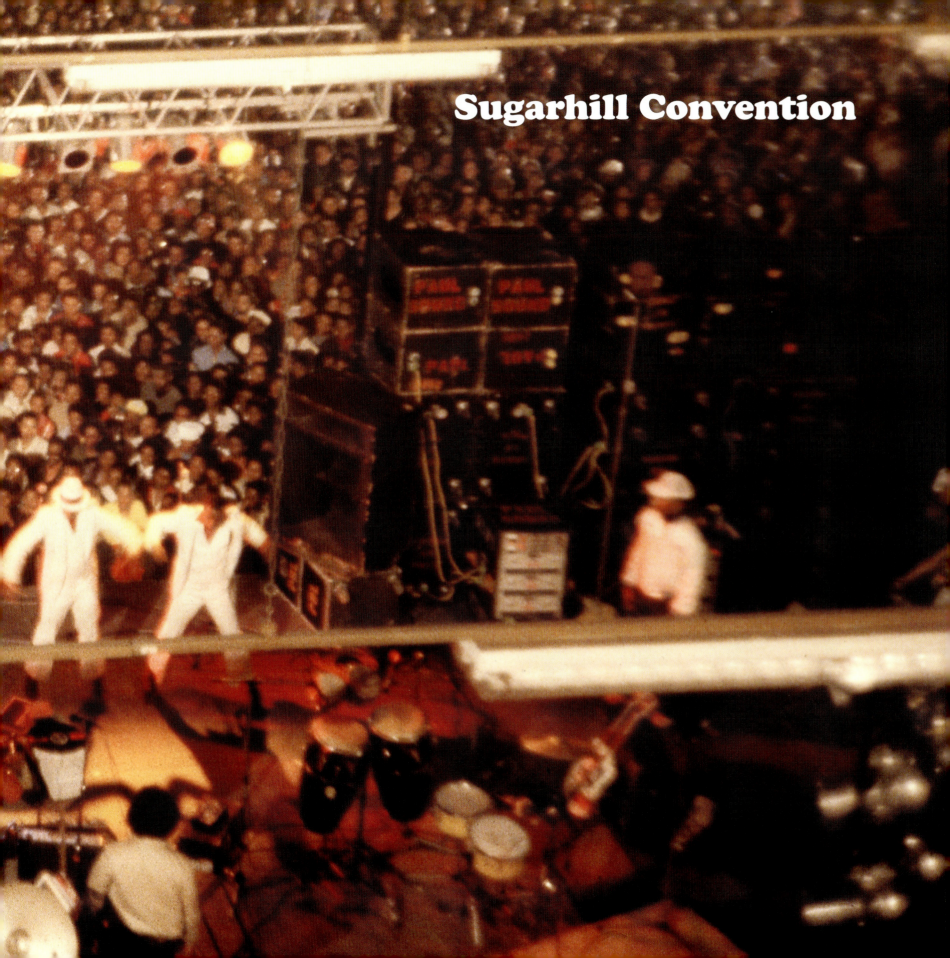

The Fantastic Five practicing at home

I remember going over to Kevie Kev's mom's place to watch the Fantastic rehearse for their big show that night at the Sugarhill Convention. Just as we were leaving, Kev slipped a pistol in the front of his pants and gave me a wink, saying he was wearing some nice gold on his chest and was just hoping someone would test him.

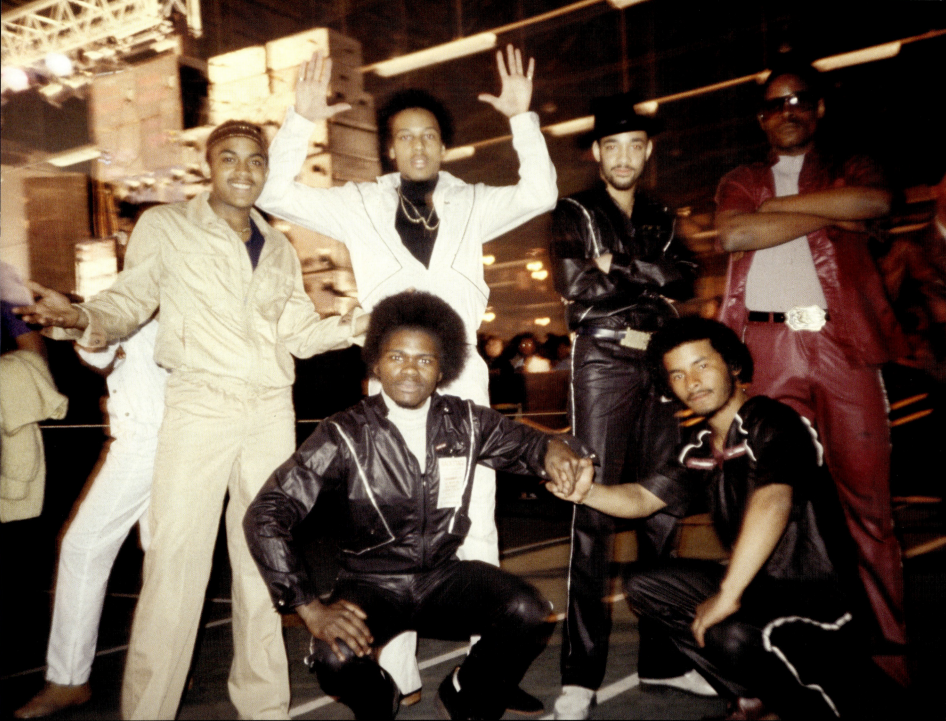

The Fantastic Five at the Sugarhill Convention, photos by Charlie Ahearn, 1981

I went with the Fantastic to the Sugarhill Convention at the Armory in Harlem—a vast airplane hangar-sized space that quickly filled up—to see what was then truly the biggest show in hip hop: Flash and the Furious Five, the Sugarhill Gang, the Funky Four, and more.

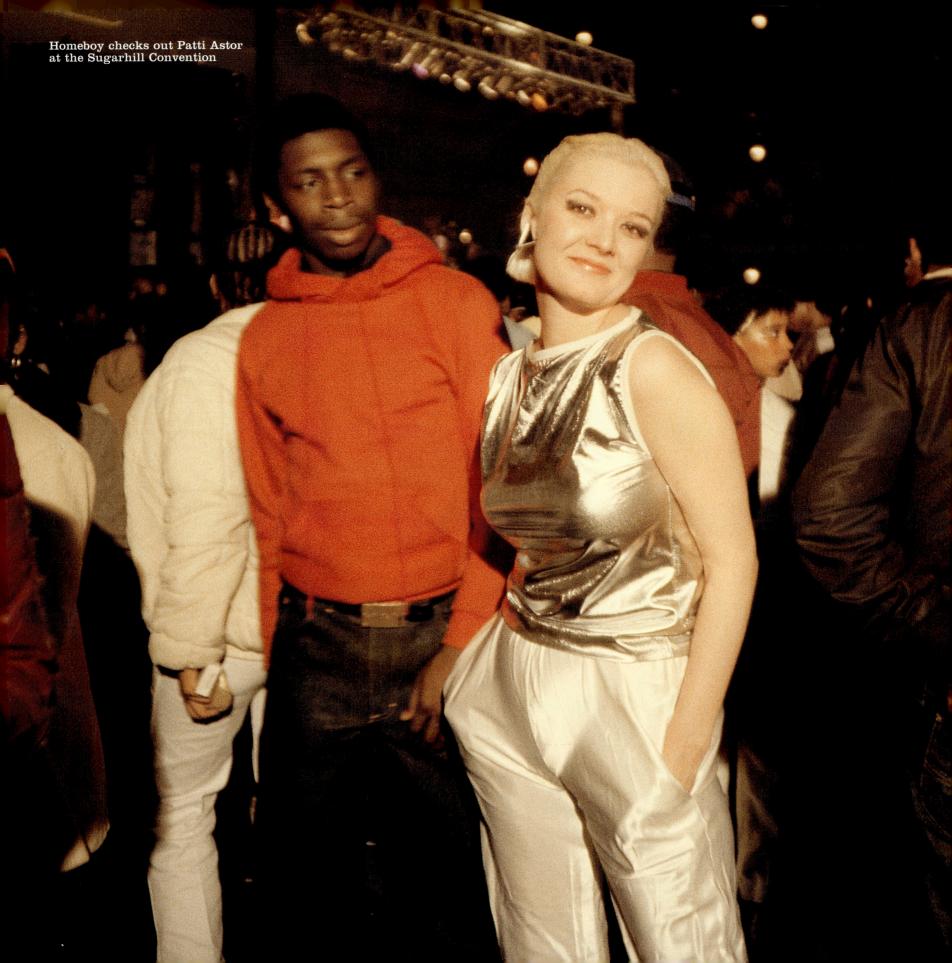

Homeboy checks out Patti Astor at the Sugarhill Convention

Patti

I found out that Charlie Ahearn and Fab 5 Freddy were planning to make a movie. I began to pester Charlie for the part of Virginia, a downtown female reporter. It was perfect! Didn't Fred already call me Lois Lane? But Charlie and Fred said I wasn't right; they wanted someone more mousy, with glasses. Naturally I knew better, and got my chance to prove it at the Sugarhill Convention.

I coerced my partner Bill Stelling, Rene Ricard, Edit Deak, and my four-and-a-half-foot-tall Japanese girlfriend Yoko to go with me (on the subway!) in the middle of the night, and ran into Charlie there. It's a good thing I did, because just afterwards shots rang out. The entire place broke into pandemonium with shouts and screams: "He's got a gun!"

Bill grabbed me by the arm and said, "We are getting out of here right now."

"But it's just getting started," I wailed. We never did get to see Sugarhill but I got the part.

I saw Patti Astor with Edit Deak and Bill Stelling. Bill and Patti would soon form the legendary FUN Gallery. It was seeing Patti in her silver lamé jumpsuit laughing it up with that hardcore crowd that instantly scored her the role of Virginia. We were thinking of Debbie Harry who after her "Rapture" video was a goddess to the kids of hip hop, but she was busy on tour and Patti really came to embody the role in real life.

The Convention was now 10,000 strong, surging across this huge open space with no seats, no dividers, and little security. I don't remember who was on stage when "the gun went off." Of course, nobody was ever sure if a gun even went off—just like at every other hip-hop event. Suddenly the audience began to scream and billow out from a point somewhere in the middle. They rolled out in quick waves and like they say about buffalo, if you stand still they will stampede right past you.

Headline acts like the Furious never went on. After some confusion I made my way safely out to the street where I found Patti. Then we went downtown to find a bar, get drunk, and discuss her upcoming part in the movie.

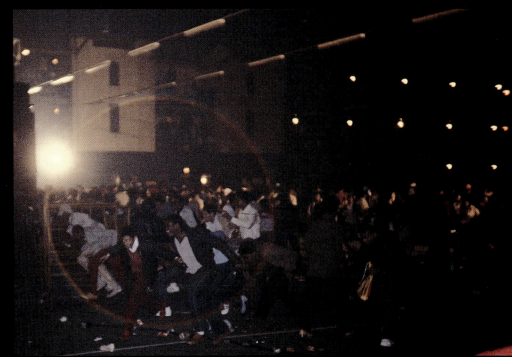

The stampede at the Sugarhill Convention, photos by Charlie Ahearn

In the Cipher with Rock Steady

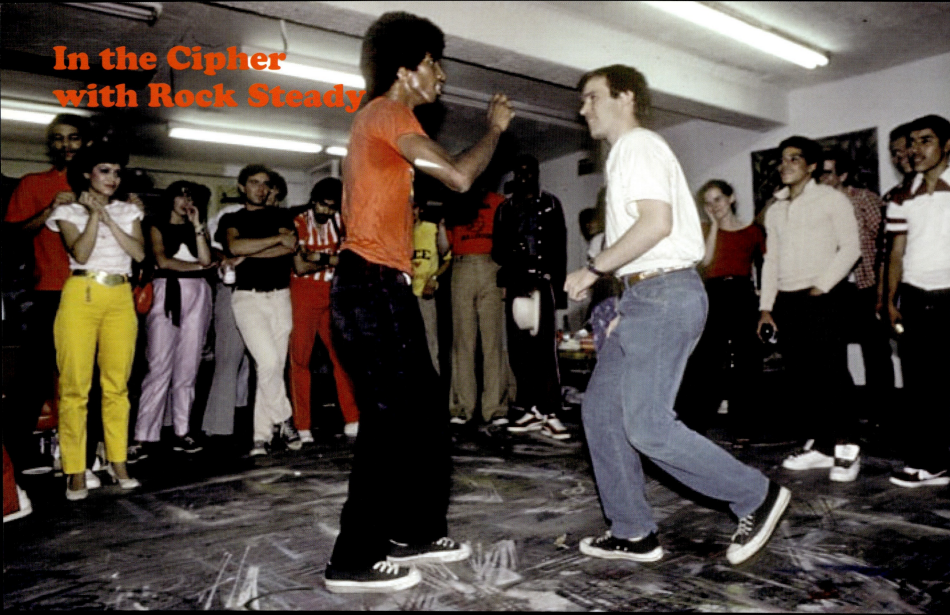

Frosty Freeze and Charlie, photo by Martha Cooper, 1981

Lady Pink

We were throwing Lee a surprise birthday party and Charlie was supposed to come. I was hoping to get my boys, the Rock Steady Crew, involved in the movie. Fab 5 Freddy forgot to bring the music, so Rock Steady had to perform with everybody just clapping the beat and they did a wonderful job. At this time, Charlie was still working on the plot; now he had found some amazing dancers and decided right then and there to include breakdancers in the movie.

Frosty Freeze

I remember Take One calling us to tell us that there was a surprise party for Lee at Futura's space. At the party Charlie was telling us about *Wild Style*. We were happy; things were happening for us. Charlie watched us dance. Then we said, "Let's get him!" We pulled him into our circle just to see what he'd do.

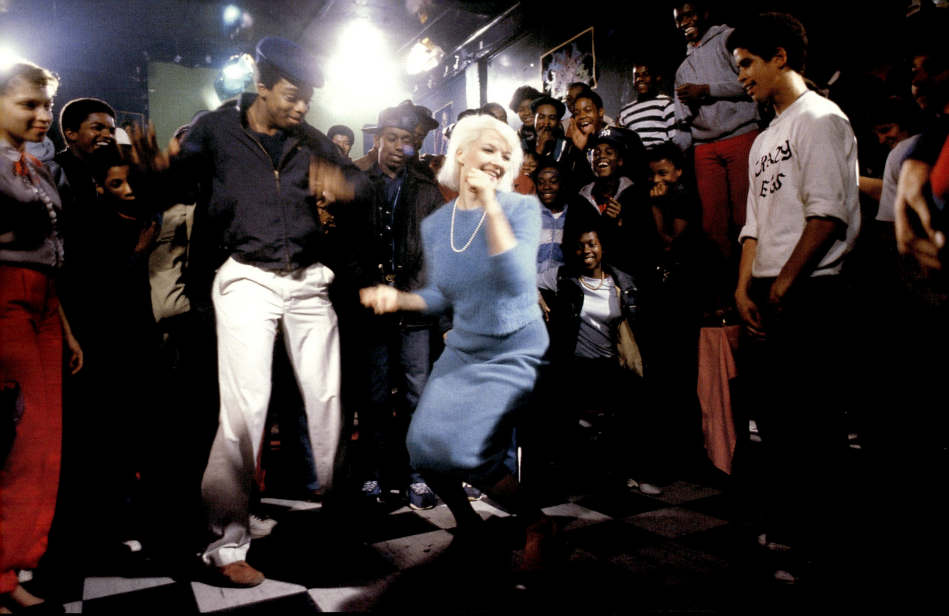

Patti and Crazy Legs, photo by Martha Cooper, 1982

I had been hearing rumors about this incredible breakin' crew, Rock Steady, from Fred and Henry Chalfant. I finally met up with them at Lee's birthday party in his studio downtown. The beer was flowing and the music was on, and a big circle formed. Rock Steady members including Crazy Legs, Ken Swift, and Frosty Freeze were taking turns showing and proving their stuff. I guess they'd heard I was making a movie and they were giving me the hairy eyeball all evening. Legs was in the cipher when he swept by me, took me by the hand, and dragged me out in front of the crowd, just to see what I would do and have a laugh at my expense.

When it came time to shoot the scene at the Dixie with Rock Steady, I asked Legs to extend the flavor in Patti's direction. She was fabulous and it was classic.

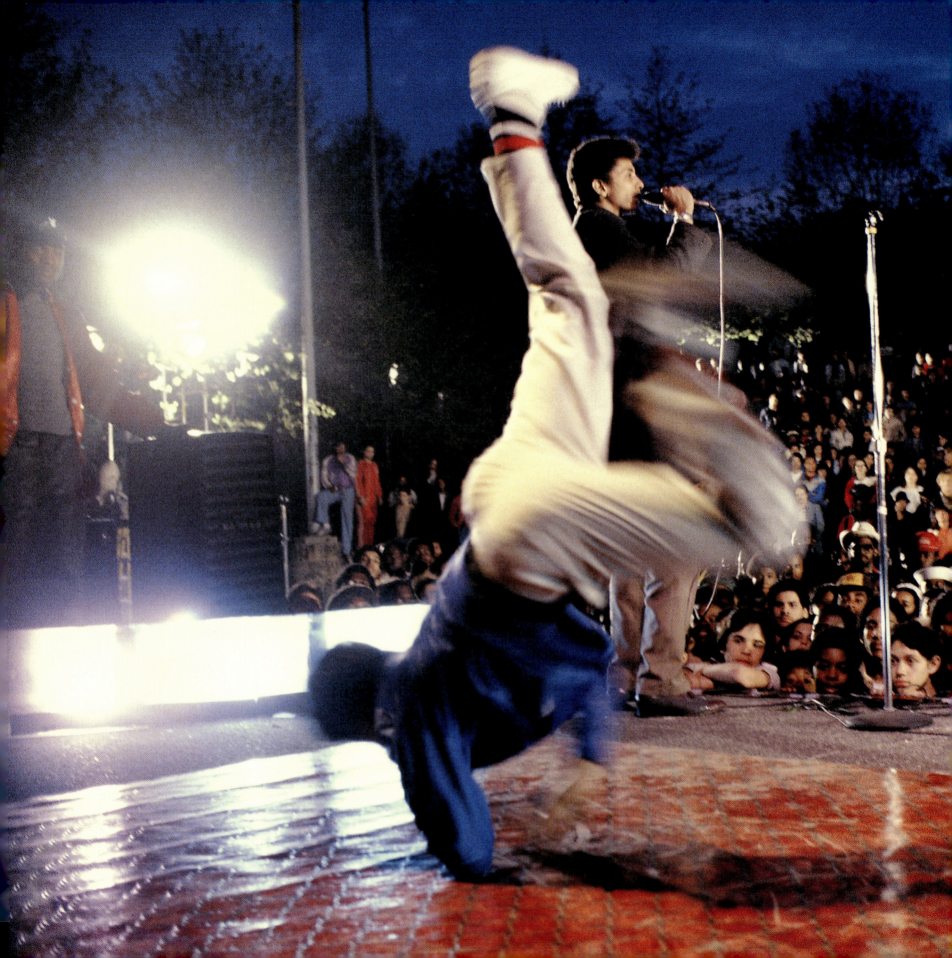

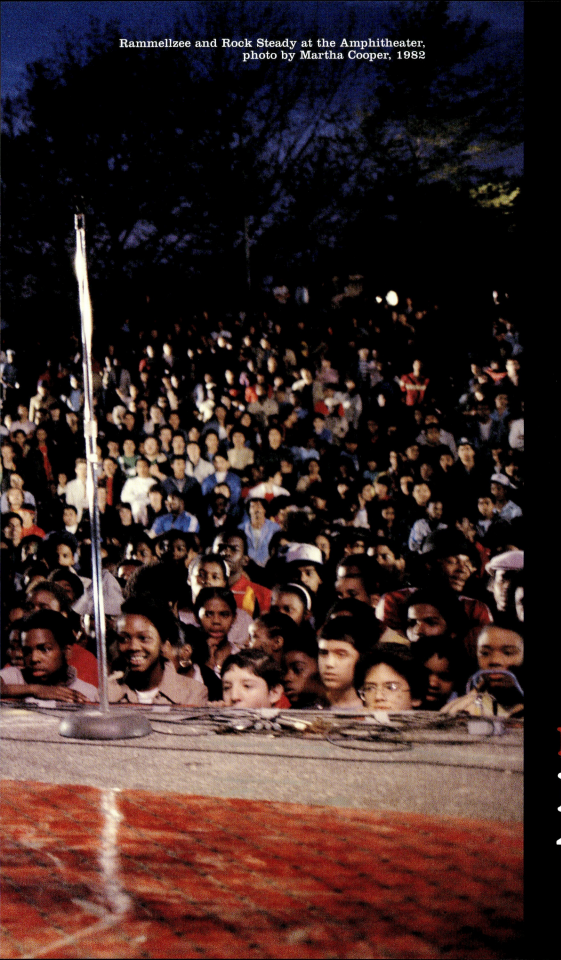

Rammellzee and Rock Steady at the Amphitheater, photo by Martha Cooper, 1982

Part 2
Making the Movie

Here's a Little Story That Must Be Told

From the beginning I knew that *Wild Style* was going to start with the lead character, Zoro, being chased in the yards, and end with a big party at the Amphitheater with everybody saying, "Ho!" I wanted the story arc to parallel the rise of hip-hop culture from the early graffiti writers to DJs, MCs, and b-boys who sparked a vibrant new art form.

Zoro was inspired by Lee, but was more of an archetypal graff writer, a super hero with nods to Batman and, of course, to the classic model Zorro, the Latin Fox, whose masked adventures always left behind those Zs. Donning his doo-rag at night to bomb the subways, his hard-won fame must remain on the down low from both his fellow writers and the police.

In the fall of 1980 that lone outlaw artist Lee was rumored to be hooking up with this very wild and pretty young girl who wrote PINK. It was far too incredible to ignore, and soon took center stage in the movie as the stormy teen romance. We embraced whatever was going to unfold as we made the film.

⭐ Fred

The greatest thing about *Wild Style* was that so many key, instrumental moments in the film came from what was actually happening. We would have problems with the script and Charlie would ask, "Fred, what are we going to do?" We'd pull out our hair, then look at each other and say, "Wait a minute. This is what is actually going on." Then those things would be incorporated into the script so we'd be able to run out and shoot the next scene.

Charlie in the Times Square *Wild Style* office, photo by Jane Dickson, 1980

'WILD STYLE'

Charlie Ahearn with Frederick Brathwaite

'WILD STYLE' is a story of teenagers in the South Bronx creating innovative and popular culture in a location usually viewed as the hopeles epitome of urban decay. Graffiti art and Rap music both sprang solely from a desire to create boldly without the support of wealth, technology or government programs. The very best Rappers and Graffiti Artists are eagerly preparing for the action narrative which will project this street culture to a popular audience.

The story follows a legendary graffiti artist, ZORRO, whose real identity has remained a mystery even to his peers. ZORRO is confronted by Roberto, his older brother just home on leave from the army, who pressures him to grow up and enlist. ZORRO tries make friends with a group of graffiti artists led by LADY BUG and ZROC who seem to be successful finding ways to make money with their art. PHASE II, one of graffiti's originators, becomes ZORRO's guide into the Rap music scene at the Black Door. BUSY BEE, the most popular house rapper, plans a giant outdoor Rap Jam to reunite all the homeboys who have created the Rap scene. ZROC is accidentally hurt while painting a train with ZORRO. They are led away by MTA Detectives and ZORRO is blamed by his peers. Depressed, he decides to follow his brother's example and enlist. PHASE II and BUSY BEE stall ZORRO's enlistment by getting him to decorate the bandshell for the outdoor VALLEY Rap Jam. The work triggers ZORRO to unleash an ever expanding panorama of figures. The following afternoon crowds descend to the VALLEY and BUSY BEE gets on the mike. He cheers on ZORRO who is still at work and by now joined by teams of artists. The bandshell becomes packed as homeboys get up to rhyme and the VALLEY shouts "Ho!"

Color xeroxes of wild images with MCs and writers became my storyboards for scenes in the movie, to be reshuffled to create narrative flow.

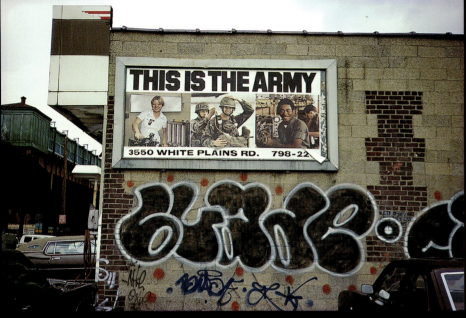

The Army recruitment billboard in the Bronx represented the pressures on teens in the ghetto to enlist, and Blade's piece seemed like graffiti's answer back; this inspired the subplot of Zoro in conflict with his soldier brother.

Smiley 149 (RIP) was one of the original subway writers from the late 60s. His doo-rag style in this image inspired Zoro's outlaw style in the movie.

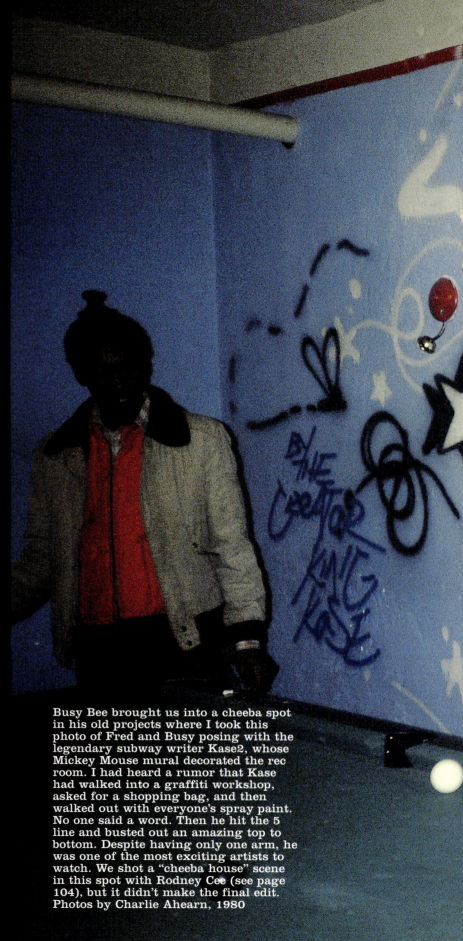

Busy Bee brought us into a cheeba spot in his old projects where I took this photo of Fred and Busy posing with the legendary subway writer Kase2, whose Mickey Mouse mural decorated the rec room. I had heard a rumor that Kase had walked into a graffiti workshop, asked for a shopping bag, and then walked out with everyone's spray paint. No one said a word. Then he hit the 5 line and busted out an amazing top to bottom. Despite having only one arm, he was one of the most exciting artists to watch. We shot a "cheeba house" scene in this spot with Rodney Cee (see page 104), but it didn't make the final edit. Photos by Charlie Ahearn, 1980

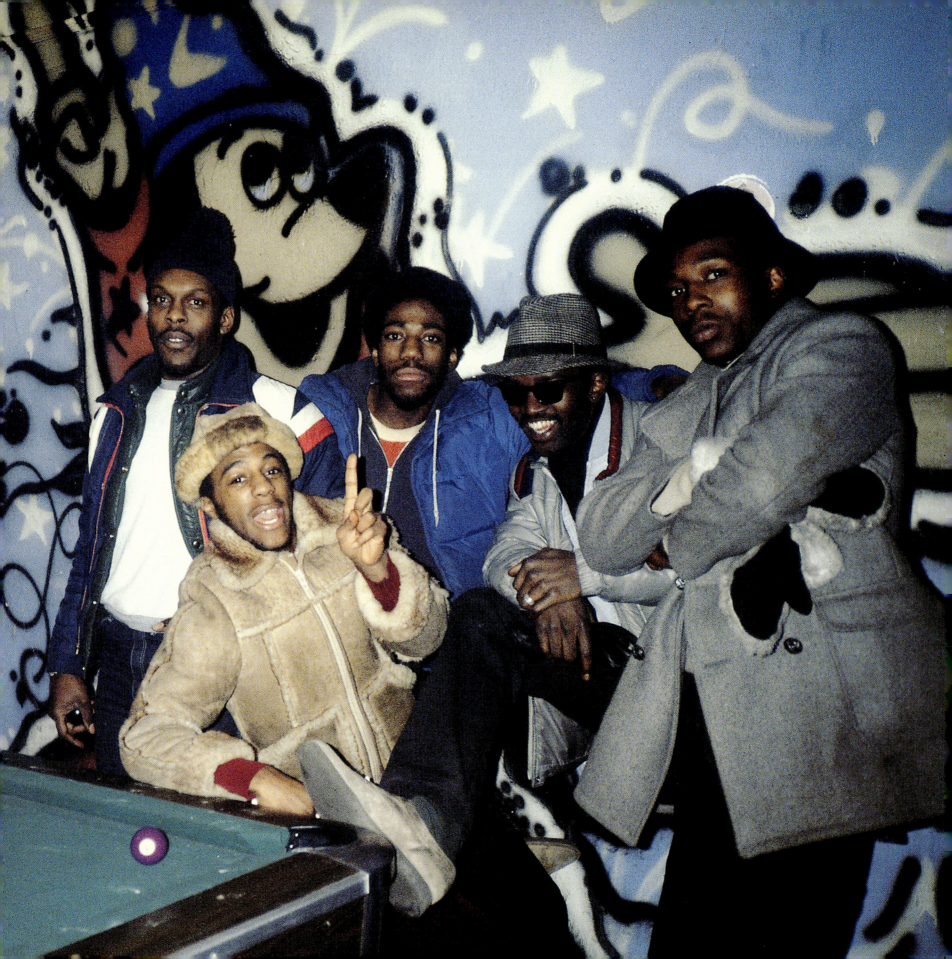

PHADE and ZORRO

(from PHASE II) I never wrote for the recognition, it was for a feeling of personal accomplishment. If I was around writers, they probably wouldn't know who I was. I could just stand there chuckling to myself. "These dudes talk alot of shit but what are they doing about it?" Sometimes they would ask what I wrote and I would make up some name. That really made it fun. Then you could study them, laughing on the inside.

After all that publicity, my cover was blown, people knew my face. I never would go to the concourse where the toys hung out before, but later it didn't matter, no more incognito. I'll tell you though, Fame is Money. If your famous, but youre not making any money from it, what good is it? I understand why ZORRO wants to preserve his incognito, but gradually he's got to make something out of it. Once he has proven himself, his game, what more can he do? He's got to snap out of it, learn about the world, and learn to use that stuff. If his game isn't making money, what is it?

The emphasis should always be on the name. It doesn't matter if it is on canvas or on a subway. If its too much like art then it loses as graffiti. Make it funky, make it weird, erie, it doesn't matter, but youve got to say it with your name. People must see the simplicity in graffiti. If graffiti starts to look too much like art, I call that "going commercial".

(on M.C.'s) The older guys like G.M. CAZ or BUSY BEE, they are great, but the younger guy's walk around thinking all the girls are on their tip. They got swell heads. I mean how long do they think this shit is going to last ? Everyone is walking around now trying to act like a gangster. before you might be tough, you might even be carrying a piece, but you didn't walk in trying to show it off. That's the way people have gotten now. These younger M.C's, man, they are in for some fall when the bottom drops.

(FRED) I don't think those guys realized that when you asked them those questions abotu grafiti, that those questions WERE GRAFFITI. They don't realize that that's what it is all about. M- Making your mark anywhere anytime that you want to.

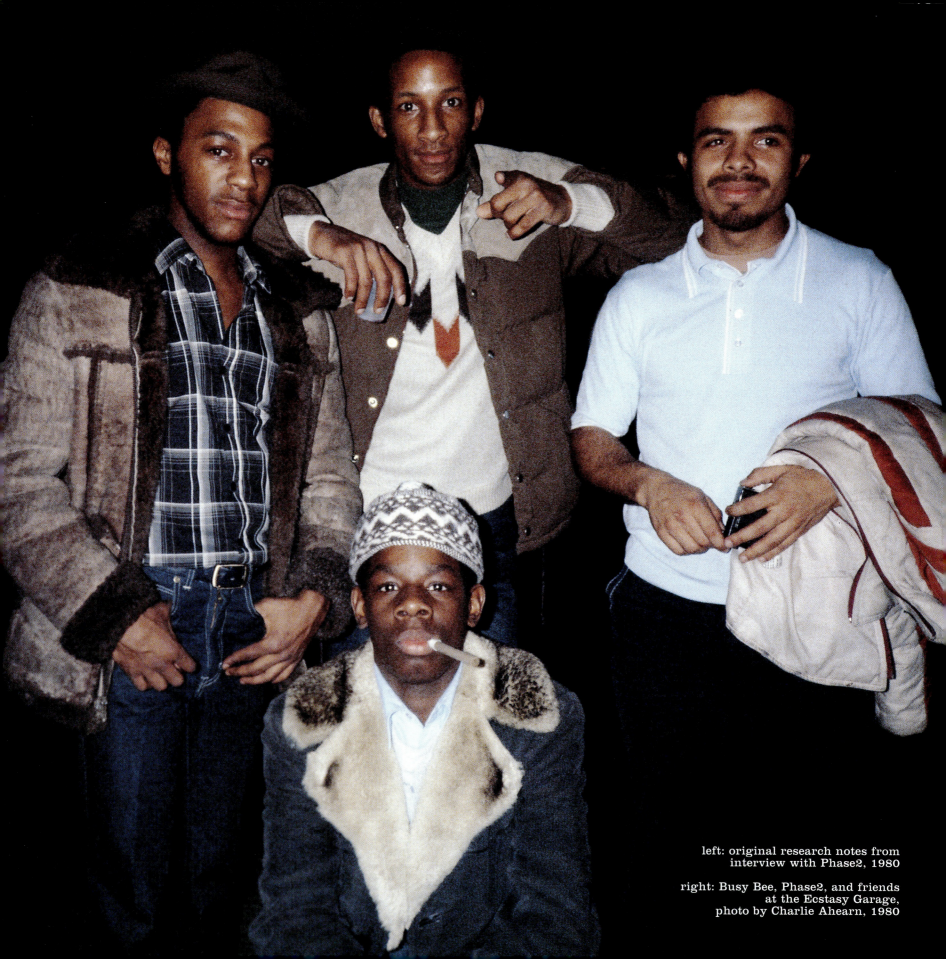

left: original research notes from interview with Phase2, 1980

right: Busy Bee, Phase2, and friends at the Ecstasy Garage, photo by Charlie Ahearn, 1980

Charlie Ahearn with Fredrick Brathwaite

#501
64 Fulton St.
New York City, N.Y. 10038
telephone # 212 964-2426

WILD STYLE (TOYS DON'T BOMB)

action narrative feature 90 minutes to be shot in 16mm

location: The South Bronx 'where Hip Hop Music meets Graffiti Culture'

budget up to 16mm release prints: $ 90,000.

Pre-Production	to December 15, 1980	$ 6,000.
Production	to June 1, 1981	60,000.
Post-Production	to September 1, 1981	24,000.
		$ 90,000.

35mm Blow-Up from 16mm negative October 1, 1981

Laboratory at DuArt, N.Y.C. with the support of Mr. Irwin Young, Pres.

Theatrical Release	New York City	November 1, 1981
Theatrical Release	other U.S. Cities	December 1, 1981
Television Release	ZDF W.Germany	December 1, 1981
Sound Track Album	(produced jointly with Record Company)	
Video Disk	(same as the above)	
Television Release	TV LAB/13 Documentary	January 1, 1982

Principle Players identities in life and in film related

BUSY BEE STARSKY (David Parker) Rap Vocalist from the South Bronx
CRASH (Johnny Matos) Graffiti Artist from the South Bronx
ZEPHYR (Andy) Graffiti Artist from Manhattan
SPOONIE GEE Rap Vocalist from Harlem

Production Crew

Steve Fierberg	Cinematographer
Darius Wolski	Cinematographer
Clive Davidson	Sound Recordist
Charlie Ahearn	Director
Fredrick Brathwaite	Director
Charlie Ahearn	Producer

Original *Wild Style* budget, 1980

Money for the Movie

The independent film world didn't exist in 1980. Spike Lee and Jim Jarmusch hadn't made a movie yet and the Sundance Film Festival was years away. Fred and I fantasized about our movie playing one of those grind houses on the Deuce, but first we had to make the film. Most underground films were shot in super8 (like the B's, James Nares, and Eric Mitchell) and were shown in clubs, or were the 16mm features of Amos Poe that often starred Patti Astor, one of the movie star queens on the film scene.

The Corporation of Public Broadcasting funded documentaries for television but their response to *Wild Style* was incredulous: "Why would we want to support vandalism?" They said that the project was of local interest only. Ironically they later gave money to help make Henry Chalfant and Tony Silver's graffiti documentary *Style Wars*.

Through Zephyr I learned about Sam Esses, who had bankrolled a graffiti art studio the previous summer. Damn near all the masters congregated to bust out canvasses provided by Esses. Fred and I went to his office and showed him our plans, but he wasn't ready for the film business.

Then a veteran of the tiny independent production world pointed out that European television was taking an interest in low-budget American films. I sent my slim outline with color xeroxes to Channel Four in the UK and to ZDF TV in Germany, and was shocked to find they were both enthusiastic to co-produce. It wouldn't be enough to finish the film but it got us started.

Break Beats

I loved hearing DJs like Grand Wizzard Theodore cut up classic hip-hop beats like "Johnny the Fox" or "Rock It in the Pocket," but when the MCs got on the mic, the music was sometimes predictable. They wanted it hot and current but not competitive with their rhyming. There was a "flavor of the month" at any given time such as "Heart Beat" by Tanya Gardner, which the Treacherous used for "Feel the Heartbeat." Everybody in 1981 was rapping over that song. We didn't want to be dependent on the hit of the month, but more importantly, I was very afraid of shooting MCs rhyming off a pile of records that I wouldn't be able to clear.

Fred

I was ready to use the music exactly as it was used at the parties, but Charlie had the great foresight to say (and this was way before anyone knew the word "sampling"), "Hey people own the rights to this music, and if we just use it, we could get in trouble at some point." Probably not at *that* point, because the music was very obscure and the hip-hop world had not become this billion-dollar global industry.

Charlie suggested, "We should come up with our own music," and I agreed. I wanted to make the equivalent of break beat records that the DJs in our film could use and mix to create the musical bed that rappers would rhyme over. That would become our soundtrack. I had never produced anything, so I figured it out as we went along. I got David Harpur to play bass, Chris Stein to play guitar, and Lenny Ferraro, who was part of the *TV Party* Orchestra, to play drums.

We went to the most antiquated studio you could ever imagine because they had the cheapest rates. I remember it was on Broadway in the 70s, not far from the Beacon Theater. The mixing board had tubes instead of transistors. Chris was great because he had guitar toys to add all these effects.

We had twelve short songs. When you make a record and mix it, you got an acetate, which is a very heavy vinyl record. We thought we'd just have some of these made and pass them out to the DJs. But when we gave these things to them, they were too heavy and the DJs weren't able to manipulate them. Regular records are a much lighter and more manageable object. We realized that we had to go back to the drawing board. We had to find a place that could press them. I think the minimum was one hundred, and that was way more than we needed.

It was your classic white label batch of records. I think I personally hand-labeled all of them. I'd throw my little graffiti flare on the labels. Every DJ that was involved in the film got two copies of that record. That's Flash, Theodore, Charlie Chase, Tony Tone, and DJ AJ.

Interestingly the DJs were all very competitive with each other. There were several tracks we knew were good—with slightly different tempos, but all with that underground dusty break beat vibe. But once one guy found out that another guy was going to use the "Down By Law" track, they all wanted to use the same track. There was no way to change their minds.

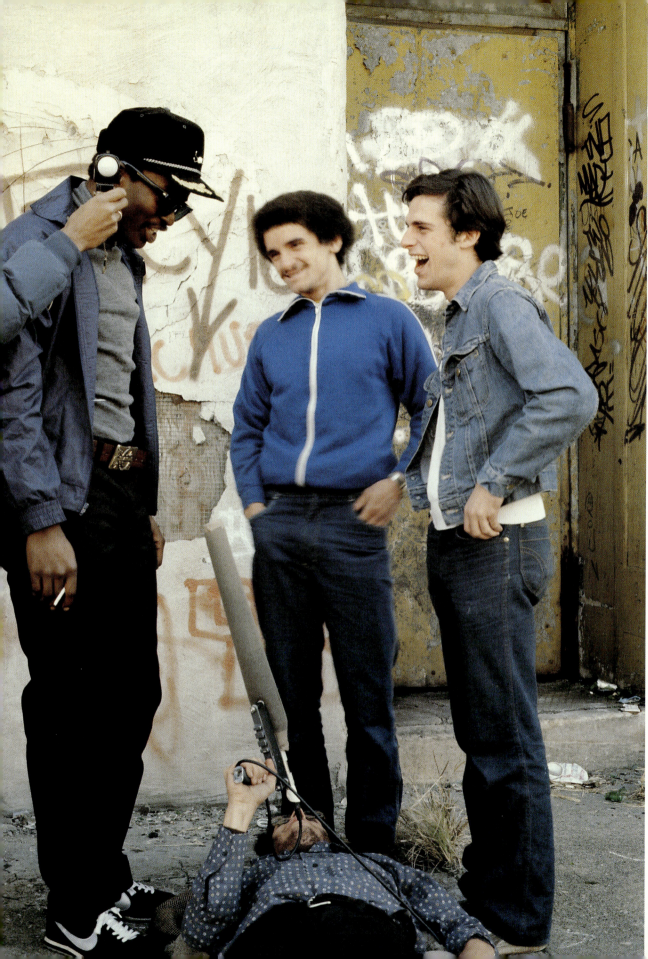

Casting

Fred, Lee, Zephyr, and boom,
David Beckerman on *Wild Style* set,
photo by Cathy Campbell, 1981

A lot of the early casting ideas didn't hold. Although Busy Bee was in from the start, I was really impressed with Spoonie Gee. The summer of 1980, he had a record out on New York Sound with a yellow label called "Spoonin' Rap," which has a laid back, menacing sound; he was sexy like LL Cool J, who came later. But he was off on tour with Sugarhill, and we lost touch when it was time to shoot.

Fred and I became very close to the Funky Four Plus One, going to their shows and hanging out with them on the block. They had recently moved from Enjoy where they did their supreme classic "Rapping and Rocking the House" to making "That's the Joint" with Sugarhill, which at that time was like entering the majors. I really thought that this group was going to be huge. They had a sweet clean look and sound like the Beatles in contrast to the rough, macho feeling of the Furious and the Cold Crush. Plus they had Sha Rock, who was a beautiful and cool MC.

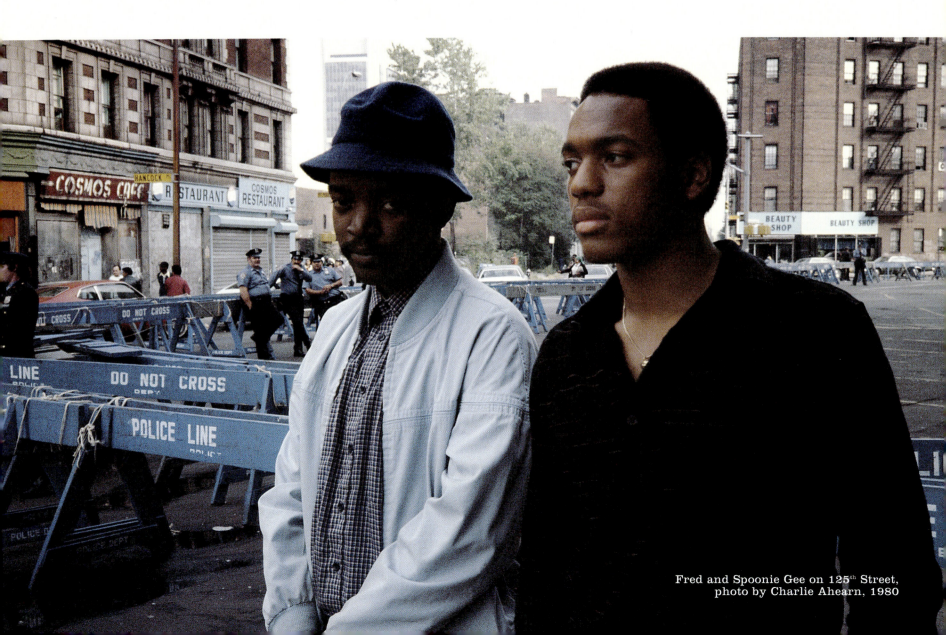

Fred and Spoonie Gee on 125th Street, photo by Charlie Ahearn, 1980

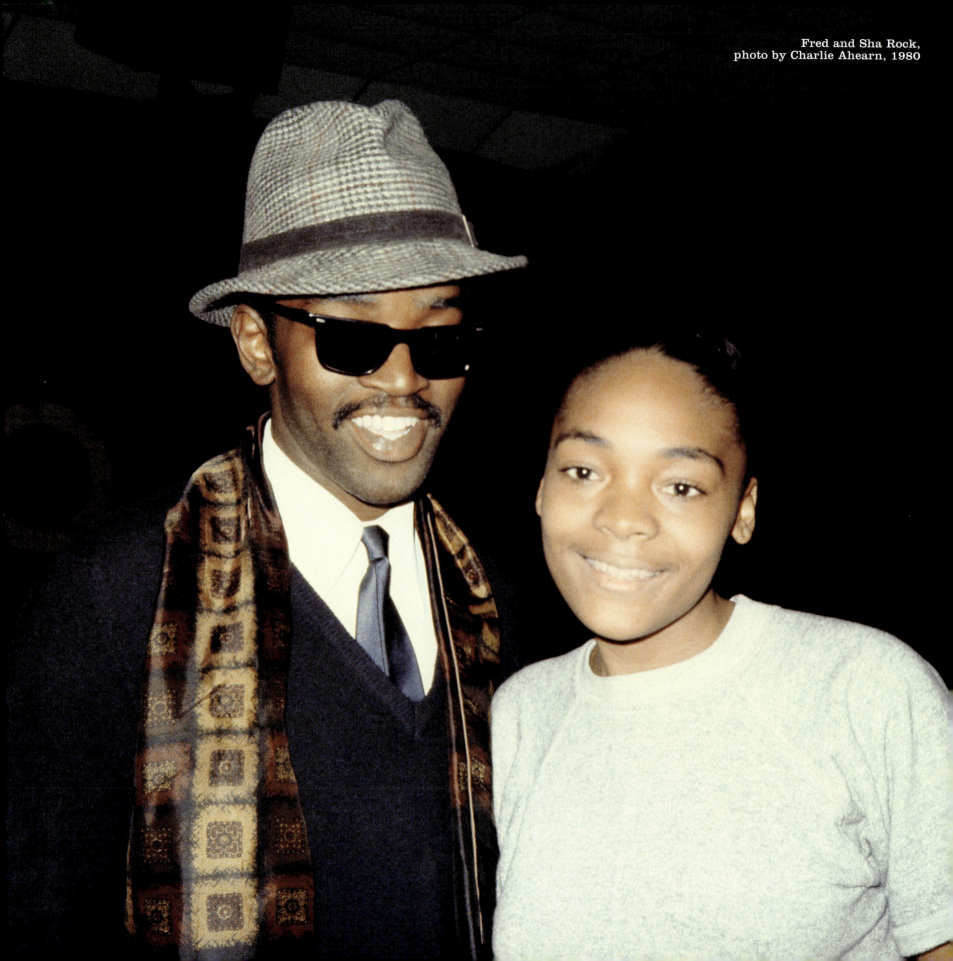

Fred and Sha Rock, photo by Charlie Ahearn, 1980

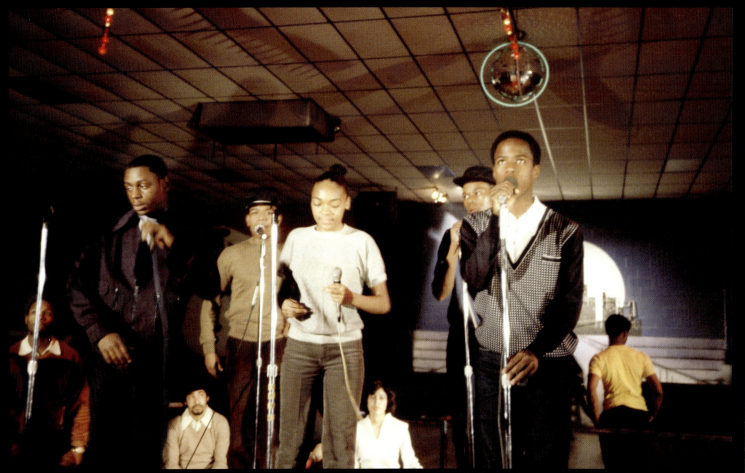

Funky Four at the Bruckner Roller Rink, photo by Charlie Ahearn, 1980

★ Fred

Blondie was going to perform on *Saturday Night Live* which was then, as it is now, the premiere venue for an artist with a hot new record. Being asked to host *SNL*, they were asked to pick a support band to also perform. They wanted someone who rapped—so they called me up and asked, "Who should we have? We know you always talk about Flash and the Furious Five."

I said, "Yes, they would be great, but even better would be the Funky Four Plus One because they are like you—a bunch of guys with a girl out front." That was Sha Rock, one of the greatest female MCs, with an amazing tonal quality to her voice and flow. She was hot. So the Funky Four went on the show and performed their hit song, "That's the Joint."

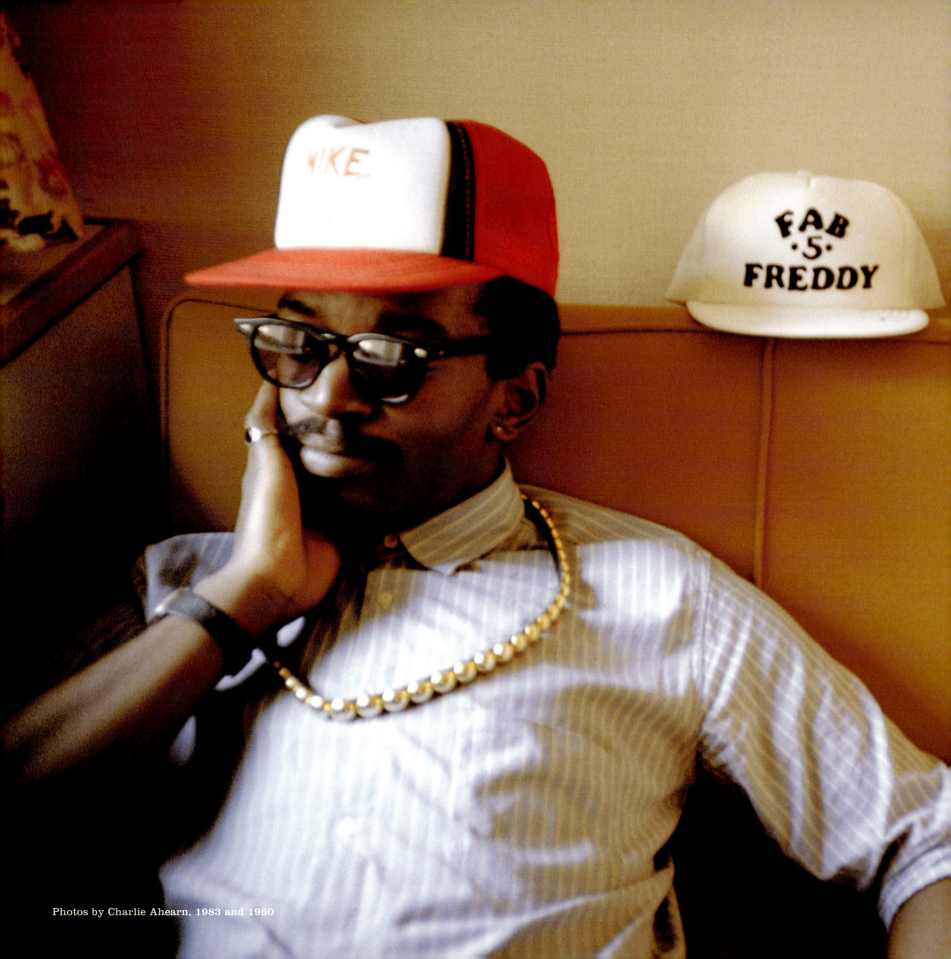

Photos by Charlie Ahearn, 1983 and 1980

⭐ **Fred**

When I had originally gotten with Charlie we were going to co-direct, co-write, co-do everything. But I was caught up in the art world, making paintings, and I really didn't have the time to focus on the movie. Charlie and I divided the duties that we would handle: I worked on the music and on creative production ideas, while Charlie did the writing and directing. But we collaborated throughout.

I need to state that it was never, never, never my intention to be on screen. My intention was to be involved in creating and making this movie. We had cast everybody except the Phade character and at the eleventh hour, Charlie turned around and said, "Fred. You."

I was like, "Get out of here," and he said, "Fred, it's perfect."

The thing that got me was the money. I was living at home in Brooklyn and desperately wanted to have my own apartment downtown. The extra money that I would be paid along with my salary as one of the producers and the music director would enable me to have my own apartment—and that was a big incentive. "Yo, I can get out of my mom's house and have my own crib."

I remember the people who inspired me, particularly Kase2. Kase had a slick way of talking and a whole persona and that was fascinating to me, and I emulated him.

Other inspirations were Flash and the Cold Crush. They would make these poses and gestures that punctuated the flow of their music and animated what they were doing. Like when I'd go, "Zoro. My man."

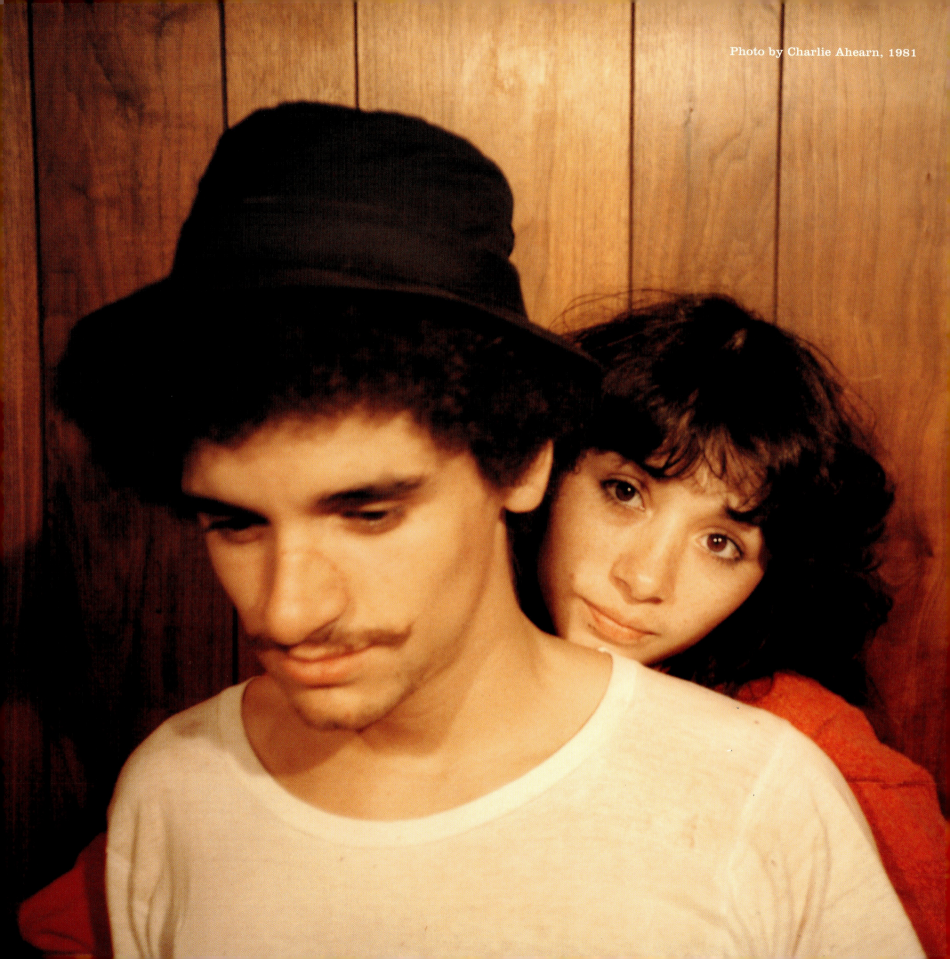
Photo by Charlie Ahearn, 1981

Casting Lee & Lady Pink

I always wanted Lee to play this outlaw artist whose art was famous all over the city, but who must keep his identity secret in order to keep painting. I would see Lee and Pink at different events and I couldn't help being drawn into this impossible romance between a shady loner and an up-and-coming graffiti writer.

Although Pink was new to the yards, she was wreaking havoc on the trains. She was perfect for the movie. But Lee was on a collision course. At night he would steal off to bomb the trains and the next day he would appear at White Columns Gallery doing a show with Fred, which really helped kick off the art/graffiti explosion that fall. Though the Zoro character was an archetype, it did reflect some of Lee's conflicts between being an outlaw and commercial artist—and he wasn't so sure about becoming a movie star.

Lee's reticence kept the role open that first year. There were so many incredible writers bombing in 1980 and they all had their own story that fit the basic conflict of the movie. I was excited to spend time in and out of the yards with some great subway stylists, such as Crash, Daze, Zephyr, and Dondi. Dondi was ruling the 2s and 5s with his blockbuster whole cars, which were being documented by Martha Cooper and Henry Chalfant. Besides being Style Master General, Dondi was so cool and handsome, he seemed like he would make a perfect Zoro. The summer of 1981 I videotaped him with Zephyr rehearsing scenes from the rough script I had written.

Fred and I also went to see Giancarlo Esposito in his play *Zoot Suit* on Broadway. With his mercurial wit and dashing looks he would have taken the Zoro into a different space. He seemed enthusiastic to play the part, but his actor's union had problems with our shooting budget.

Lee

When the film was introduced, I thought, "Wow. This film was a mirror of what I'm doing right now," but I was afraid it would exploit the way I was doing things. So my question was, do I really want to show myself to the world like I never had? I was under the cloak of my darkness and thought I was going to be painting trains for the rest of my life.

At that time it dawned on me, hey, this thing is happening. Charlie was still a mystery, but I found out that he was indeed a filmmaker; preproduction was in full effect. There were interviews in Charlie's office in Times Square for various actors, mostly for the main character.

More and more, the film revolved around my life, and I knew Charlie had an interest in who I was. I remember Charlie as a white boy with a camera making *The Deadly Art of Survival* in my neighborhood. It was very intriguing. So when I found that Fred and other heads like Zephyr, Pink, Caz, Crash, and Daze were involved, I thought, hey, maybe its not such a bad thing.

Pink was my girlfriend at the time and I thought, wow, if anyone is going to take hold of this whole reality and show it in the right light with a little sense of honest precaution, it should be me.

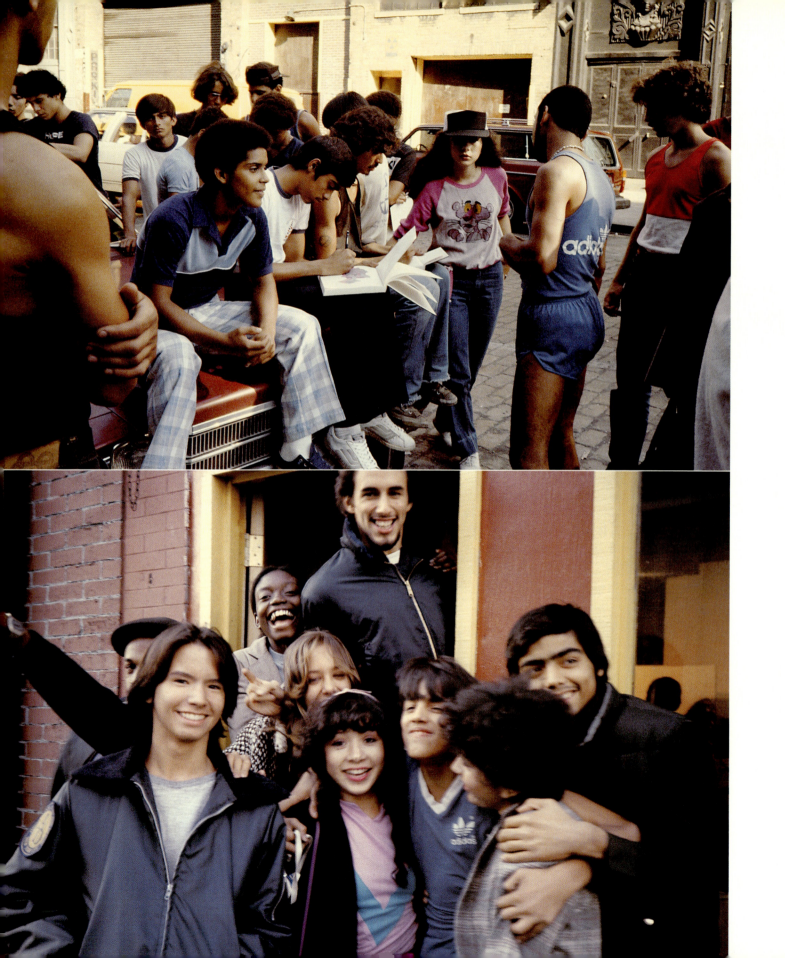

Lady Pink

I don't remember how I was chosen to be in the movie or why. I can only say it was lack of competition. There were no other females around. I started painting trains in the summer of 1980. I had painted a few, not many, just some window-down panels, just starting to get my legs, learning how to do straight lines in the dark, with all that fear in my throat. I was a young toy, in way over my head with these guys, these masters who had already graduated from the subway trains. So I had to get good very fast.

I met Lee on September 6, 1980, at OK Harris Gallery where Henry Chalfant was exhibiting his photos of trains. That was the first time I had met people like Lee, Kel1st, Crash, Daze, Zephyr, Futura, Dondi, and the gang. Later they invited me to be in the first exhibit at Fashion Moda, an art gallery in the South Bronx. I was 16 years old. I had to do a really nice piece for Fashion Moda because it was going to be seen in daylight. Lee had to help me out a little bit because I was nervous.

I met Charlie at OK Harris, and he got us involved in the movie. I know Lee didn't want to have anything to do with Charlie's movie at that point. Charlie interviewed over 20 guys for the part of Zoro. Meanwhile, the entire time, I was trying to convince Lee to do it. He was the only person for it. On and on it went until I finally wore him down and he threw up his hands: "Fine! I'll do the part if you just shut up!"

It was September, only a week from our planned shooting date, and I still hadn't cast the leading role. I met with a reluctant Lee and proposed the following: if he agreed, he would be paid a weekly salary (like $200) and a piece of the profits. If he didn't agree then some actor (like Giancarlo) would be doing the make-out scenes with his girlfriend Pink. He agreed.

top left:
PINK and other writers at Henry Chalfant's opening at OK Harris, September, 1980

top bottom:
Heart, Crash, Pink, Mare139, and Kel1st at Fashion Moda GAS (Crash's Graffiti Art Success) opening, December 1980

right:
Pink, Kel1st, and Mare139 at GAS opening, photos by Charlie Ahearn

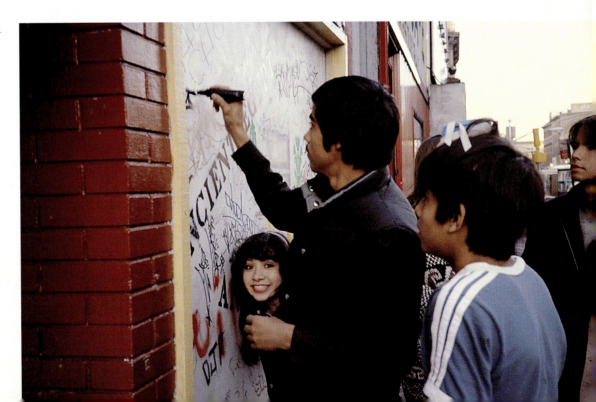

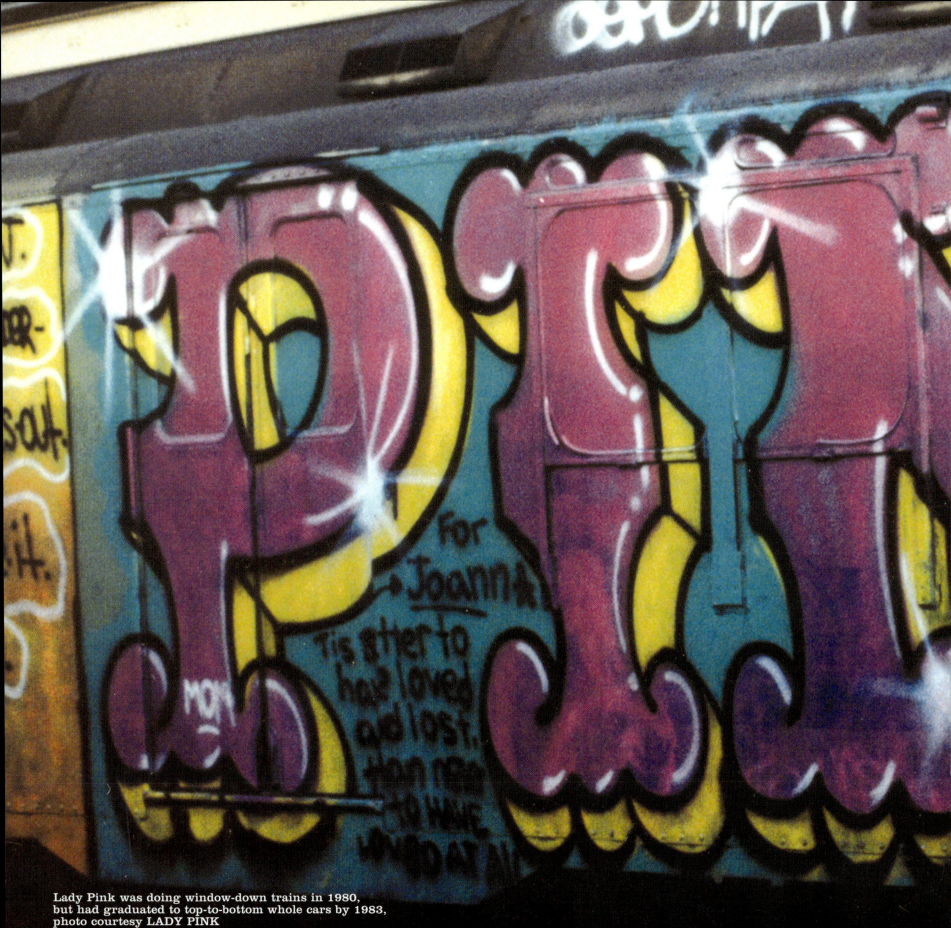

Lady Pink was doing window-down trains in 1980, but had graduated to top-to-bottom whole cars by 1983, photo courtesy LADY PINK

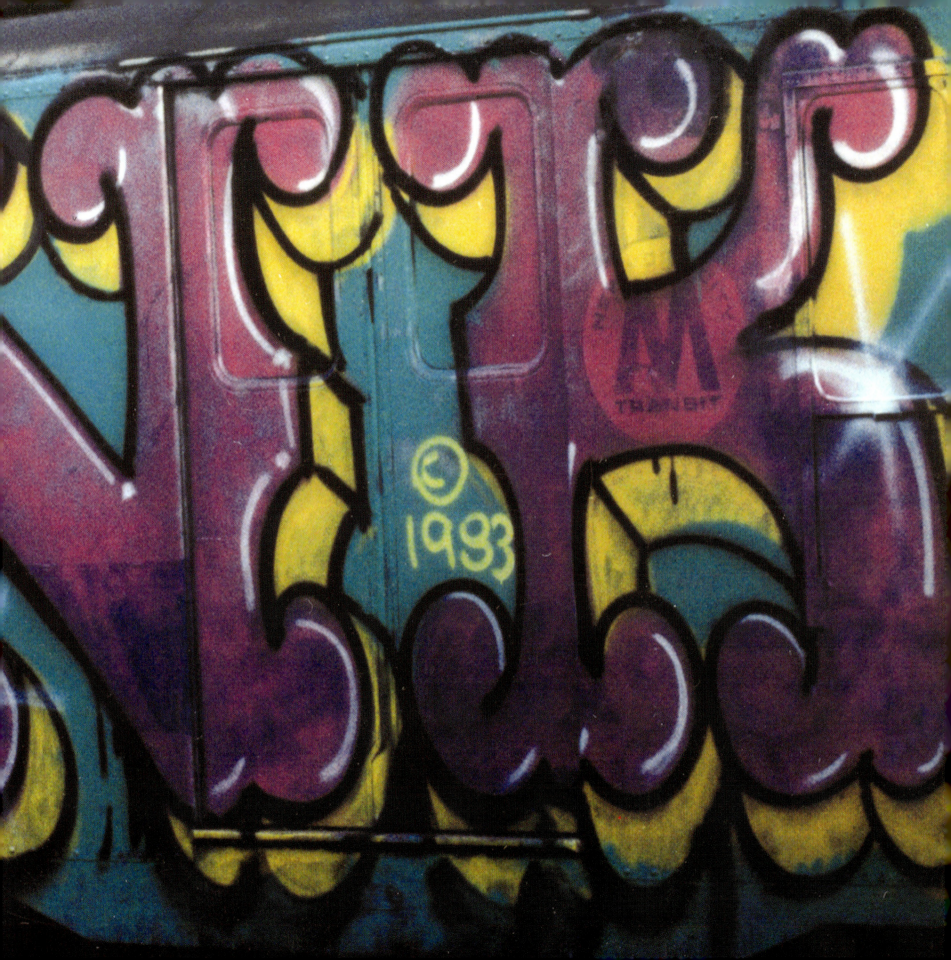

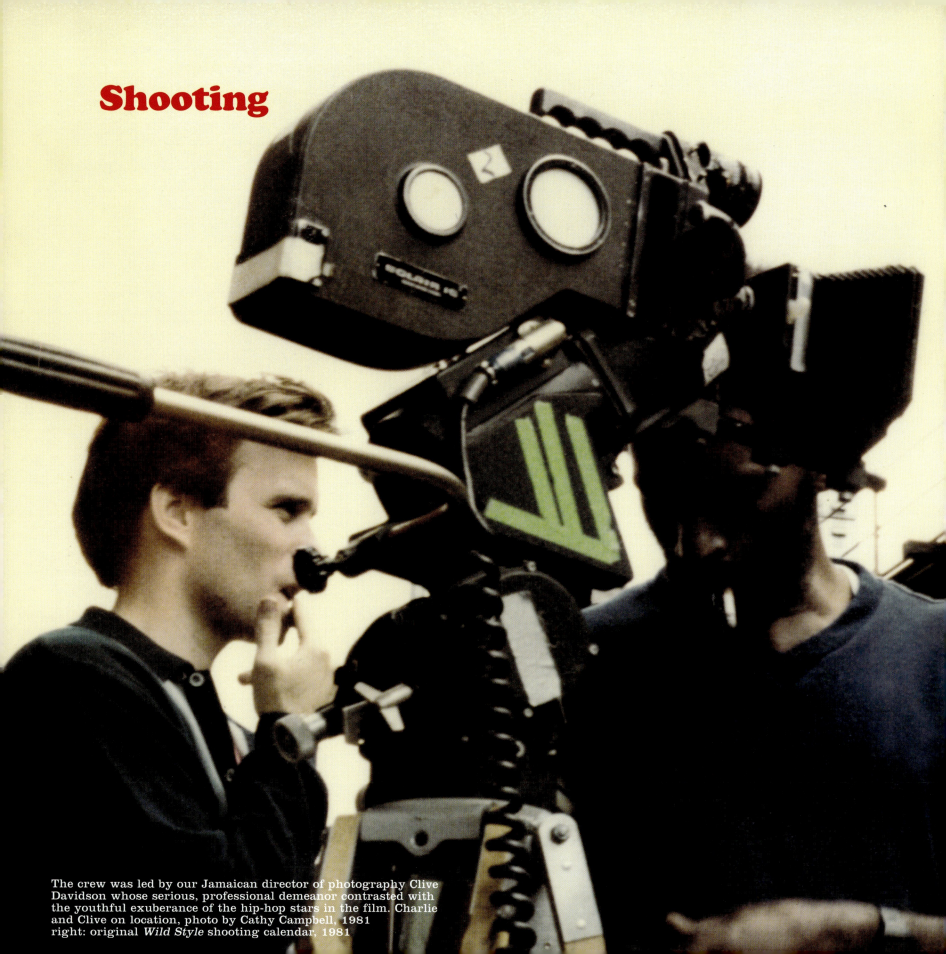

Shooting

The crew was led by our Jamaican director of photography Clive Davidson whose serious, professional demeanor contrasted with the youthful exuberance of the hip-hop stars in the film. Charlie and Clive on location, photo by Cathy Campbell, 1981
right: original *Wild Style* shooting calendar, 1981

SUNDAY	MONDAY	TUESDAY	WEDNES-	THURSDAY	FRIDAY	SATUR.
SEPTEMBER	14	15	16 KASE'S SPOT	17	18 COP'S OFFICE	19 YOUNG WRITERS AMP
20	21	22 KID'S PUSH VIRGINIA'S CAR	23 DIXIE OFFICE	24 CONNIE'S	25 STOOP RAPPING	26 PAINTING DIXIE MURAL
27 WHITE WASH AMP	28 x	29 BREAK DANCE w/ BUSY BEE	30 VIRGINIA ARRIVES AT DIXIE I w/ UNION	OCTOBER	2	3
4 BASKET BALL RAP I	5 DIXIE JAM w/ BREAK BOYS FANTASTIC COLD CRUSH	6 DIXIE JAM w/ CAZ BUSY BEE LISA & RODNEY	7	8 AMP MURAL PAINTED	9	10 AMP JAM
11	12	13	14 RAY PARADE ZROC ARGUE	15 FLASH'S HOUSE	16 BURNED STORE	17 BASKET BALL RAP II
18 VIRGINIA w/ UNION AT DIXIE II	19 NIGHT VIRGINIA'S CAR	20	21 NIVA'S PARTY	22	23	24 x JS 22
25 UNION BASE I (RAY & ROSE)	26	27	28 DIXIE NIGHT EXTERIOR- w/ VIRGINIA x	29 DIXIE NIGHT EX w/ LIMO	30 JOHN'S HECTOR v.s. ZORO	31
NOVEMBER	2	3 UNION BASE II INTERIOR	4 NIGHT EXT.- RAY on the STREET	5	6	7 RUBY'S ALPS HOTEL scene
8	9	10 SUBWAY GRAFFITI SHOT w/ RAY	11 UNION BASE EXTERIOR DAY	12	13	14 x
15 MTA SHOOT YARDS	16	17	18 RAY on SUBWAYS	19	20 NIVA'S	21 CHASE W/ COPS
22 CHASE W/ VIRGINIA	23	24	25	26	27	28

Lee as Movie Star

On the first day, Lee appeared on the set ready to act. There was something odd-looking about his face. I wondered, what is that? There was pancake make up on the scar that runs over the bridge of his nose. Lee seemed stressed out and said, "I don't want the damn cops to catch me!"

★ Lee

People knew me because of the scar. "Yo, that's Lee, the guy with the scar."

It's my fingerprint. And it sometimes glows. Maybe at that time it was glowing a little red.

I knew the police knew who I was because I was being followed everywhere and harassed by the anti-graffiti squad. I didn't want them to put two and two together, even though my face is obviously *there*. I didn't want my scar to be the tell-tale sign of who I was. In essence I was keeping the Zoro mentality alive….

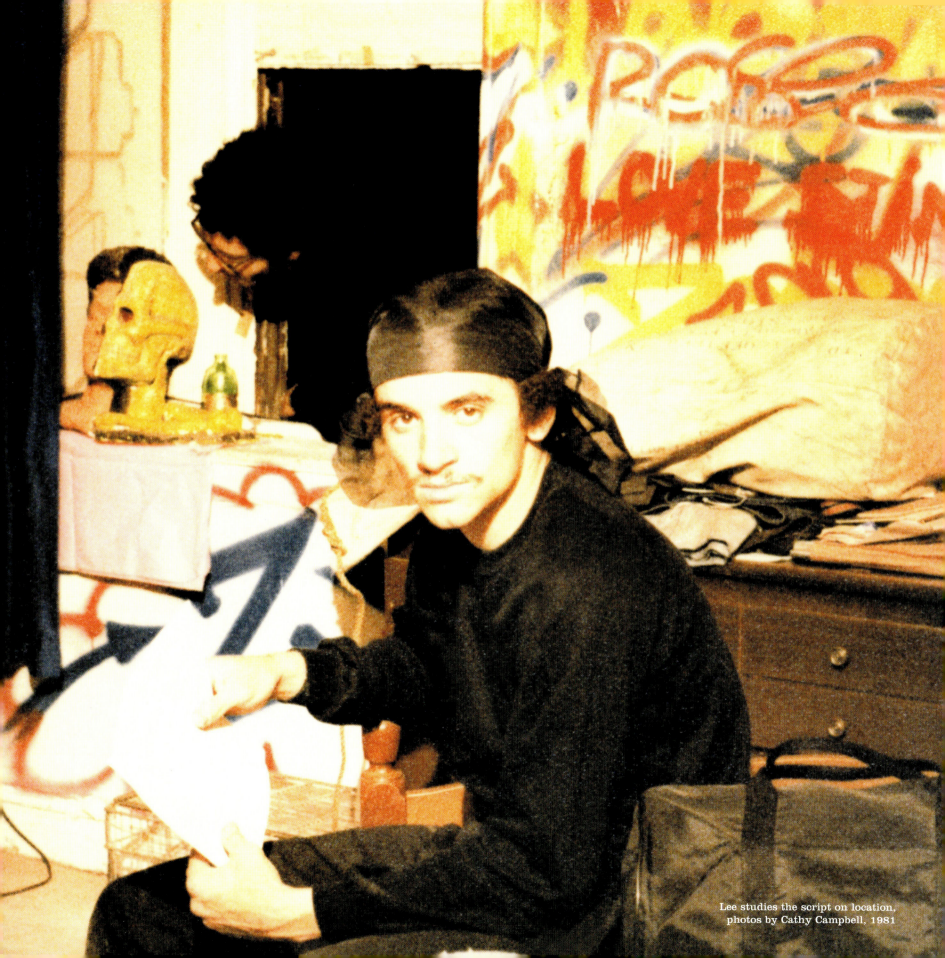

Lee studies the script on location, photos by Cathy Campbell, 1981

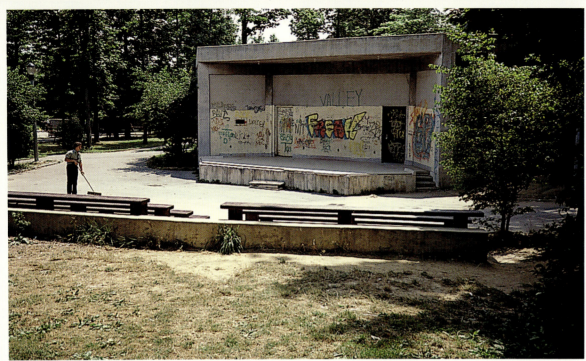

The small amphitheater in the Valley, photo by Charlie Ahearn, 1980

Locations

I had first met Busy Bee in the Valley, which was actually an outdoor park in the South Bronx. Fred and I brought Lee there to consider the small stage and surrounding cement walls, as the location for his big mural for the climax of the film. Lee mentioned to me that he knew of a much better spot to stage the climactic jam for the ending.

The East River Park Amphitheater was built in 1941 as a classical setting to stage theater downtown. The 1,000 person-seat audience rises over a spectacular view of the river flanked by the majestic Williamsburg and Manhattan Bridges. In the mid-50s it was the original home for Joseph Papp's *Shakespeare in the Park*. But by the 70s the site was a rotting, abandoned shell, a dangerous magnet for kids and drug addicts.

Lee, whose home was only a few blocks away, had grown up playing in the ruins of the Amphitheater. He presented the location to me with a deep sense of nostalgia and pride. At first it seemed too vast to consider for our little movie, but it waited there until we were ready for it. The cement slabs on the roof were falling in, the elegant, black iron gates were torn open, and the random tags sprayed over its walls gave it the abused and neglected appearance that was everywhere back then. But to Lee this was an amazing and beautiful place. The Amphitheater came to represent our proud but broken city, which might be invigorated by this new culture from the South Bronx.

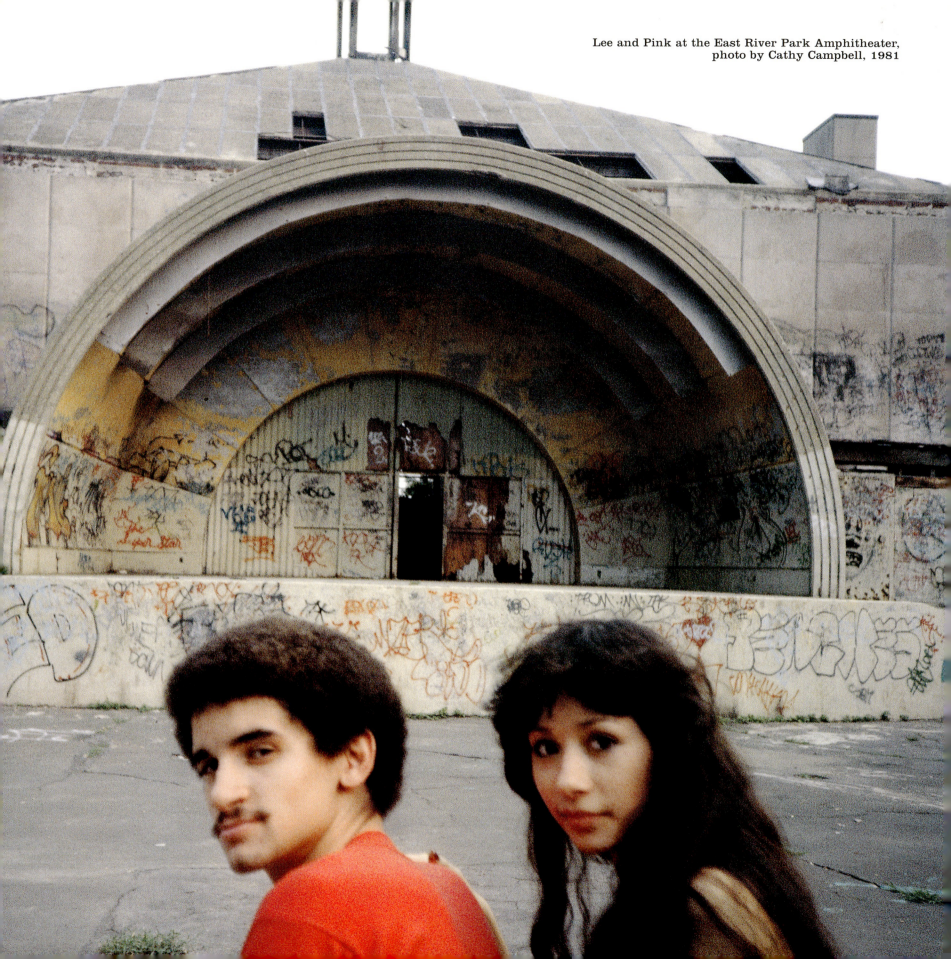

Lee and Pink at the East River Park Amphitheater, photo by Cathy Campbell, 1981

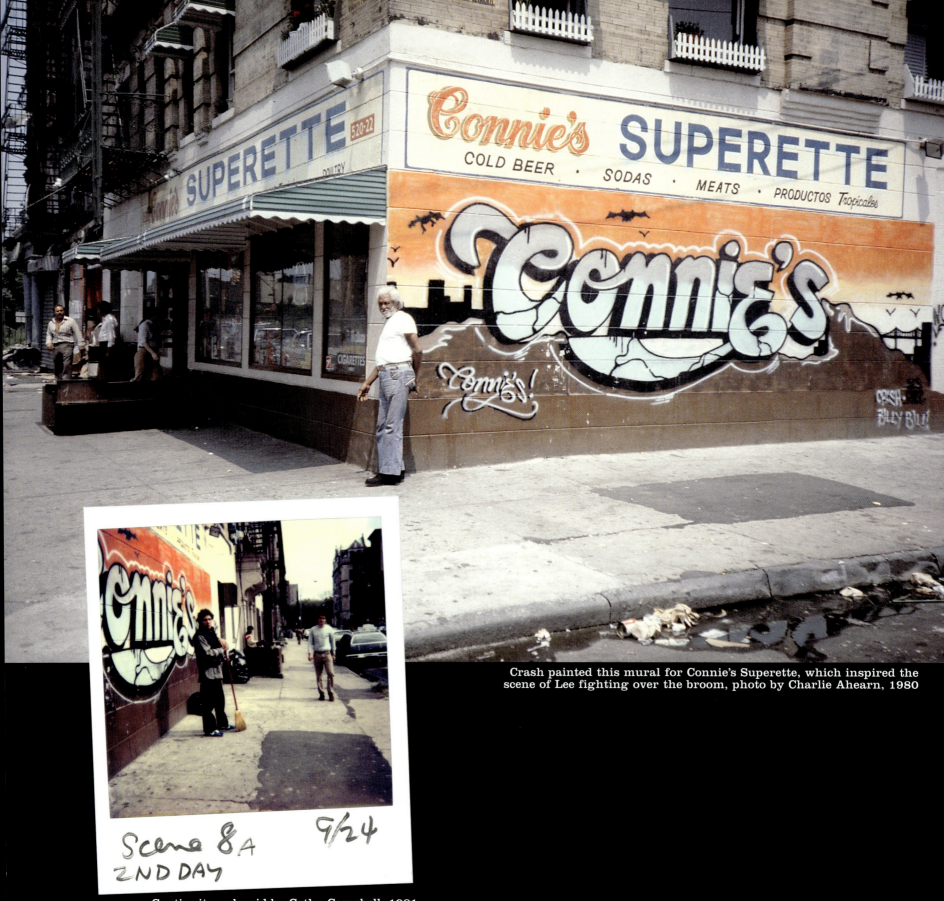

Crash painted this mural for Connie's Superette, which inspired the scene of Lee fighting over the broom, photo by Charlie Ahearn, 1980

Continuity polaroid by Cathy Campbell, 1981

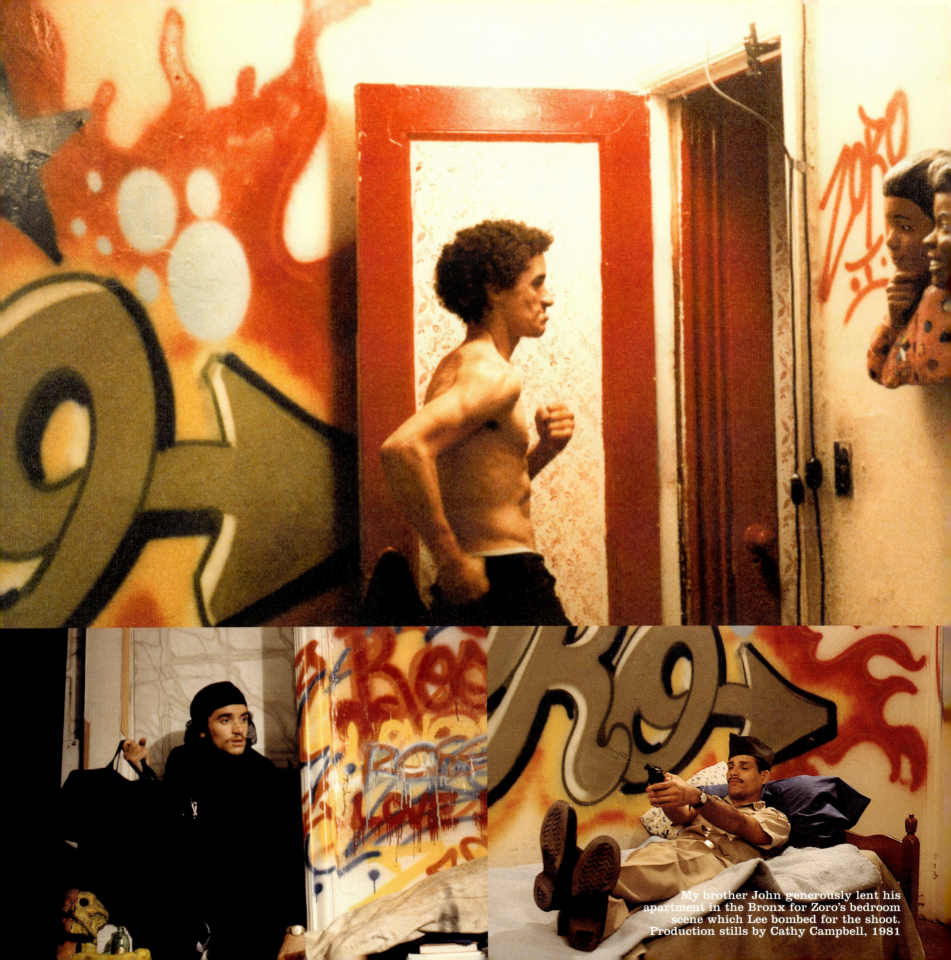

My brother John generously lent his apartment in the Bronx for Zoro's bedroom scene which Lee bombed for the shoot. Production stills by Cathy Campbell, 1981

Cathy Campbell

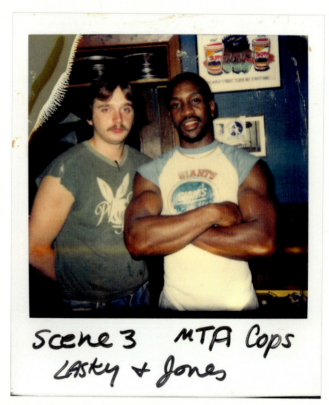

Cheeba House scene (which didn't make the final edit) with Rodney Cee and Angie B, who later became R&B star Angie Stone.

MTA Anti-Graffiti Squad office scene (which didn't make the final edit) with graff legend IZ THE WIZ and martial arts sifu Nathan Ingram.

Cathy Campbell was the script supervisor. Her job was to take detailed notes and Polaroids to assure continuity from take to take and from the scene to scene.

⭐ Cathy

Continuity Polaroids are vital for organizing wardrobe and props—even though we didn't have a wardrobe or a prop department. (The actors got money to buy their own clothes.) Obviously, the most important props were the Krylon cans, but the best graffiti artists in the world weren't in danger of picking up the wrong spray cans. As for making sure that the actors repeated the same dialogue and gestures from take to take, that's nearly impossible when 90% of the scenes were improvised. Also, if the shocking truth must be told, continuity wasn't exactly my calling in life. I read a couple of pages about how to do it the night before the first shoot (the same day I was hired, thanks to no competition). I can't say that I was a natural. Charlie was cooler about it than the editor Steve Brown.

Part of my problem with keeping track of what was going on within the camera frame was that I was just as interested in what was happening outside the frame. That's why I brought my 35mm camera and started taking behind-the-scenes production stills.

Continuity Polaroids are often thrown away at the end of a production. Yet in the same way that *Wild Style* captured more about the spirit of countercultural rebelliousness than a traditional three-act movie could, these Polaroids show more about fun and affection than continuity. So glad Charlie didn't fire me or throw these out.

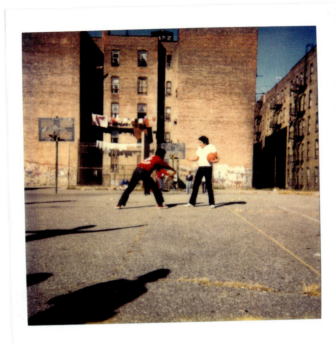

Basketball scene rehearsal with DJs Grand Wizzard Theodore and Charlie Chase

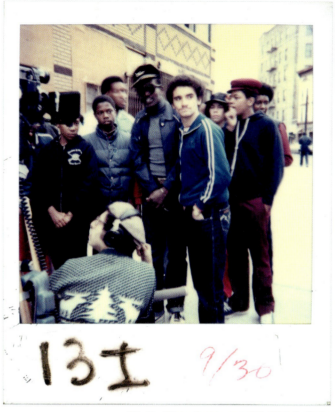

Dixie Mural scene with Fred, Lee, and boom David Beckerman

Crazy Legs freezes for the Rock Steady scene

Lee on location in the Love Stinks scene
Continuity Polaroids by Cathy Campbell, 1981

"We're all graffiti artists!"

Virginia and the Kids

1	long	E	Car stalls before stop sign	Kids playing in area
	detail		ignition key won't turn over	
2	tight	W	Virginia peers out window	kids behind her
(10)	medium	E	Kids playing watching her	approaching (sound) "need help?"
3	Close	W	Virginia's jumps around startled she tries to roll up her window,	at Kid at her window (threatens to call Cops)
	-close	E	Virginia framed by Kid	asks "Where is the telephone?"
4	med	W	the kids all grin	
5	tight	W	"there's two around the corner but they're busted for weeks the nearest one is 6 blocks away..." (lead)	
	-tight	E	Virginia rolls her eyes	
6	tight	W	"aren't you the reprter...looking for the Dixie...?" (lead)	
	-tight	E	Virginia suprised eyes "Yeah, I&m looking for the graffiti artists..."	
7	close	W	"We're all graffiti artists!" they wave and cheer ("Weve been hearing that you were supposed to be coming..")	

Original shooting script for scene with Virginia, the downtown journalist, and kids

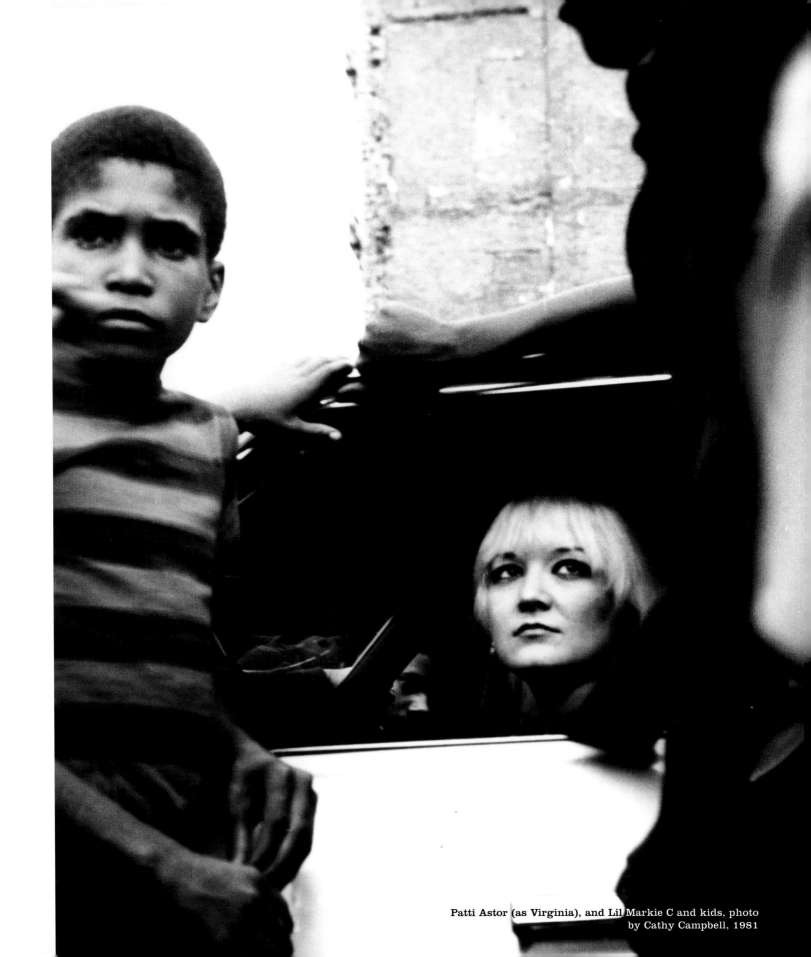

Patti Astor (as Virginia), and Lil Markie C and kids, photo by Cathy Campbell, 1981

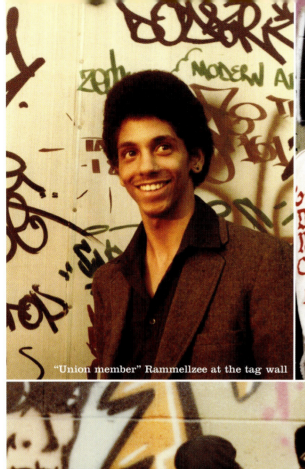
"Union member" Rammellzee at the tag wall

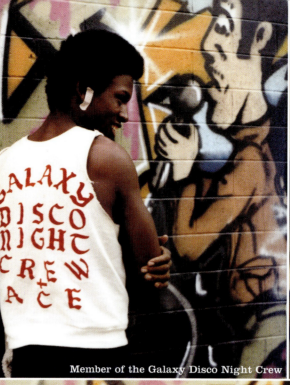
Member of the Galaxy Disco Night Crew

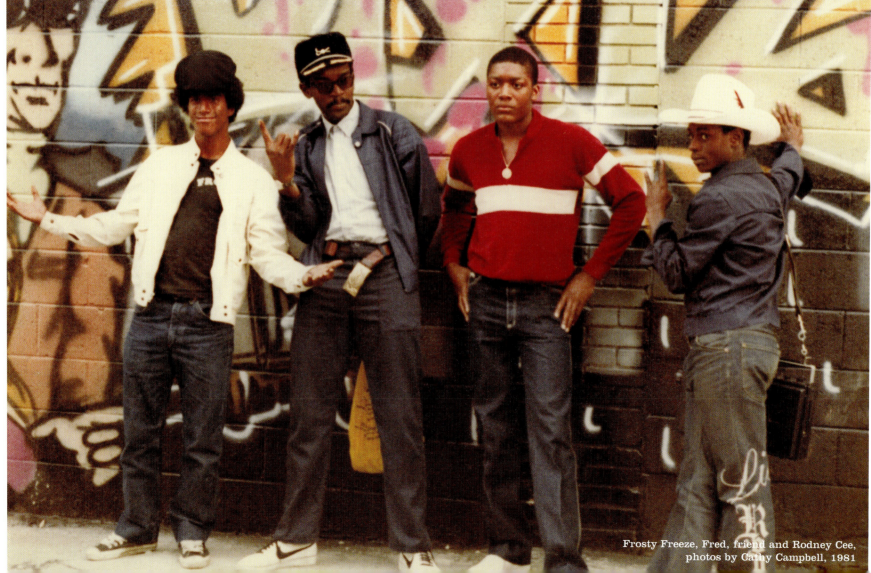
Frosty Freeze, Fred, friend and Rodney Cee, photos by Cathy Campbell, 1981

Dixie Mural

The last time I checked, the ruins of the Dixie Club was still on Fremont Avenue in the Bronx: a solid block of sagging, two-storied wooden buildings covered with tar shingles, just up the street from the train station. When we shot there much of the neighborhood was in a desperate state. The gas station on the corner looked firebombed. Most of the windows were covered in tin and the lots around the subway were leveled to rubble. I was shocked on my most recent visit to see rows of cute suburban-looking brick houses with driveways and little front gates just across from the old Dixie.

The Dixie was once one of Flash's famous party spots in the late 70s, only a few blocks south from his first indoor location, the Black Door. The local gangster crew, the Nines (named after 169th Street), tried to hold up Flash's parties at the Dixie several times. They probably resented Flash bringing in the Casanova Crew to do their security. It was the Nines' turf so why shouldn't they be getting paid?

By the time we used the club in 1981 it was a Jamaican spot. We opted to shoot in the smaller rooms downstairs, which were still kept up at the time.

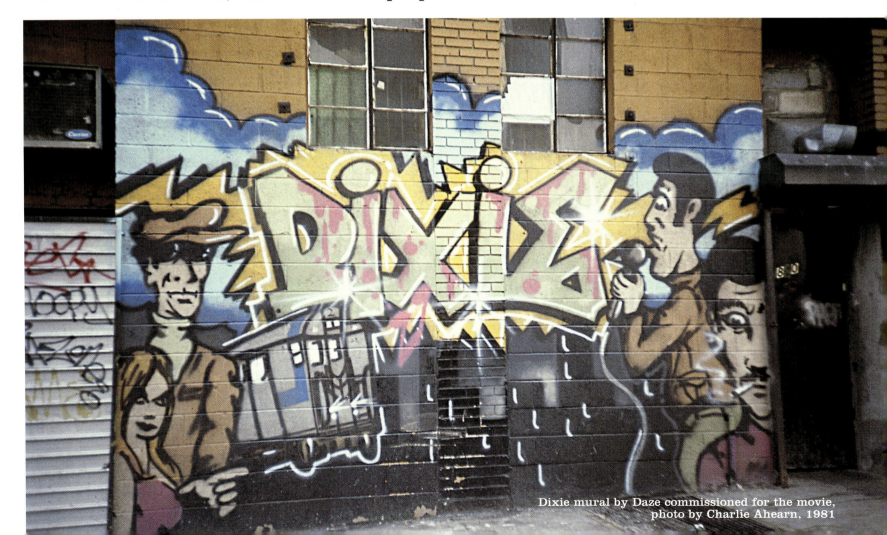

Dixie mural by Daze commissioned for the movie, photo by Charlie Ahearn, 1981

Rodney Cee, Jazzy Jeff, Lil Markie C, KK Rockwell, and friends in front of Rodney's mom's house, photo by Charlie Ahearn, 1981

Funky Four member Rodney Cee lived at his mom's house two blocks away from the set. He generously introduced me to his neighborhood where much of the film was shot. With Rodney down, we were like family to the kids and grown-ups on the street. KK and Rodney's "Stoop Rap" was shot across the street from his mom's house; when we staged Patti's car being pushed, we filled the frame with Rodney's local proteges like Lil Markie C and Sput who said, "We are ALL graffiti writers!" They later boogaloo'd in the Dixie scene and with Double Trouble on stage at the Amphitheater.

Fred and I were very impressed with the Funky Four and were planning to have them star in the movie. Later I was getting phone calls from Jazzy Jeff and Rodney in the middle of the night talking to me from two sides of a fence. Rodney felt that Sugarhill was ripping them off and that they should leave. Jeff was trying to hold it together.

★ Fred

We were on the set shooting outside the Dixie, and would see Rodney, his mom, and his brothers every day, and sometimes go by his house and hang with them.

One day Rodney came over and pulled me to the side: "So Fab. I got to tell you. It's over. The group, we've split. They decided to stay, and me and KK left. It's officially over."

I had to sit down. I was in shock because this was one of the groups we were most excited about. Rodney said, "Yeah, it's all good. We got another group. KK and I are going to call ourselves Double Trouble. And Fab, I wrote this rap and I want you to hear it: *Here's a little story that must be told, about two cool brothers that were put on hold. They tried to hold us back from fortune and fame. They destroyed the crew and killed the name...*"

It was so moving. It almost brought tears to my eyes because the rhyme that Double Trouble performed in the movie was so specifically about the Funky Four Plus One and Sugarhill Records. Charlie heard the rhyme and said, "No question. Double Trouble is in the movie."

I always felt that Rodney and KK were really laying down that story on the Stoop—it was their Declaration of Independence and when they appeared at the end of the movie in their white suits, hats, and machine guns, it was like they were truly rising up from the ashes and taking flight into the future.

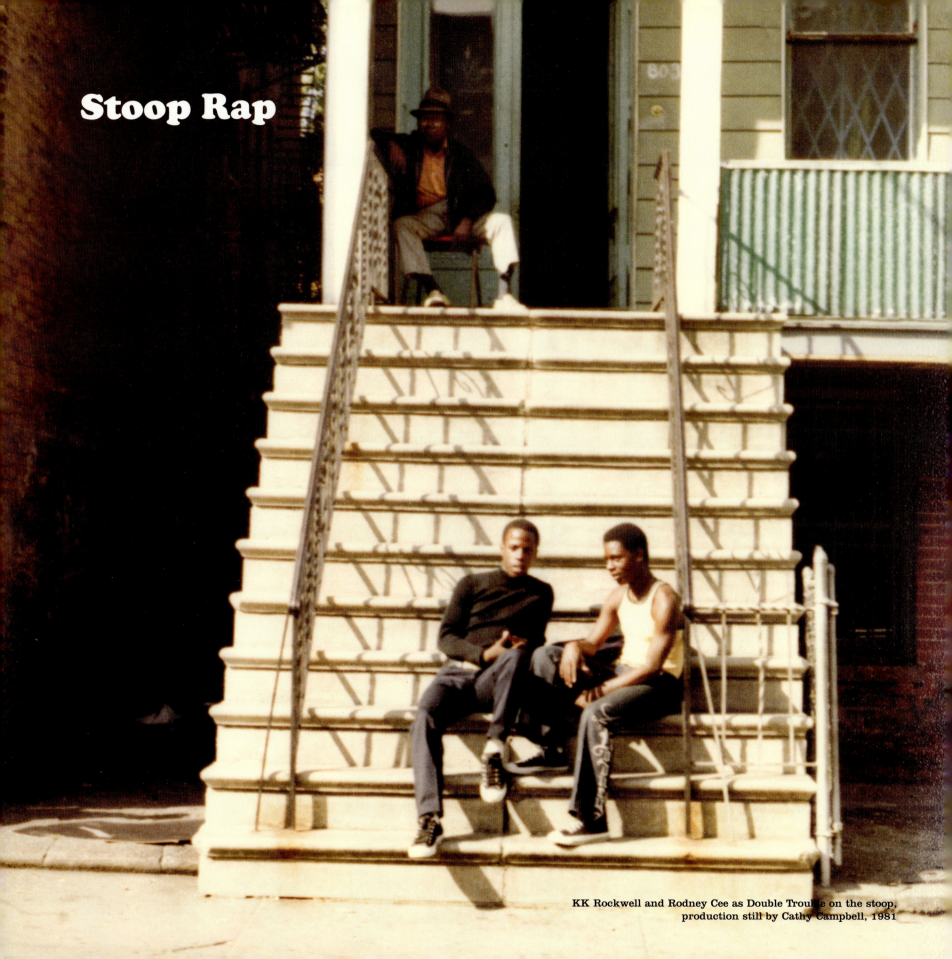

Stoop Rap

KK Rockwell and Rodney Cee as Double Trouble on the stoop, production still by Cathy Campbell, 1981

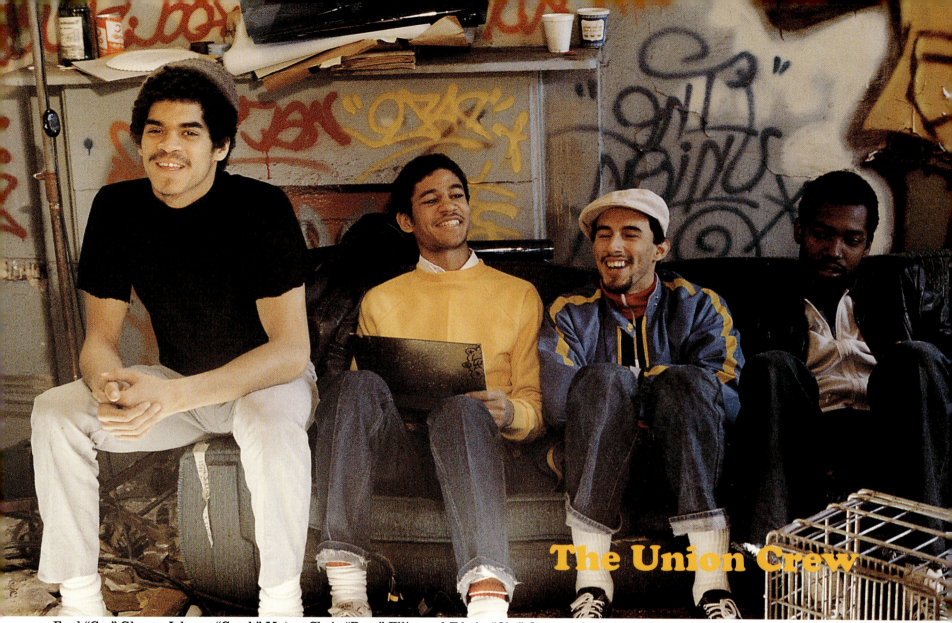

Fred "Caz" Glover, Johnny "Crash" Matos, Chris "Daze" Ellis, and Edwin "Obe" Ortez and on the Union couch, photo by Cathy Campbell, 1981

Crash showed me an abandoned building a few blocks from where he lived in the Bronx that seemed like an inspired graffiti spot. It had rooms facing the trains whizzing by. Daze and Crash were inseparable at that time, bombing trains, painting murals, and launching art shows. They spent the time during their scene snapping on each other and cracking jokes at the expense of their fictional Union Crew leader, Rose, played by Pink.

⭐ Lady Pink

I might have been the leader of the Union Crew in the movie, but in reality I was the young one. I was the toy and the older guys resented me playing their leader. They knew I had the mouth for it, but I didn't have the social status to take on that role. It was a bit funny.

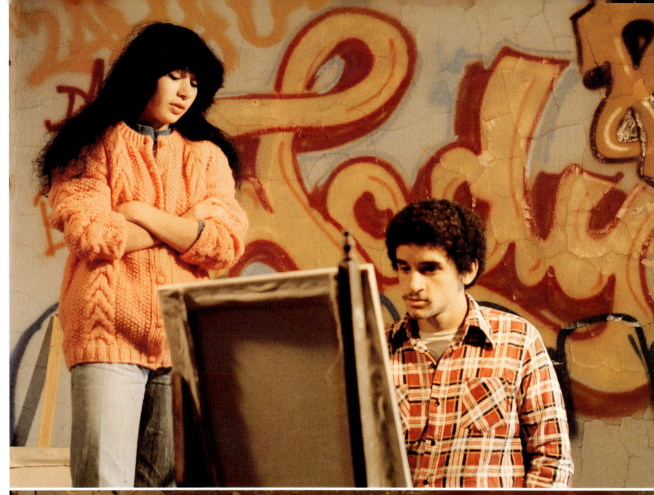

⭐ Lady Pink

We were in that abandoned building at one point, and were on a break. Lee and I went up to the roof and did pieces together for the very first time. Somehow we got into an argument and he crossed me out. He completely took me out and there was nothing I could do but cry and carry on. The film crew was waiting and wringing their hands and wondering why people were having fits and conniptions. I never pieced with Lee before and we never collaborated again. That was just the way the relationship went. He was a wild and crazy dude.

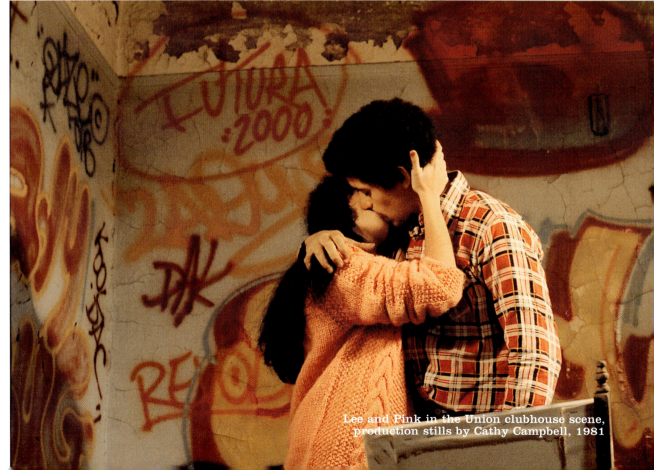

Lee and Pink in the Union clubhouse scene, production stills by Cathy Campbell, 1981

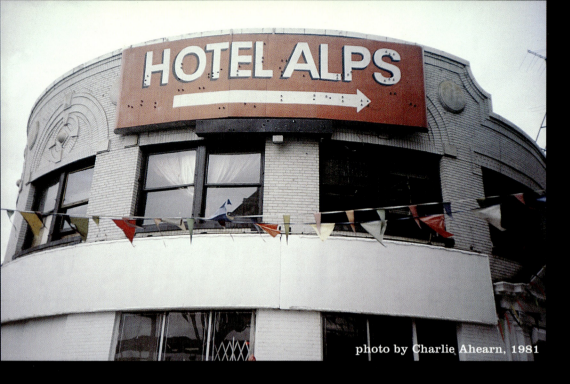

photo by Charlie Ahearn, 1981

Where's That Place We Work It Out?

The limo ride "to the Alps" was inspired by a routine of Busy Bee's which referred to the Alps Hotel off Tremont Avenue, a local spot Busy and other MCs would bring girls after their shows. Busy would shout, "Where's that place we work it out?" and the audience shouted, "In the Alps! We work it out!" Busy said they got a lot of business off his rhyme, but I only showed a bit of their sign in the movie; the scene was shot elsewhere, in a friend's bedroom. The scene called for a wild party ending in an orgy, but I knew I couldn't ask Lisa Lee or any of her friends to get naked so I opted for the smoke/money/bras/Zodiac sign montage.

 Lisa Lee was in the original Dixie scene but was too pregnant in the spring for the Dixie reshoot. She was one of the original female MCs down with Afrika Bambaataa's Zulu Nation. Lisa and Busy rocked the limo scene. Once when I was visiting Kevie Kev from the Fantastic I noticed a photo of him posing in front of a big K made out of dollar bills which was lying at his feet. In the Alps, Busy gets to show Lisa Lee his dollar-bill letter B. "See that B there? That's my B. Don't fuck with it. Don't be playing with my dollars."

Busy Bee

The Alps is a Howard Johnson's now. I went in there, and they had some Indian guys by the door, talking about it costs this and that. I said, "This here's my spot, man. I made this spot famous, man. You're going to get rich because of me. This spot is called 'the Alps.' Where we work it out!" He asked, "What is he saying?" I sang it, "Where's that place we work it out!" He said, "This is the Howard Johnson's now. I don't know what you are talking about." I said, "Well this is the Alps to me. Give me a room!"

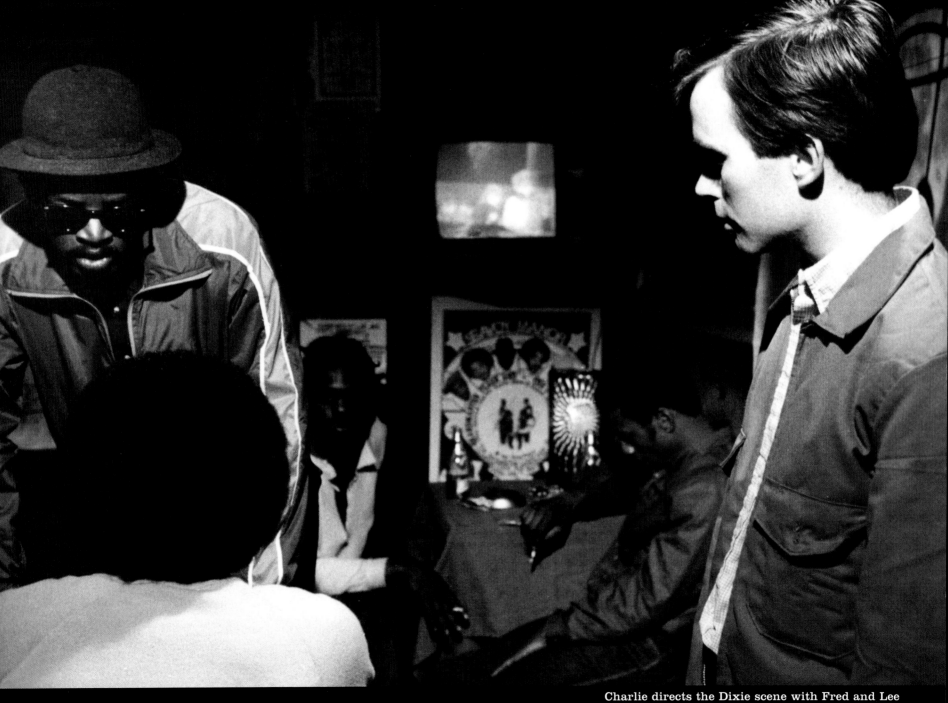

Charlie directs the Dixie scene with Fred and Lee (note guys from the stick-up scene, p. 127, as extras in the background), production still by Cathy Campbell, 1981

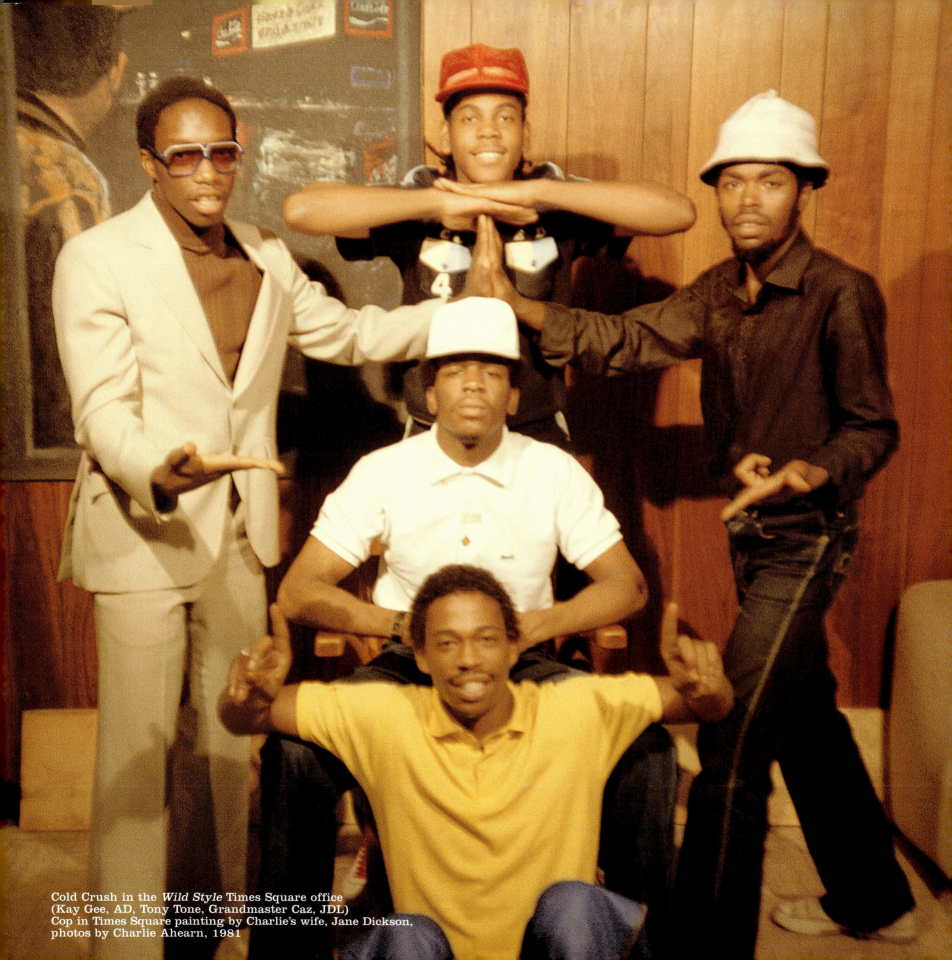

Cold Crush in the *Wild Style* Times Square office
(Kay Gee, AD, Tony Tone, Grandmaster Caz, JDL)
Cop in Times Square painting by Charlie's wife, Jane Dickson,
photos by Charlie Ahearn, 1981

Wild Style Theme Song

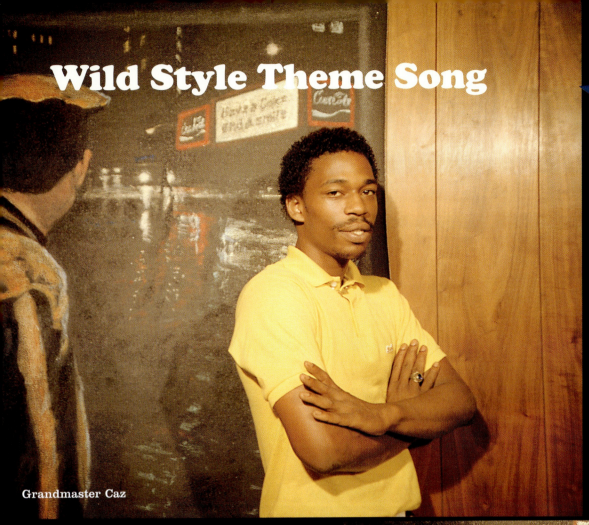

Grandmaster Caz

★ Grandmaster Caz

The soundtrack was orchestrated by Charlie, though Freddy was our musical director. My work on the sound track was with Charlie and he guided me through the process. I remember being a little nervous because this was a movie soundtrack and I was making the theme song. Charlie told me the kind of feel he wanted, and what direction to go lyrically. I only resent that I didn't sound more confident and natural on the track, but I'm a perfectionist.

Grandmaster Caz, one of the most respected lyricists in hip hop, was my choice to pen the movie theme song. He opened with, "South Bronx, New York, that's where I dwell, to a lot of people it's a living hell." We recorded one version a cappella, which was used in the movie, and another with DJ Charlie Chase, scratch mixing under Caz. Later Chris Stein edited and over dubbed a heavily embellished version with his guitar effects.

JDL (Jerry Dee Lewis)

The Basketball Throwdown

In the Bronx there were two MC groups ruling the streets at that time—the Cold Crush Brothers and the Fantastic Romantic Freaks. No doubt the Furious were the first and greatest MC crew out of the Boogie Down but they weren't playing the Bronx much since they signed up with Sugarhill. They were out touring the country when the Cold Crush and the Fantastic were killing it at the clubs. Although they all knew each other from back in junior high, this rivalry was serious. People were always comparing them and arguing over who would win in a battle to the death. It was Charlie Chase vs Grand Wizzard Theodore down the line, so when I thought of the basketball scene it was always going to be them.

The idea came to me one day when I was exiting the subway at West 4th Street station and there was a fierce game of street ball on the half court right there. Some unrelated DJ was practicing on his turntables by the court. I stood in awe, staring at the game. In my mind I was watching a musical right then and there. Of course, the opening street fight in *West Side Story* was an unconscious connection. I remember seeing that film with my brother John when we were 12 years old, and bursting out of the theater as the Jets, snapping our fingers and leaping off fire hydrants for the two miles home.

Caz was living at his mom's place on Creston Boulevard, only a few blocks from the park at Valentine and 183rd Street where we shot the basketball scene. He ushered me into his bedroom and showed me a closet stacked to the ceiling with boxes of fresh adidas in different colors to match his outfits. Then he spread across his bed a collection of school notebooks, the kind with marble covers, and inside them were volumes of rhymes, each one written in exacting penmanship. The rhymes came straight out of his head and into the books with no corrections. Caz was legendary for his tight narratives, and he graciously worked with me to write the movie's songs. That day we walked over to the park to discuss making a musical on the local court. Caz had played ball there as a kid, and had rocked that spot as one half the DJ crew Casanova Fly and Disco Wiz the night the lights went out for the big blackout of 1977.

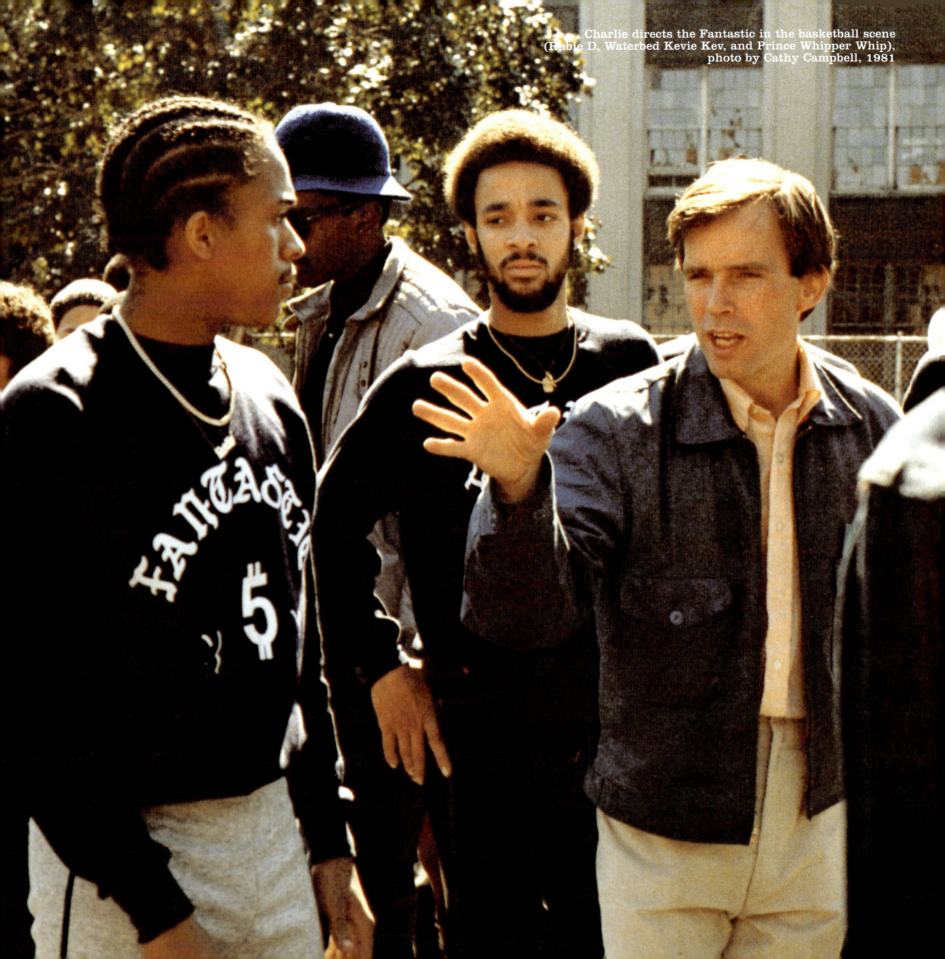
Charlie directs the Fantastic in the basketball scene (Rubie D, Waterbed Kevie Kev, and Prince Whipper Whip), photo by Cathy Campbell, 1981

Grandmaster Caz

Charlie wanted a scene resembling the *West Side Story* fight/dance scene but in a hip-hop style. What could be more confrontational than a basketball game with a little MC battle braggadocio? The set was a basketball court on 183rd Street across the street from EBB IS 115 (Elizabeth Barret Browning Intermediate School). I spent my adolescence in that schoolyard and played basketball there every day.

I first joined the Cold Crush Brothers in 1979. I was in the process of shaping the group into what we would later become—legendary—when filming for *Wild Style* started. The park where the basketball scene was shot was where we, the Cold Crush would break from practice, and work it out. Most times, sweaty and tired, we would return to my house for another intense practice session. The scene was set up by Charlie but I did have a hand in selecting the location and writing some of the lines that were said.

As Clive Davidson and the crew laid down the track for the dolly pull back, Fantastic and Cold Crush were off in their separate huddles preparing their lines. This was the serious moment. They knew that their reputations were on the line. As the camera moved back on the dolly, the tension built up between the crews. They were chanting in unison and dissing their rivals, but someone would blow a line and we'd have to start all over again. We did eighteen takes of that zipper shot before we made it to the end, and Caz got to say, "Play ball!"

On a normal movie set the music would be prerecorded in a studio and the players would lip sync to playback. This was too complicated for our budget. They were doing it for real on the street, playing ball and rapping live with radio mics, changing their lines with every take. After we had put it together in the editing room, we later decided to add the sequence with the girls' chorus to fill out the scene. Although Lisa Lee was visibly pregnant, she really made it happen.

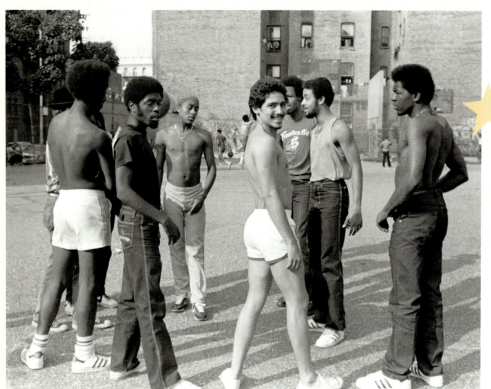

Waterbed Kevie Kev

I was being straight up 'cause I was a real ball player. I was looking at all those other MCs and I said what I felt: "Y'all can't ball!" That was it. Years later, my mom told me that I got a phone call from Shaquille O'Neil. I said: "Stop playing, mom." Then I spoke to Shaquille, and he wanted to use that "y'all can't ball" on a song; Zomba Records cut me a check.

Basketball rehearsal with Cold Crush and Fantastic, photo by Joe Conzo, 1981

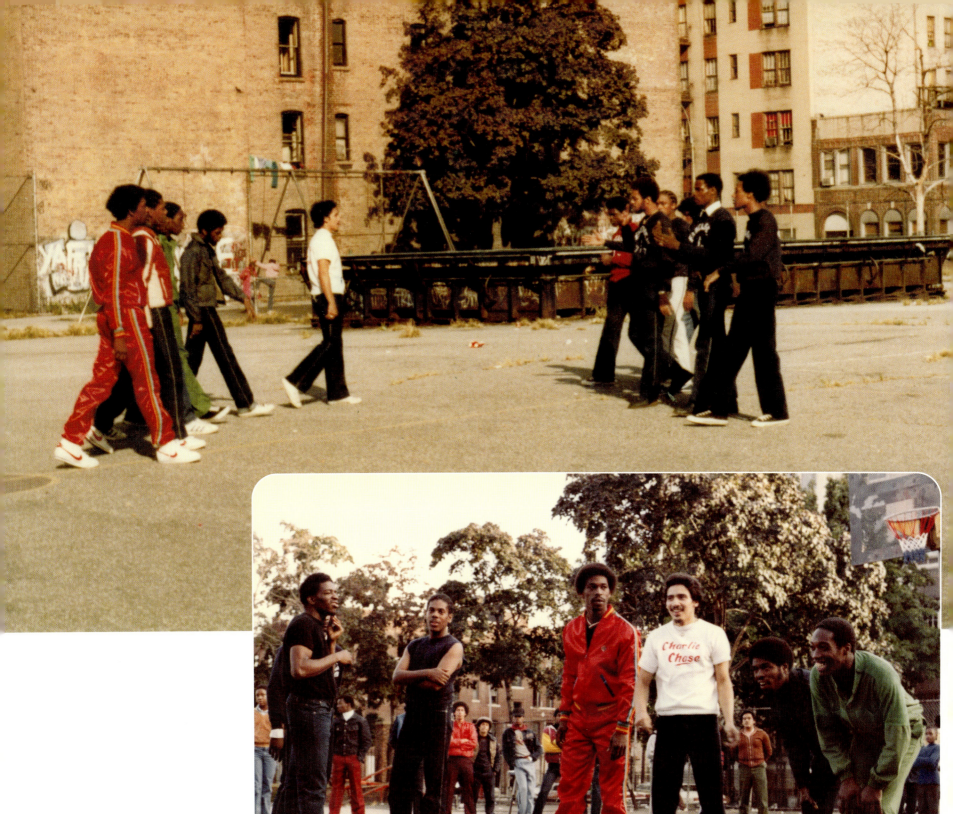

top: Cold Crush vs. Fantastic, photo by Cathy Campbell, 1981

bottom: Cold Crush (Tony Tone, AD, Caz, Charlie Chase, JDL, Kay Gee), photo by Cathy Campbell, 1981

above: Cold Crush sign *Wild Style* contract with Charlie before the Dixie scene, photo by Joe Conzo, 1982
right: Dixie flyer by Fred, 1982

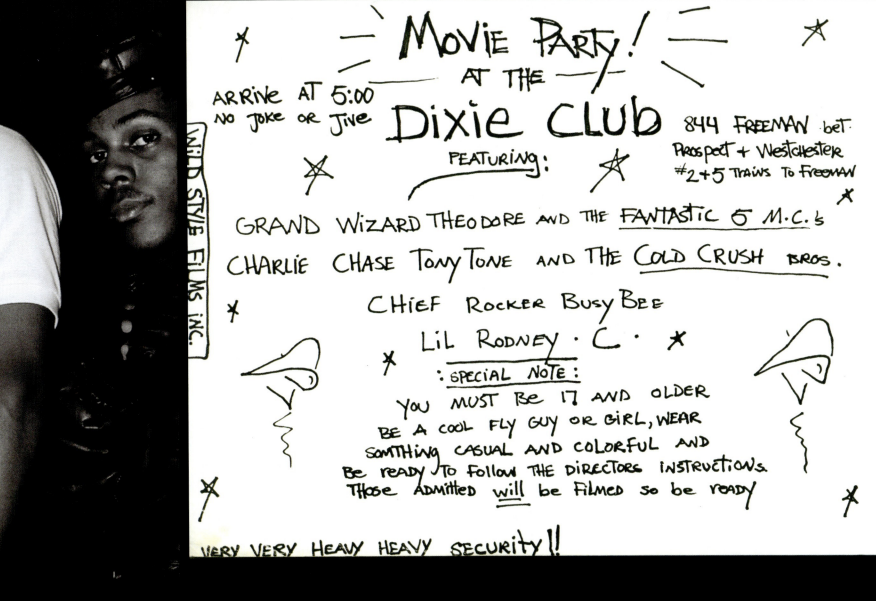

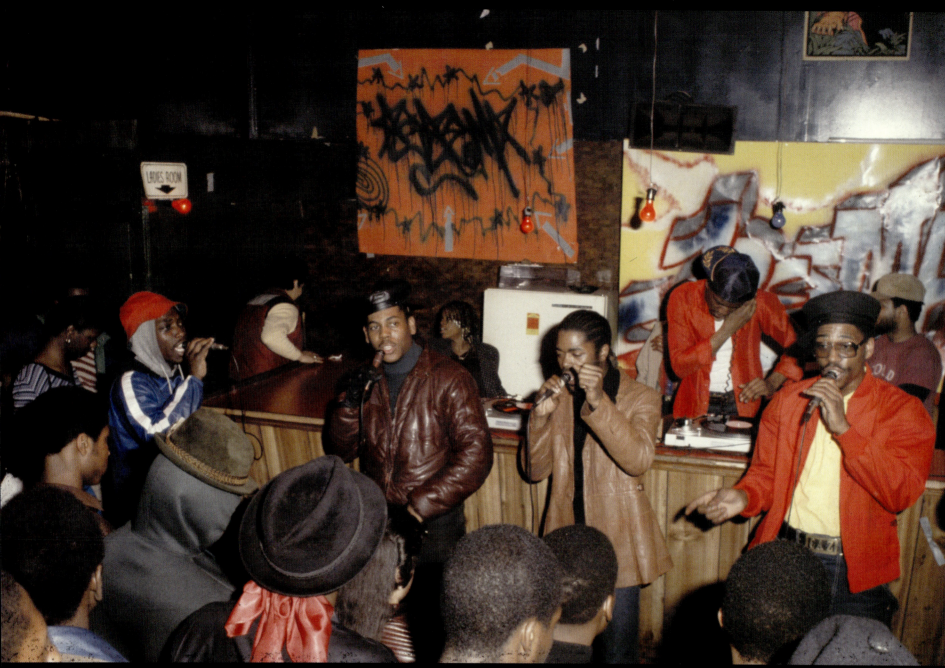

Cold Crush (Kay Gee, AD, JDL, CAZ, and DJ Tony Tone) at the Dixie, photo by Joe Conzo, 1982

The day after the basketball shoot we set up the Dixie Battle scene between the two super rivals: Cold Crush and Fantastic Five. As the battle closed with Caz doing his classic "Evette" rhyme, Fashion Moda co-founder Joe Lewis played the community organizer, discussing plans for the Amp Jam; over the years some have mistaken Joe with Kool Herc in this scene.

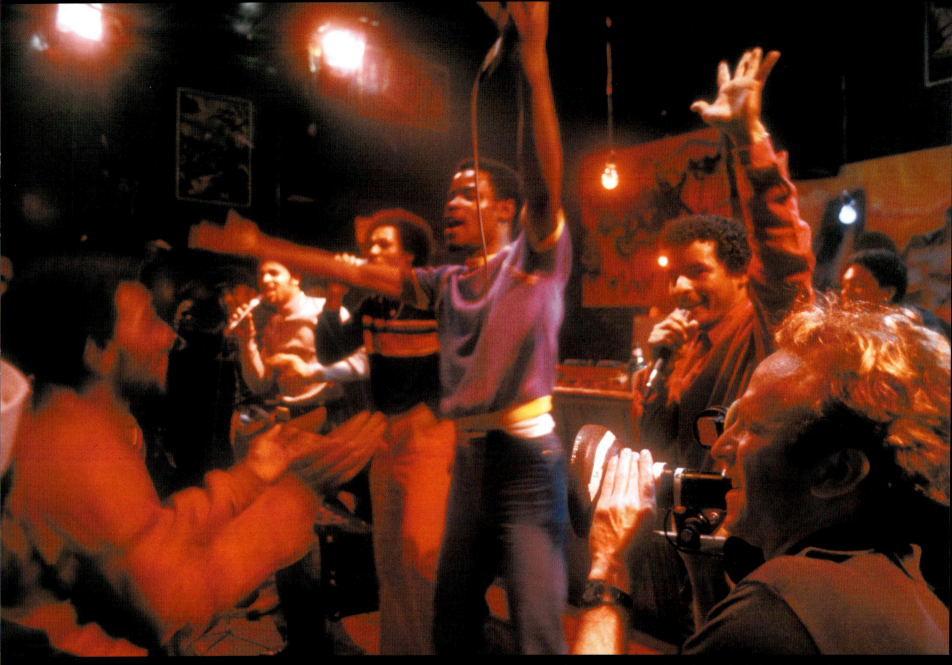

The Fantastic (Kevie Kev, Whip, Rob, Dota Rock, and Rubie D) with camera man John McNulty at the Dixie, photo by Martha Cooper, 1982

Waterbed Kevie Kev

"Soundman say turn it up!" (from Fantastic at the Dixie) is one of the biggest samples in hip hop. Everybody used that, Public Enemy, everybody. I'm telling you that shit is so big! It was like you throwing a lottery ticket into the hamper and it hits. Bang!

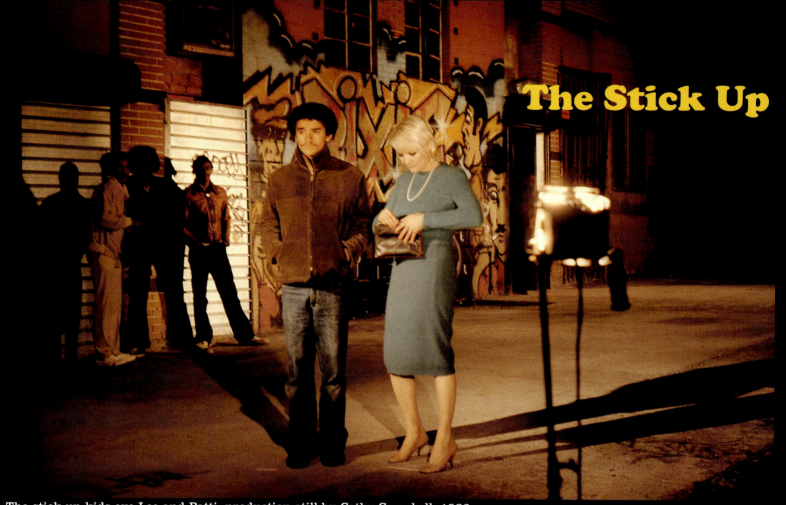

The Stick Up

The stick-up kids eye Lee and Patti, production still by Cathy Campbell, 1982

We were about to shoot the Stick Up scene, so during the battle at the Dixie I spotted a few guys who looked hard enough for the part. I asked them if they would want to play the stick-up kids, and they were enthusiastic. That night while Clive Davidson was positioning the lights, I began to run through the scene with Pookie and his two friends. I showed them our prop gun; I was proud of it because it was a heavy starter pistol with a decent weight. Remember, we were on a desolate strip of the Bronx late at night with no security whatsoever. Pookie took one look at it and said, "I don't want to use that. That's a pussy gun." He leaned back to where his car was parked on the curb, popped the driver's door, reached under the front seat, and pulled out this raggedy looking, sawed-off shotgun. I was very impressed. I didn't have the nerve to ask him if it was loaded as we were rehearsing the scene. With no help from the script they knew their lines perfectly. I did not write any of their classic dialogue such as, "A to the K? A to the mutha-fucking Z!" That was some real shit.

 The scene ran very late that night. We were returning from the Bronx around four in the morning. I was driving, barreling downtown through Harlem; Fred was asleep next to me. All of a sudden, a car came speeding from a side street straight into the side of a car directly in front of us. It landed upside down in flames, with the second car still stuck in it. The police, still giving chase, were right behind them with a siren wailing. We just kept right on driving and never looked back.

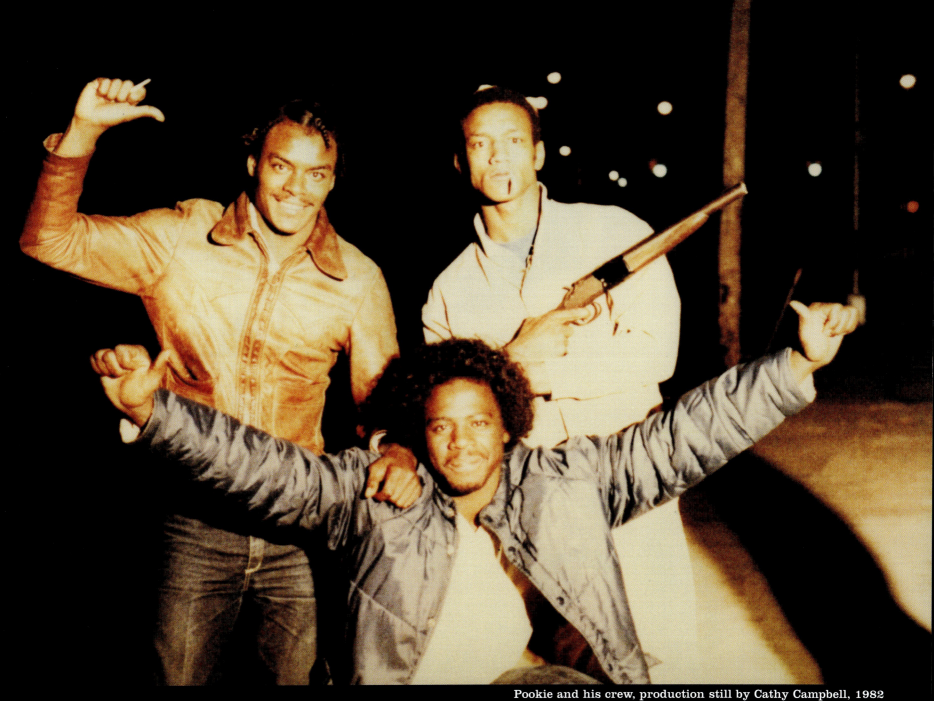

Pookie and his crew, production still by Cathy Campbell, 1982

Trouble in the Yard

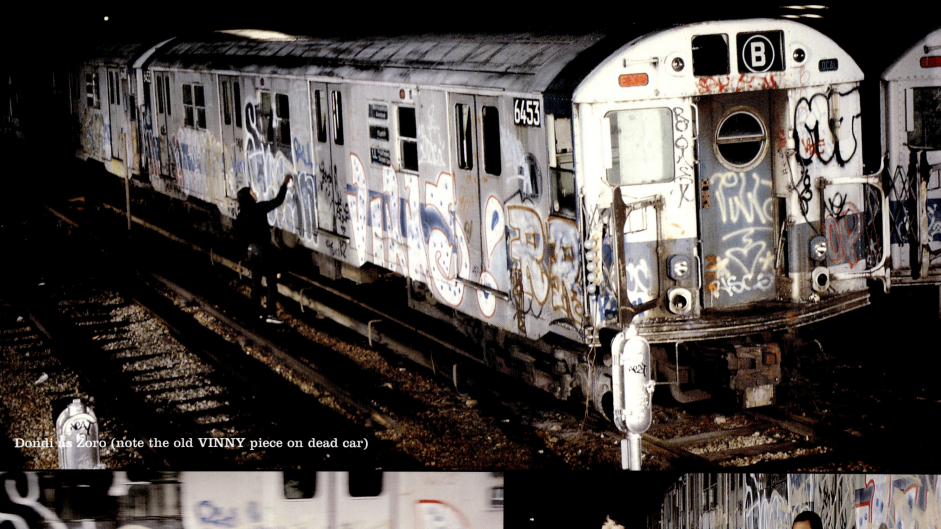

Dondi as Zoro (note the old VINNY piece on dead car)

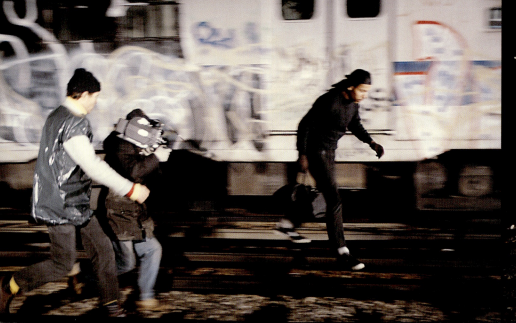

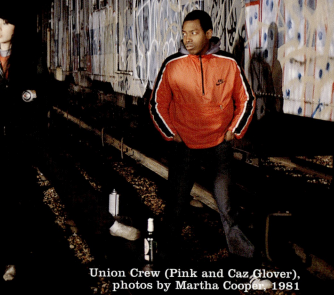

Union Crew (Pink and Caz Glover), photos by Martha Cooper, 1981

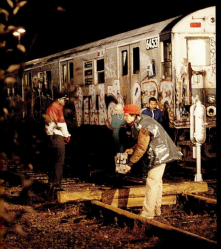

Fred, Patti, Dondi, and PA Gabriel Icaza (note rainwear), photo by Cathy Campbell, 1981

We scripted Zoro to open the movie by sneaking into the yards to bomb the trains, before getting chased by cops. What!? How was I going to pull this off? At the yards there were squads of detectives, barbed wire fencing, police dogs, and darkness. But I patiently spent a year wooing the men at the MTA to grant me permission to bring a film crew and lights into their heavily guarded war zone, and allow us to paint a train right under their nose. Finally they agreed, but it was going to cost us more than a quarter of the entire shooting budget, paid by certified check two months in advance. We had four hours to shoot on a given night and the date was not changeable.

It was already dark and raining hard when the crew began unloading equipment at the gates of the yard. It always came down to the practical issues of getting the scene shot under primitive circumstances with almost no crew. This required a dozen large HMI movie lights tied to a quarter mile of cables throughout the yard. Fred, Patti, Zephyr, Pink, and other writers shivered under a tarp, waiting for the rain to stop, but it never did.

I had cast martial arts star Nathan Ingram, along with graffiti writer Iz the Wiz, to play legendary yard detectives Hickey and Ski who may have even chased Lee once upon a time. Lee never showed up that rainy night, and I eventually convinced Dondi, who was there helping out, to don the doo rag and play Zoro with his back to the camera. We shot it with the lights on our side so the rain didn't show.

★ Lee

I was at home that night, breakin' Charlie's balls on the phone! I remember he and two other production people were calling me, trying to get me to come to the set. I remember Charlie was even saying (because I had a bit of a cold that night) that he would send an ambulance to pick me up and bring me to the set, which was out on Metropolitan Avenue in Brooklyn—the M Yard!

I didn't want to go to the yards that night. I don't know why it never dawned on me that we were going to shoot on location at the actual subway yards or lay ups. I thought that it was all going to be improvised, that sets were going to be built. But when we were on the sacred ground of tracks, bumpers, and trains layed up, I thought, no way Jose! I'm not going in there. I'm not going to cross those lines of my discipline. I'm not going to be there with the lights on my face.

But to be there and have the MTA shut down the power…

It must have been horrifying. I was in the comforts of my home watching *The Munsters* or something, and Charlie was there pulling his hair out! Oh my god, Jesus: I have to go to the confession for this one, man!

★ Lady Pink

That's just the way Lee is. He didn't want to be in the yards with other graffiti writers. That stuff is sacred. And the fact that there was a film crew probably just threw him. It was against his beliefs.

None of the other fellows had any problem with it: Iz the Wiz, Dondi, Caz, Zephyr; we were all there. Even though we had security watching us, when we were in the car, bored, waiting to be filmed, we snuck around to the back and went inside. Someone pulled out a marker and, even though some of the writers were retired, we all turned into little toys again. We were tagging the insides like children and having a wonderful time.

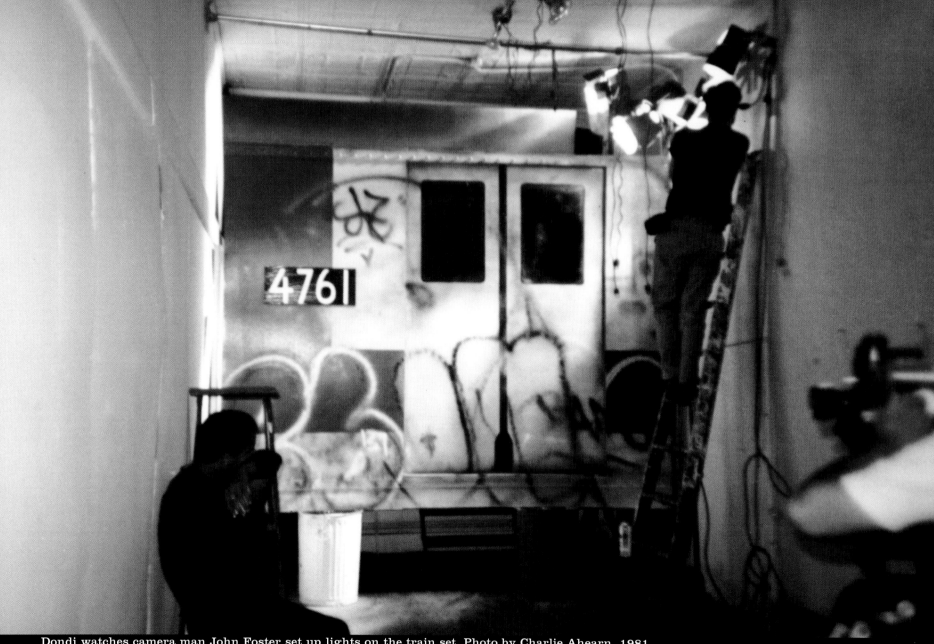

Dondi watches camera man John Foster set up lights on the train set. Photo by Charlie Ahearn, 1981

They had given us a "dead car" to paint in the yards, but the sides were streaming with rain and the paint wouldn't stick. With all this trouble, we had no time for the painting details, dramatic dialogue, or the chase scene—all of which was done later, some in a location under the Manhattan Bridge by Lee's GRAFFITI 1990 mural. Working there, away from the pressures of the yard, inspired visuals like Lee scaling down his handball-court mural in the opening scene of the movie.

Later, working in a loft space in Rafik's, we built the side of a train out of masonite to reshoot the scene. Dondi came over to play Zoro again, this time painting in close-up.

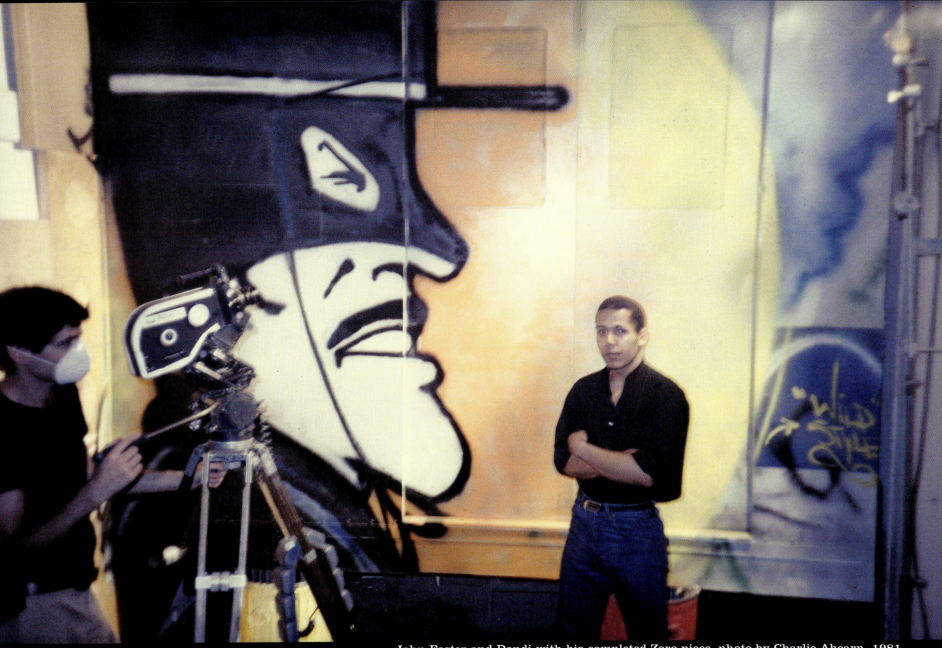
John Foster and Dondi with his completed Zoro piece, photo by Charlie Ahearn, 1981

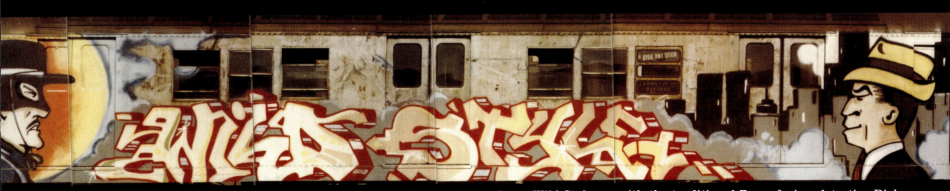
Dondi went out and knocked out a brilliant window-down *Wild Style* car with the traditional Zorro facing detective Dick Tracy on opposite sides of a car that ran in the system and appeared in the movie. Photo by Henry Chalfant, 1981

Uptown 81

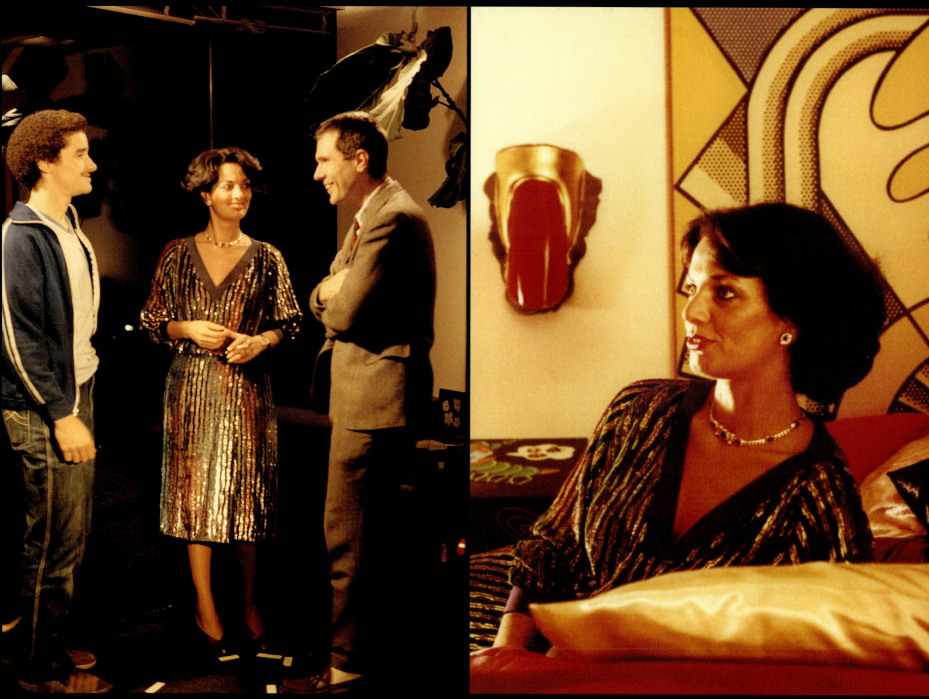

Lee, Niva Kislac, and Glenn O'Brien, production stills by Cathy Campbell, 1981

Glenn O'Brien

1981 was a big year. I was wrapping up shooting on *New York Beat*, at the time the biggest budget, most ambitious underground New York film ever. It was also the year that our backers vanished, leaving us penniless in the editing room. Little did we know it would take 19 more years to complete the film and release it as *Downtown 81*.

That was also the year that Charlie Ahearn made *Wild Style*. Charlie and I were friends. We just hit it off. I don't remember where we met. I just remember being in many atmospheric rooms together, from the fabulous aesthetic squalor of the *Times Square Show* to the fantastic nexus of apocalyptic *joie de vivre* that was Mudd Club. Charlie and I were the Irish guys in fedoras. People always thought I was Charlie and that he was me. He was a twin but somehow nobody ever confused me with John. But I did feel like Charlie was a brother. We were into the same kind of things. We even had very similar ideas about filmmaking.

Downtown 81 and *Wild Style* are almost twin films, portraying what was happening in New York during that crazy time. You could call *Wild Style* "Uptown 81." We were showing two sides of the same explosion. Charlie and I also shared a distaste for documentaries. We wanted to show what was happening and the people who were making it happen but we didn't want to be all corny and serious and sociological about it.

In *Wild Style* I appear at a fancy uptown art collectors party as the curator of the "Whitley Museum." Fab 5 Freddy attempts to tell me about a new art form called graffiti and I tell him that I know all about it, having spent $50,000 in the past year removing it from the museum.

I remember the shoot. I improvised my lines and the first take was really good but it was spoiled because I cracked up the whole set. Everybody laughed at me. I was pretty believable. I did have nice clothes and I had spent enough time around the art world when I was working for Andy Warhol to do the society lockjaw accent and be dismissive of anyone who wants something. I guess I projected something because I remember one night coming home to my St. Mark's Place apartment at about five in the morning without a penny in my pocket and overhearing one drunk punk girl say to another, "There's goes Glenn O'Brien, that rich asshole." I had to sell my review copy record albums every month to pay my $130-a-month rent.

The other straight guy in that scene was the late great actor and painter Bill Rice, who was playing a media executive, and he too projected a believable though funny character. He had the self-important alcoholic hack down flat. And Bill cracked me up.

The apartment in the scene belonged to a foxy Israeli woman named Niva. It was in a fancy hi-rise building and it was filled with art Niva had collected—Lichtenstein, Stella, Indiana. She was interested in graffiti too. Or maybe she was interested in graffiti artists. I couldn't be sure which, but that was kind of what the scene was about.

Flash's apartment in the South Bronx had three turntables set up in his kitchen laboratory. He was like the mad scientist experimenting with new sonic chemistry. Originally Fred was shot rapping to Flash about bringing his crew, the Furious Five to the Amphitheater that evening. The Furious did come and did tear up the place, but due to some sound problems the entire Amphitheater scene was scrapped and had to be re-shot the following spring. By then his group was split up and couldn't make it. Since the Furious' performance didn't appear in the movie, the scene was cut to only showcase Flash's amazing skills.

Flash in the Kitchen

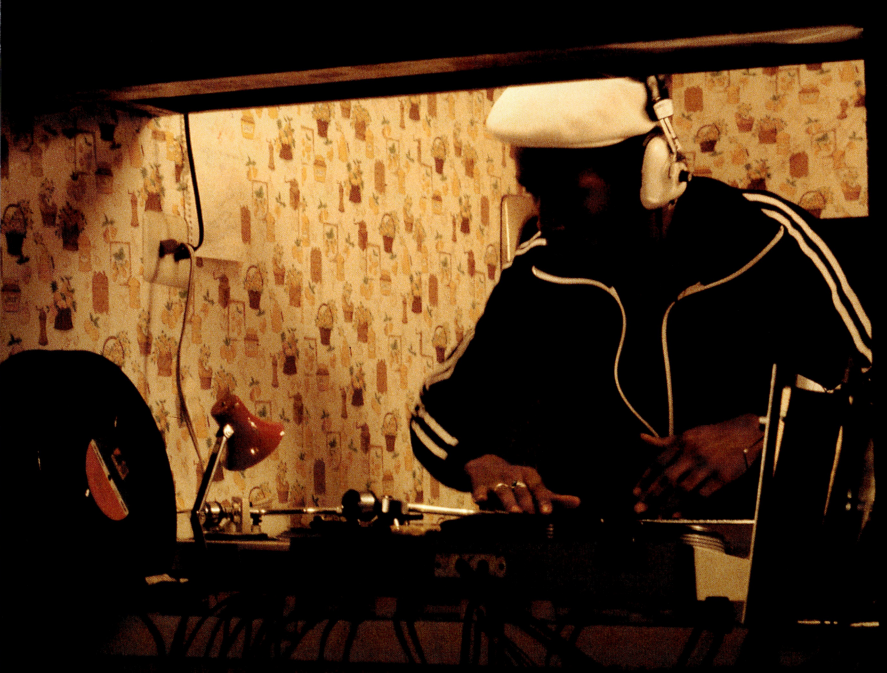

GrandMaster Flash in the Kitchen scene. production stills by Cathy Campbell, 1981

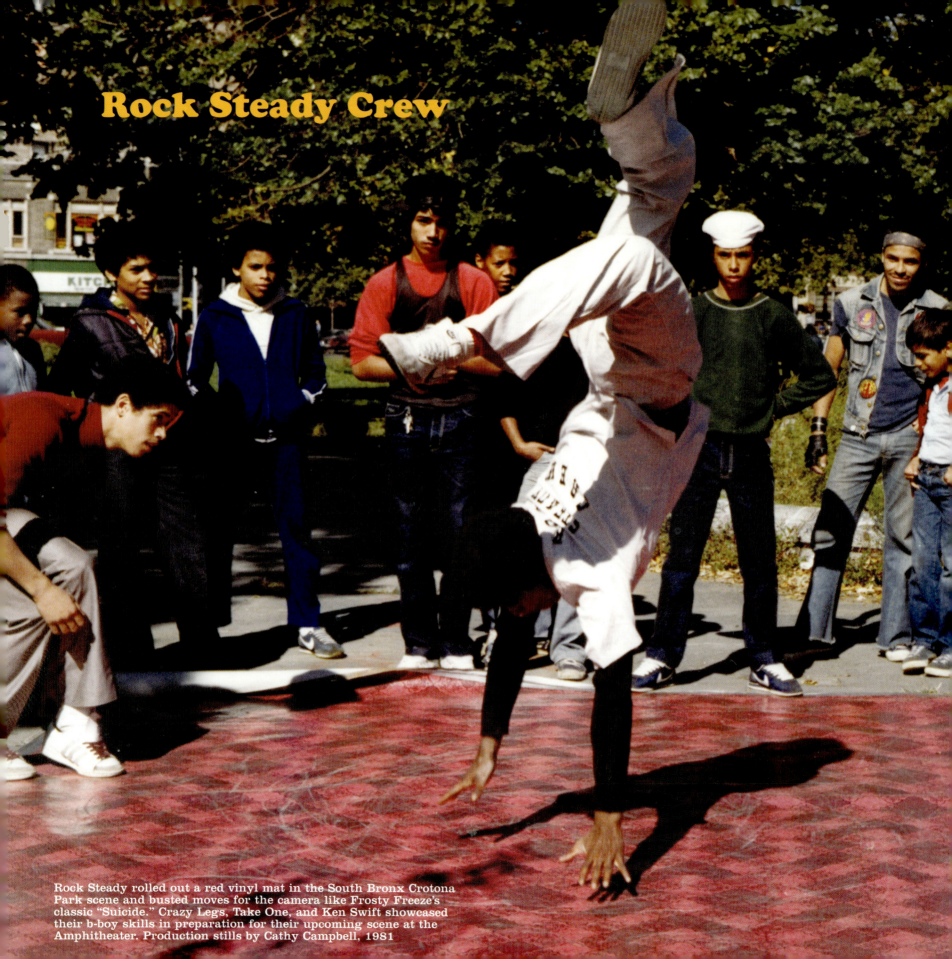

Rock Steady Crew

Rock Steady rolled out a red vinyl mat in the South Bronx Crotona Park scene and busted moves for the camera like Frosty Freeze's classic "Suicide." Crazy Legs, Take One, and Ken Swift showcased their b-boy skills in preparation for their upcoming scene at the Amphitheater. Production stills by Cathy Campbell, 1981

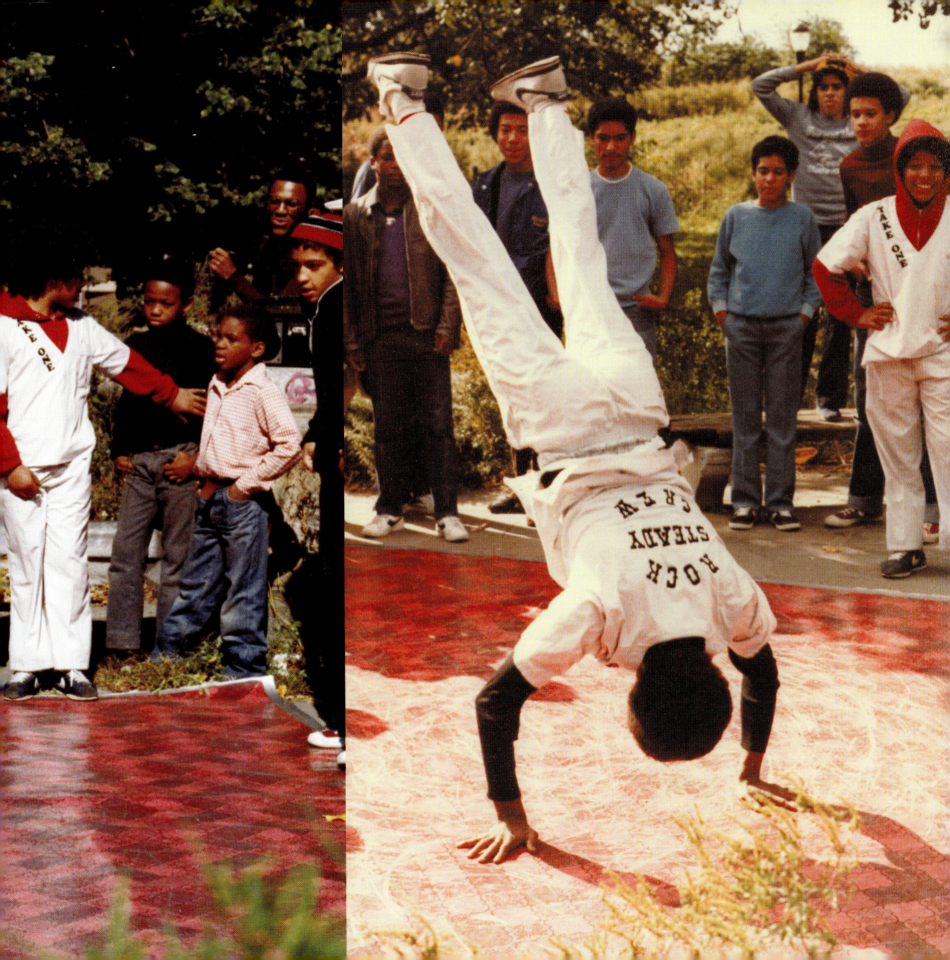

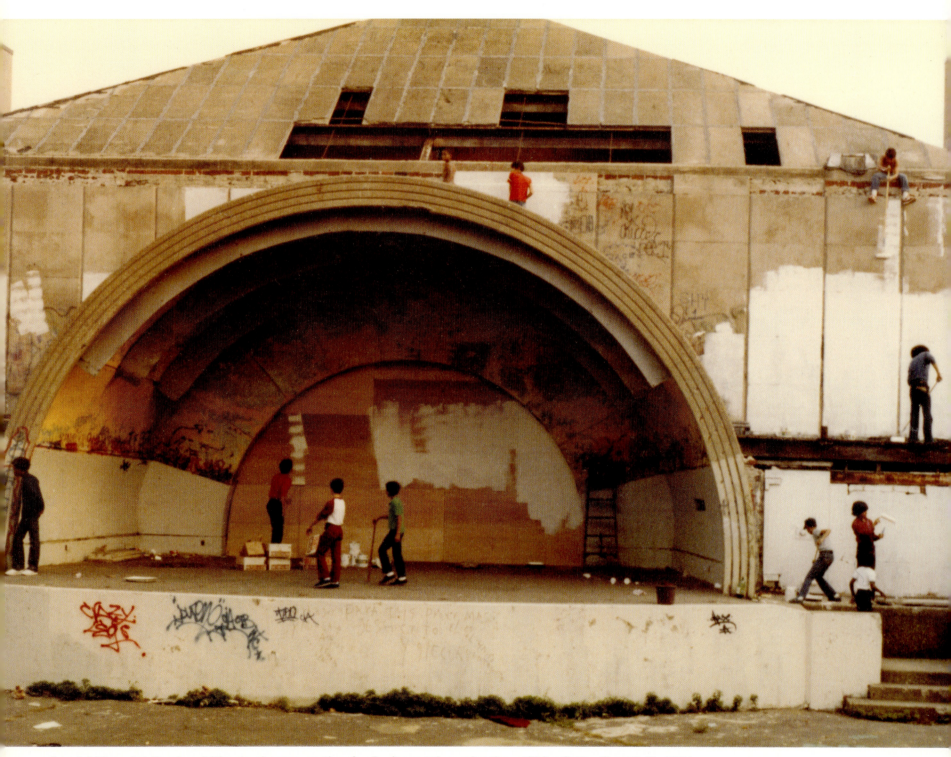

Local kids paint the Amphitheater in preparation for Lee's mural, production still by Cathy Campbell, 1981

Lee Gets Busted

After I got past my initial fear of the sheer scale of the Amphitheater, I began the bureaucratic process of applying for a permit from the City Parks Department. After months of meetings and applications, it was time to shoot and I still had no permit. We were to meet Lee at noon at the bandshell to look at his designs for the big mural he was going to paint. Pink arrived and told me that Lee had been arrested on his way over.

Lady Pink

Lee was bringing Charlie the final illustration for the Amphitheater, but he didn't show up. I knew his habit of never paying his train fare, so Charlie and I back-tracked, to trying to figure out exactly what happened to him. Lee had gone into the Second Avenue train station, down one flight of stairs. There's a little nook there, and apparently a cop was there. Knowing Lee, his intention would have been to head right for the subway tunnel; that is what any graffiti writer would do.

Lee

It was the East Broadway station on the F. If I remember correctly, I jumped a turnstile because I was in such a rush. I was trying to get to Charlie, so I didn't notice that there was a sting operation; they were going after turnstile jumpers and chain snatchers. I jumped into a sting operation, literally ran into a gauntlet of cops that were there undercover, and they chased me down the stairway. When I saw what was happening I jetted into full warp speed, but I had a cop on my shoulder, holding my shirt. He literally flew off his feet going down the stairs with me and broke his ankle. They finally wrestled me to the ground at the bottom of the stairwell.

Wow. If I had the drawings, I dropped them. They must have fallen onto the tracks. For some reason I wasn't able to run as fast as I could or should have. It might have been because I was carrying the drawings. Maybe the drawings got scattered in the ruckus and ended up in the tunnel.

Lady Pink

I figured, because he never carried a bag of any sort, he was holding the drawing in his right hand, and it must have flown into the subway tracks. So when Charlie and I went to the station and looked into the tunnel, the drawing was there on the tracks. I remember Charlie jumping down and grabbing the illustration. I helped him back up. And even though Lee was sitting in Central Booking, we saved the drawing.

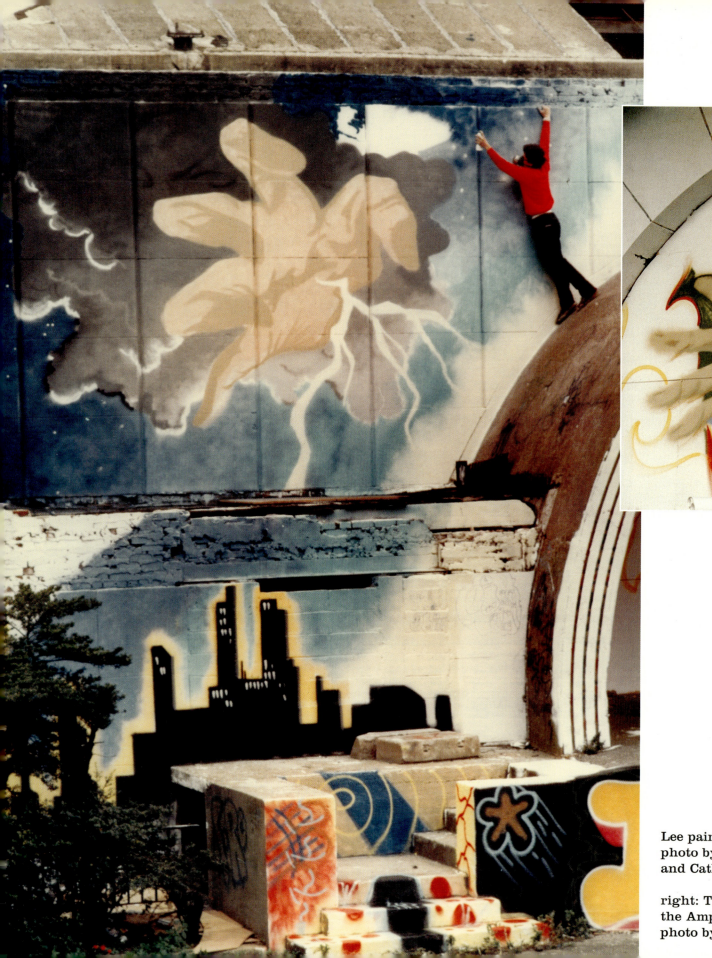

Lee painting the mural,
photo by Martha Cooper (left)
and Cathy Campbell (middle), 1981

right: The Salsa Twins holding
the Amphitheater flyer,
photo by Cathy Campbell, 1981

Painting the Amp

We began shooting the scene with the kids crawling all over the broken roof of the Amphitheater, which still gives me goose bumps. The Salsa Twins came by and played on their conga drums as Lee took out his cans of Krylon and began to paint. The mural took the whole day and we shot the entire process. When I arrived for the big party scene the next day, I was shocked to see that the Zoro mural was gone! It had been painted over during the night and replaced by a big star with lightening bolts. When I asked Lee about it, he just shrugged and said he wasn't happy with the first image so he changed it. But that left me with a big painting scene that went nowhere and a party scene with a big star as the background.

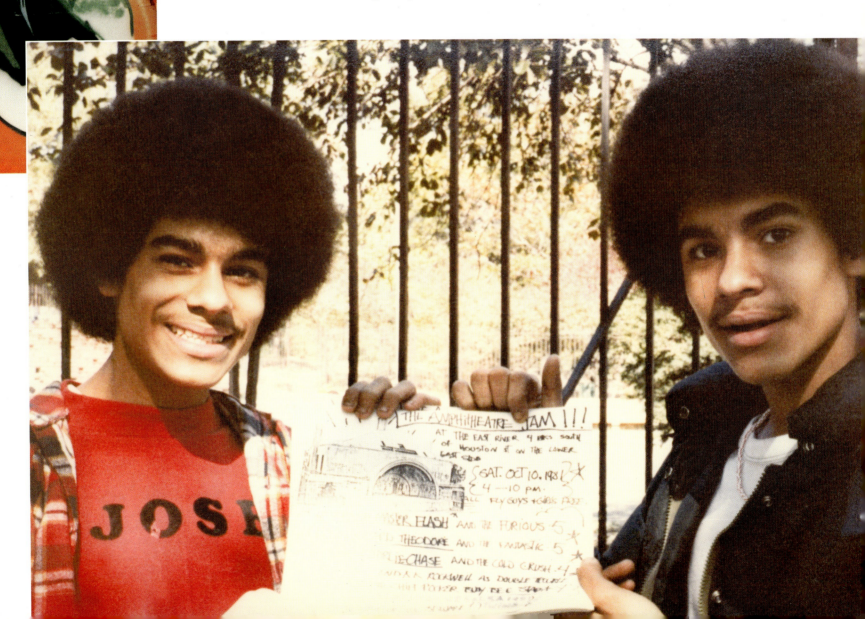

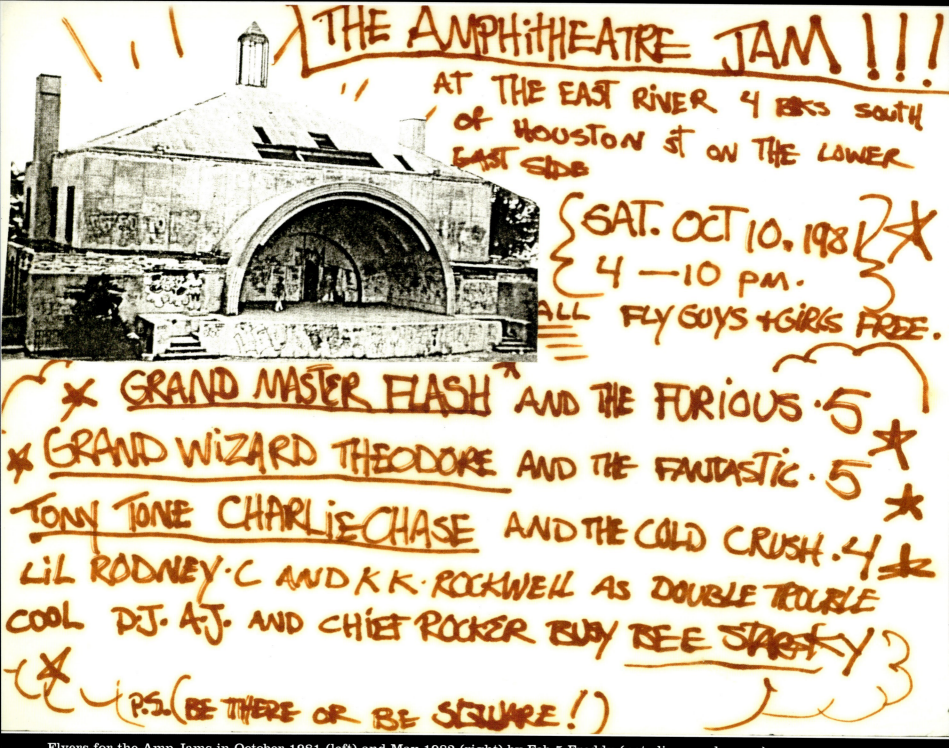

Flyers for the Amp Jams in October 1981 (left) and May 1982 (right) by Fab 5 Freddy (note line-up changes)

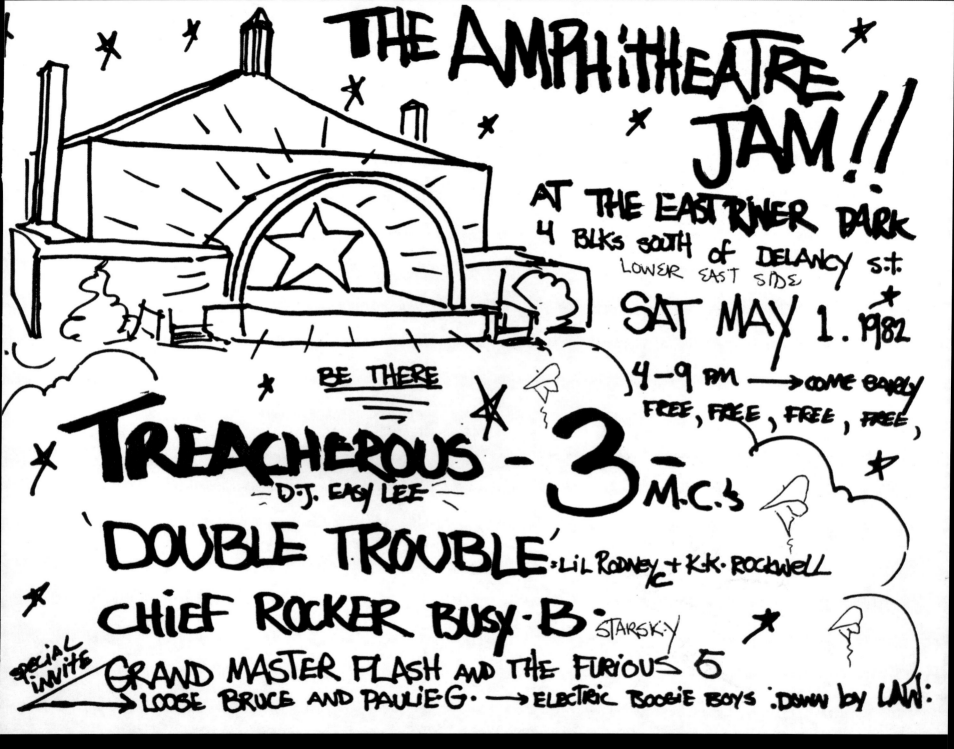

The Amp Jam

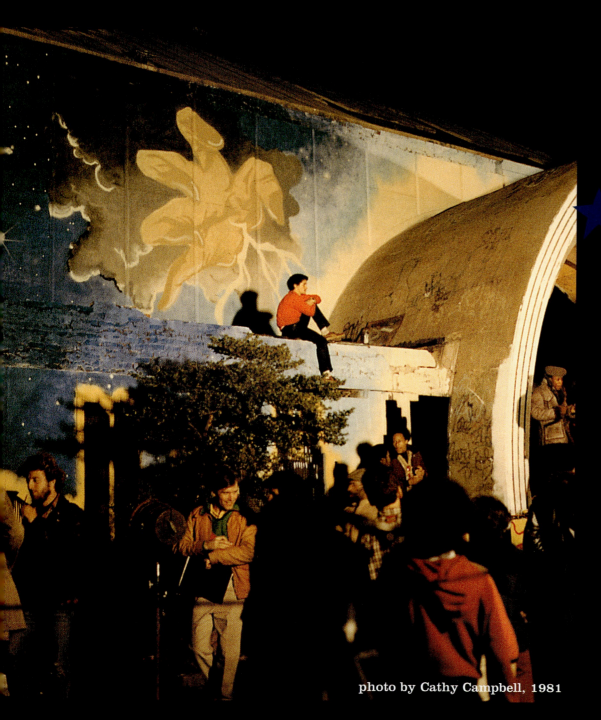

photo by Cathy Campbell, 1981

Lee
All of a sudden it came to me: wait a minute, we are all stars! This Amphitheater was the magnetic force bringing all these different sources and forces, ethnicities and genders together into one huge explosion. That's the way it was in the parks back then—all the way from the Sedgwick section of the Bronx to the Lower East Side. What was happening in the Bronx was happening on the Lower East Side—tapping into a lamppost and bringing music to the masses. The music influenced me to paint trains.

The image of the star and the hands with the lightening bolts were because I was into the Silent Thunderism concept where you could see the lightening but you couldn't hear the thunder—it all happens so quickly.

Despite months of attempts with city bureaucracy, we had no permits for sound amplification, crowds, or filming, so the crew was nervous about the authorities. We had the entire park lit up with movie lights and Tony Tone's speakers were bouncing bass all over Avenue C. My assistant director Colleen Fitzgibbon came rushing over to me during the show to warn me, "The cops are here!" I spotted the idling police car and walked over with my director's clipboard (empty of permits). I gushed into their window, "Thank you, thank you so much for coming out. We've been here for hours and we haven't seen a cop anywhere all night. Could you please help us out and stick around for the rest of the show?" As I made my way back to the stage, I glanced back to see the cop car slowly pulling out of the park. We were free. That was hip hop.

 I remember walking around the site with my gaffer. We silently passed a very large, heavily-locked, electrical feed box and that was it—we had electricity. That night, on October 10th, the *Wild Style* party was on! But the original line up was quite different from what you see in the movie. We had Busy and Double Trouble, but Rock Steady hadn't yet graduated to the stage (they danced in the crowd), and Rammellzee was not there. Instead, the Cold Crush Brothers rocked the show along with the entire Furious Five backed by GrandMaster Flash.

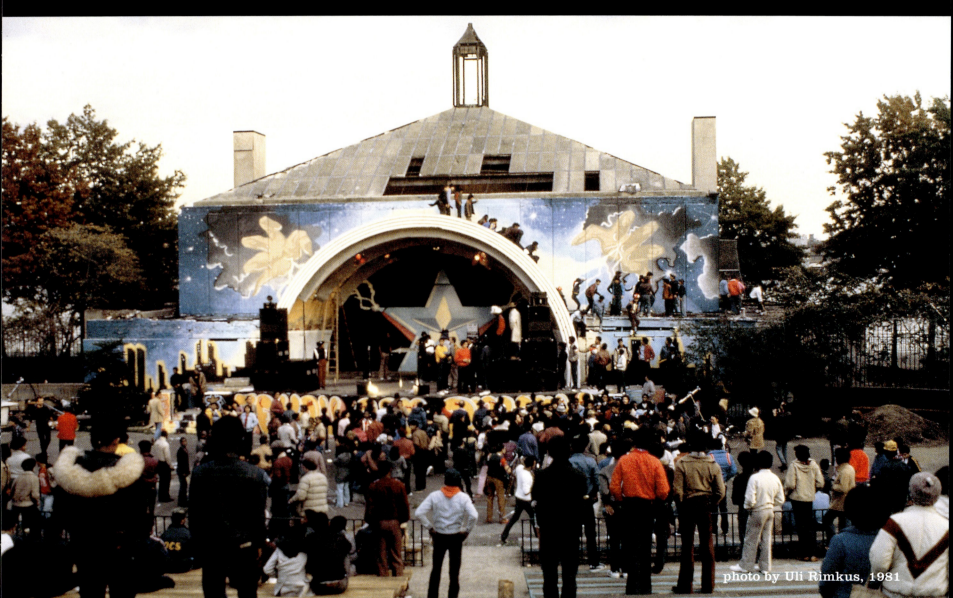

photo by Uli Rimkus, 1981

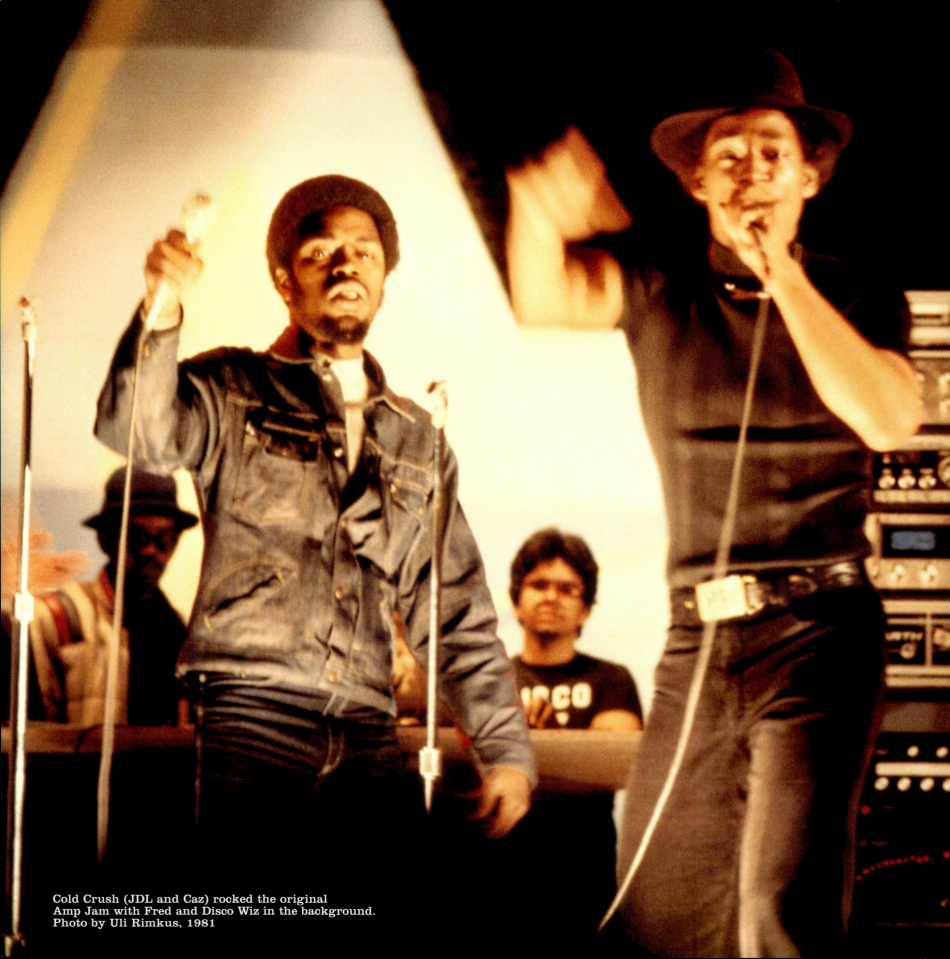

Cold Crush (JDL and Caz) rocked the original
Amp Jam with Fred and Disco Wiz in the background.
Photo by Uli Rimkus, 1981

Grandmaster Caz
The Amphitheater scene was magic and the group and I were very disappointed that they had to reshoot it. We were not able to make the reshoot, which is another thing I would've done differently. Our rivalry with the Fantastic Five was very real and coincided with the movie's production. With us out of that scene, they had a chance to go back, reshoot their performance, and get their shine on.

Biz Markie
The *Wild Style* Amp Jam was the Hip Hop Woodstock. I was there for both of them. I had just got down with the Zulu Nation, so I heard about everything. I was coming out of Long Island at that time. It was so awesome for me to see all my idols there. I was in a cloud and wished I could have been up there on stage with them.

Melle Mel
The Furious Five came out and killed it. The footage from the first jam is like the lost page from the Hip Hop Bible on how to smash a crowd—but was never to be seen by the public at large. But with Cowboy, the Furious, and Flash up there, it was nasty nasty.

How to End the Movie

The film was in big trouble. We spent that winter holed up in our editing room on the ninth floor of the Film Center Building in deep anxiety. My editor Steve Brown (who regretfully was struck down years later from AIDS) was making a heroic attempt to pull the film together before the German sponsors from ZDF came. Adjacent to our room, editor Don Letts with his Jamaican patois and dreadlocks lit up another spliff and worried about how he was going to finish his own film called *The Clash On Broadway*. They were sweating a visit from their producers, who eventually pulled out of the project. But we had our own problems. *Wild Style* was a sprawling three hours long with no ending and the music scenes were crippled by audibly poor sound quality. We had used the Cold Crush's speaker system, which was loud enough for parties, but the sound was over-modulated in recording and not useable for the movie.

When the ZDF representative finally did come to check on the progress of our project, we distracted him with an impromptu location tour in his rental car, with Fred blasting our newly recorded rap scenes from his boombox in the back seat while we made our way through Brooklyn to the yards. Paralleling the scene with Patti, Fred and I led the man through a broken fence and out between the mighty subway cars, warning him not to step on the electrified third rail. Our adventure was complete when someone saw us and we had to run.

For months I lay awake at night worrying over what I should do to save the movie. What was I going to do about my ending? Zoro paints his mural. Then there's a huge party with a different mural. I would lie there muttering possible endings for Zoro such as him leading all the kids out of the city or ending with another chase. Finally my exasperated wife Jane slapped my pillow in the dark and says, "Zoro this, Zoro that, all you think about is Zoro! Nobody cares about Zoro. People are coming to the jam to see the rappers. They're the real stars of this movie!"

Silence.

I grabbed her, gave her a big hug, and said, "That's it! You did it! You did it!"

She said, "What did I say?"

I finally had my ending: in the spring I staged it with Lee and Pink by the waterfront, duplicating the conversation between my wife and I that night.

Reshoots in Spring

When the weather got warm enough it was time to do our reshooting. John Foster, who had worked as a gaffer under Clive, stepped up to be the director of photography. The first thing was to shoot was Lee and Pink along the East River for the new ending. Lee showed up smiling with freshly cropped hair done in the new street style. Another continuity issue. I grabbed his hand and we rushed off to 14th Street to one of the cheap wig shops to cop an afro. But once he was out in the sunlight it was frighteningly big and black, not at all like his original 'fro. After some trimming, Lee strolled out to the waterfront like James Dean, just as a huge ship appeared in the river, perfectly matching Lee's red sweatshirt and black pants. And Pink was just awesome. I was so impressed with her acting, like when she told Lee off in the yards with this hot Latina fire on her luminous moon-like face.

On the morning of the reshoot for the big jam at the Amphitheater, I was riding down St. Nicholas Terrace in Harlem in our bus with the Treacherous Three who were the new headliners. Flash and the Furious had broken up so they were out of the picture, and the Cold Crush Brothers had a prior engagement. Special K of the Treacherous Three (who I respect greatly as an MC) stopped the bus and jumped out, telling us that he had to speak with his lady and would meet us later that evening. During the Amp Jam we saw no sign of Special K, so I told his group that they could perform but we would not film the "Treacherous Two." Busy Bee shocked us all with his "clap the hell out of that man that killed all those children down in Atlanta!" Double Trouble came back like a dream in their white gangster suits while Rammellzee tore up the show with the Rock Steady Crew.

I was crouching along the back trying keep control of the crew and stage action. I would roll off a C note as each performer finished his act. But things didn't go according to plan. All the DJs were told to play only our break beats record but D.St. was cutting up a classic, well-known beat. Kool Moe Dee of the Treacherous Three, who must have been pissed watching from the sidelines as all the other MCs rocked, just grabbed a mic and started pogo-ing across the stage yelling, "Jump! Jump! Jump!" Then everybody on the sides grabbed a mic and the whole stage was jumping as one. It was pure hip hop.

The stage gloriously flew out of control creating everybody's favorite moment in the movie. Then, as if on cue, people began exiting the Amphitheater as LA Sunshine (from the Treacherous Three) thanked them all for coming. It was the perfect ending. After 25 years, I am still seeing new weird stuff in it: who are those guys in top hats and tuxedos waving to the camera?

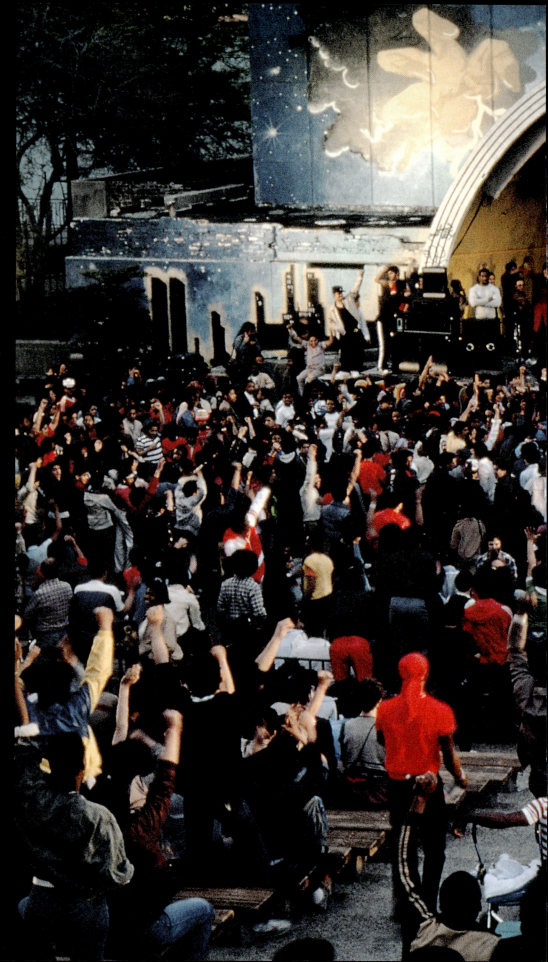

Frosty Freeze
I wasn't sure how I was going to perform 'cause I was in a fight the day before and I was still hurt. I was nervous but once I started to move, the crowd was cheering. I did my Suicide move and it was really good.

Busy Bee
The Amphitheater was one of my favorite spots in hip hop, because when we first saw it, it was a piece of trash. They didn't want to have nothing to do with it. We told them that the Amphitheater was beautiful and we put it together. Oh my god, it was a masterpiece.

 I didn't know what I was going to do before I went on stage. OK, I did know, but I changed my mind because there was a tragedy: a man was killing little kids in Atlanta, GA. It bothered me a whole lot. That night, I asked everybody to act like we caught the man, like he was in your right hand, then smack the hell out of him. And that made a groove until we start going "da da de de de de da da—clap your hands, come on!" A lot of my friends today used that; my friends Jurassic 5 (Chalie Tuna and the crew) and I had fun doing a couple of shows with it.

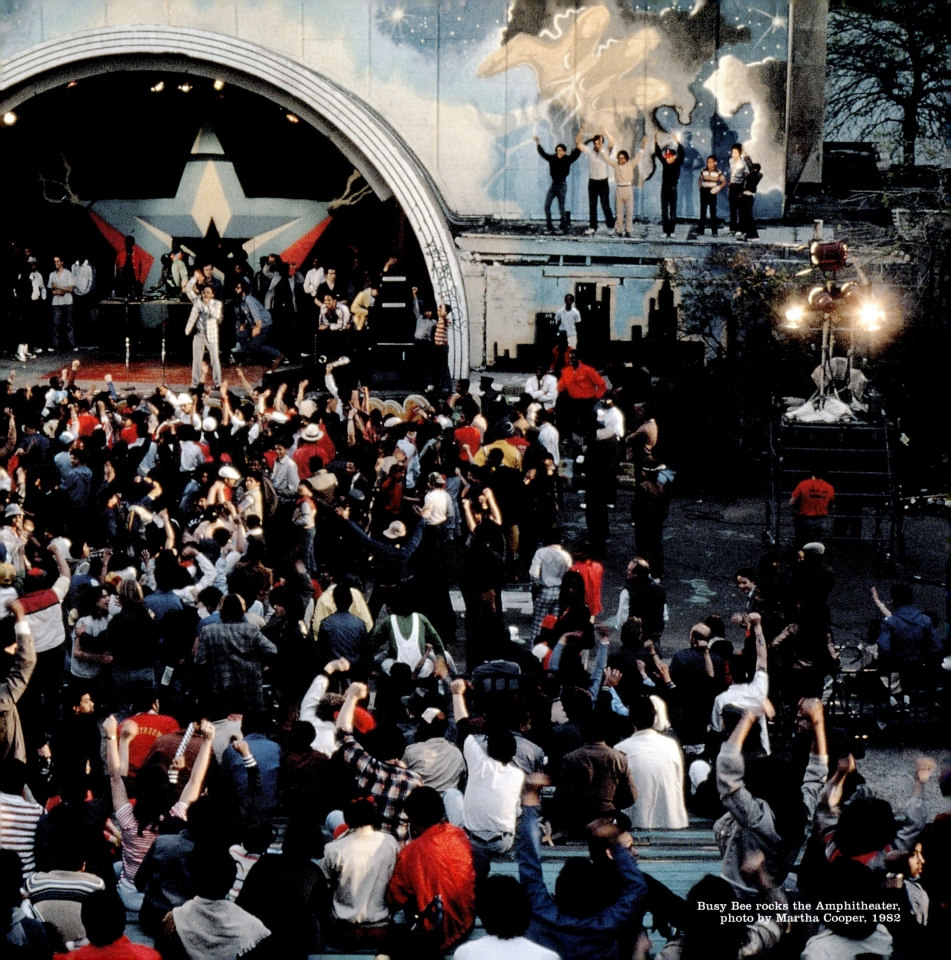
Busy Bee rocks the Amphitheater, photo by Martha Cooper, 1982

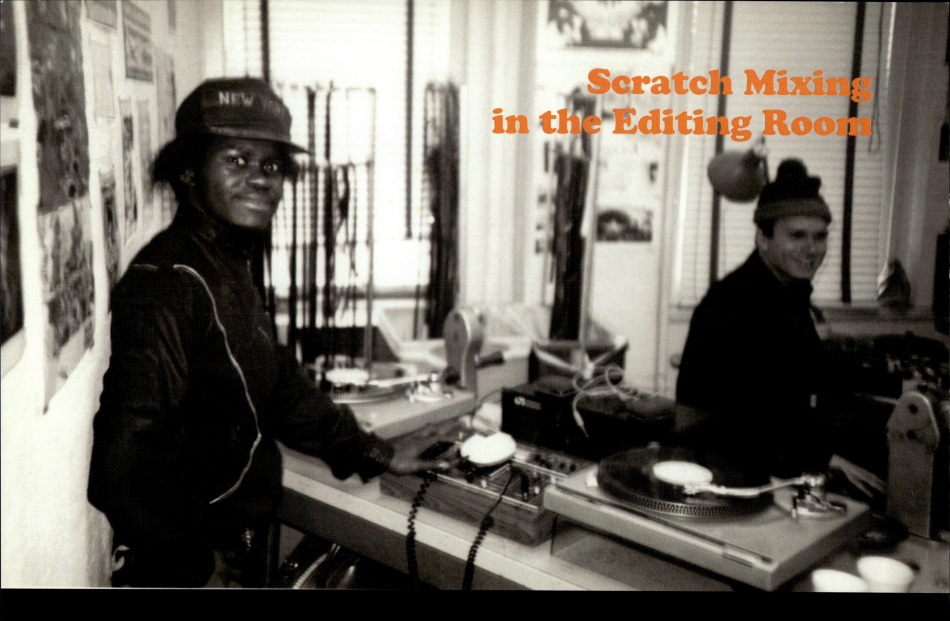

Scratch Mixing in the Editing Room

Grand Wizzard Theodore, the scratch inventor, along with DJ Kevie Kev Rockwell, brought a set of turntables over to our editing room for an experimental session to create a new kind of movie soundtrack. We would play him a scene on the flatbed; Theodore would scratch mix the break beats to juggle the rhythm and scratch the sound to underscore the action. The "Military Cut" and "Gangbusters" are some of the pieces that made it into the soundtrack.

Grand Wizzard Theodore aka Scratchadamus

I am lucky to be a part of something that's bigger than I am. I am proud to be the the first person to score a movie by sitting in front of a small editing screen with two turntables, scratching one scene after another, and creating the score for this historic story about the foundation of hip hop and the real people who made it what it is today.

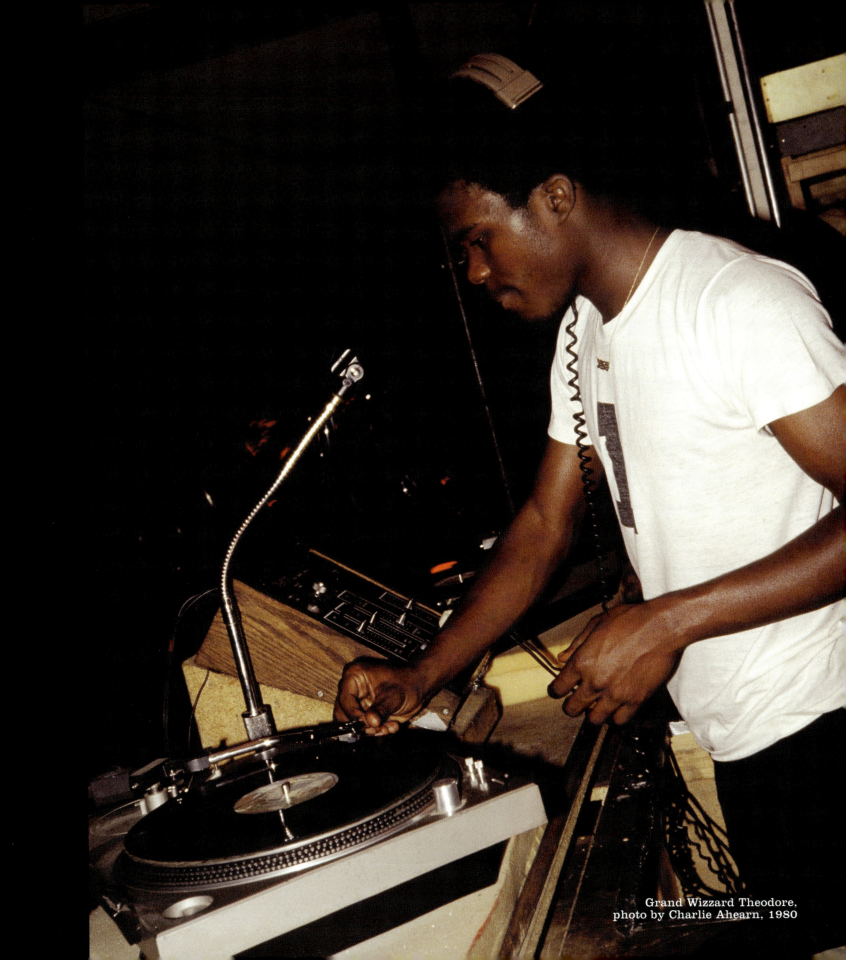

Grand Wizzard Theodore,
photo by Charlie Ahearn, 1980

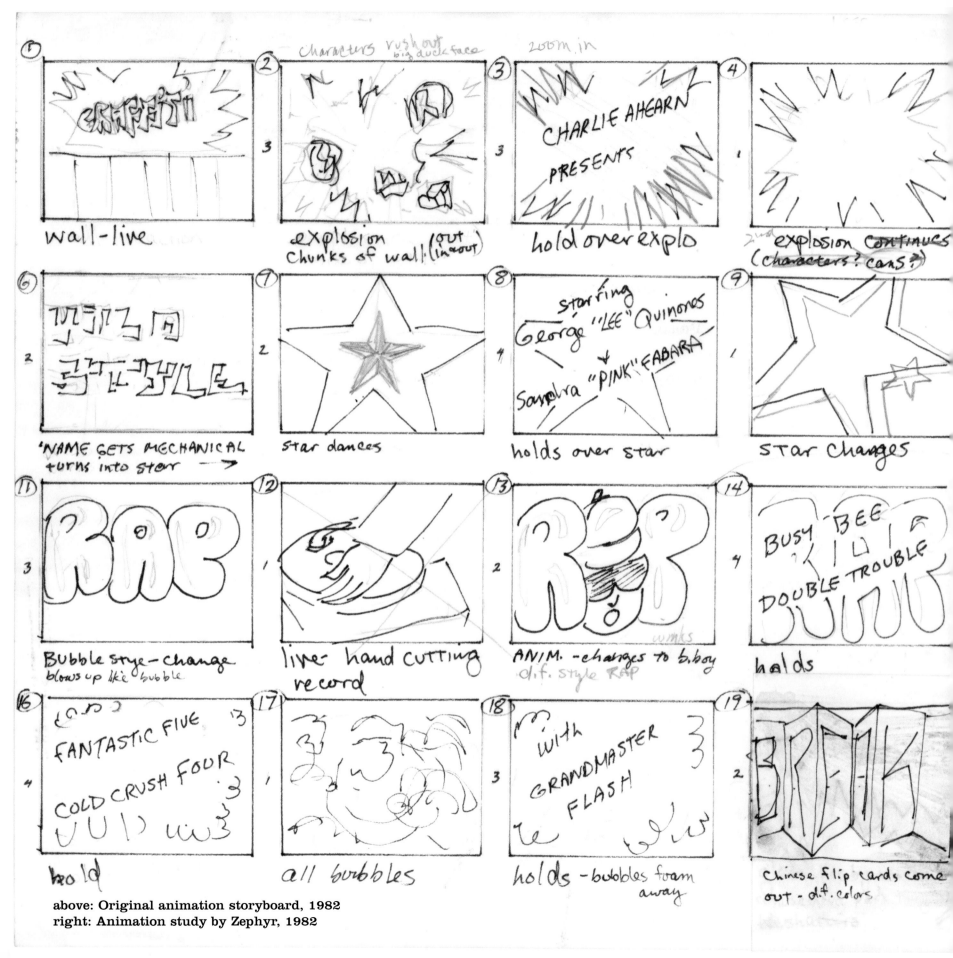

above: Original animation storyboard, 1982
right: Animation study by Zephyr, 1982

The Animation

The title animation began during the summer of 1982 in our Times Square office. In the movie Zephyr played Zroc who was, like most of the characters, a thinly disguised version of his role on the scene. His writing and design work was the best around so I asked him to create some graphics that would look like a writer's black book come to life. Zephyr brought in his partner in crime, Revolt, who was also and amazing artist with pen and ink.

Revolt

I worked on the animation with Joey Ahlbum (an SVA animation "wonderkindala" hired by Charlie to direct the credit sequences), the lovely Becky High, and Zeph. There was electricity in the air; we were rocking to WBLS on the radio and old James Brown on the turntable. We were working from a loose storyboard drawn by Jane Dickson. Z was penciling the letterforms and the in-betweens for the movement. I was doing the inks and color designs. Most of the art was done on paper and colored with markers; there was a lot of X-acto knife work. We didn't use a copier back then, so when we fucked up on a finish frame, we had to do it all over again. Pain in the ass! But that's old school....

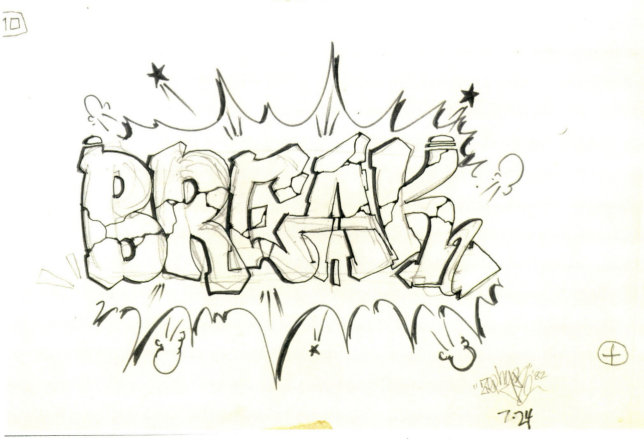

Zephyr

Charlie described his idea for the animation sequence to me as his "wanting to bring black books to life." Like many folks back then, he was dazzled by our "black books"—bound sketchbooks that we'd fill with "pieces," or "styles," that we'd execute with thin black Flair pens and colored alcohol markers; Design markers were our favorite. We'd draw our best ideas in those books, and during that era, every writer worth his salt had a black book under his arm always—except when we'd circulate them amongst ourselves. When you had someone else's book in your possession, you'd try to draw the best piece possible, attempting to "burn" all the other pieces in the book. Just like we'd attempt to do with our spray cans in the train yards every weekend.

I did all the drawings for the *Wild Style* animation sequence on paper; no cels (clear acetate pages) were used. And to really obtain the black book feeling that Charlie envisioned, I did all the drawings with Flairs and Design markers.

When Charlie first came to me with the idea, I knew little about how animation was done. So we went over to the School of Visual Arts animation department and recruited their best animation student—a shy, soft-spoken genius named Joey Ahlbum. Under his guidance, and with the assistance of Revolt and a lovely woman named Becky High, we cranked out the sequence, which required over 1,000 final drawings—12 per second for 90 seconds of running time.

Charlie was nothing short of a visionary madman when he made the film *Wild Style*. And while during production none of us were quite certain what his vision was, his enthusiasm was so infectious, and he was able to get people to do things that fell outside the realm of plausibility. *Wild Style* is quintessential guerrilla/shoestring/bumrush the spot/"by any means necessary" filmmaking. And while the creation of the animation sequences may have been less spontaneous than some of the other aspects of the film's production, it was equally unconventional, eccentric, and simply bizarre.

Becky, Joey, and Revolt and I spent an entire summer—five days a week, Monday through Friday—holed up in Charlie's mouse-friendly loft in the heart of Times Square. There, we'd turn out the work that helped serve as the visual pacesetter for the film. Just why, with so little monetary compensation available, we committed ourselves so fully to the rigors of creating the animation, is a story in itself. The fact is that all four of us were very aware that we were part of something strange and extraordinary. And although we had no sense of what the final film would be (or even if there would be a final film), we knew that we were part of something grand.

Charlie had an incredible gift for getting people to trust him. And it was often painful to watch him struggle to get his vision onto the big screen—you just wanted to help. The making of *Wild Style* was one wild, once-in-a lifetime ride. What an amazing thing to have been a part of it. I still pinch myself. Did it really happen? Did we really pull it off? I'm so grateful and proud to have been a part of it.

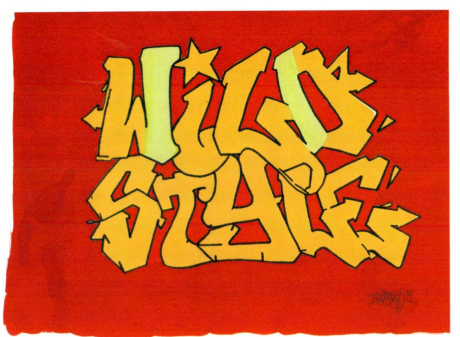
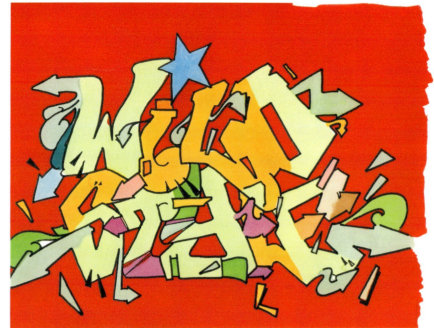
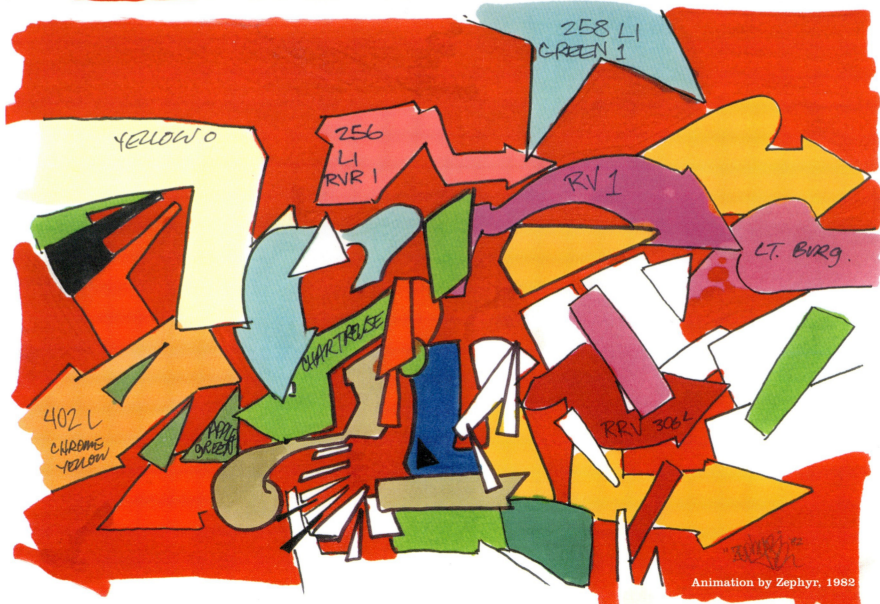

Animation by Zephyr, 1982

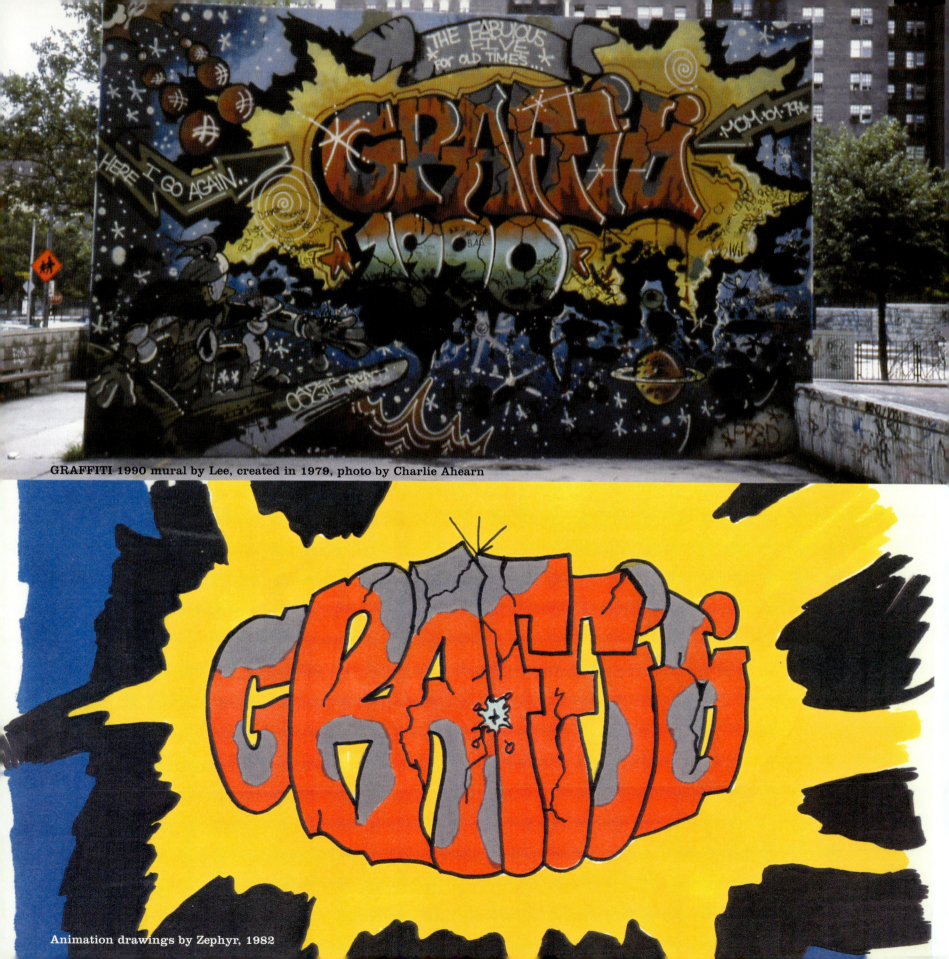

GRAFFITI 1990 mural by Lee, created in 1979, photo by Charlie Ahearn

Animation drawings by Zephyr, 1982

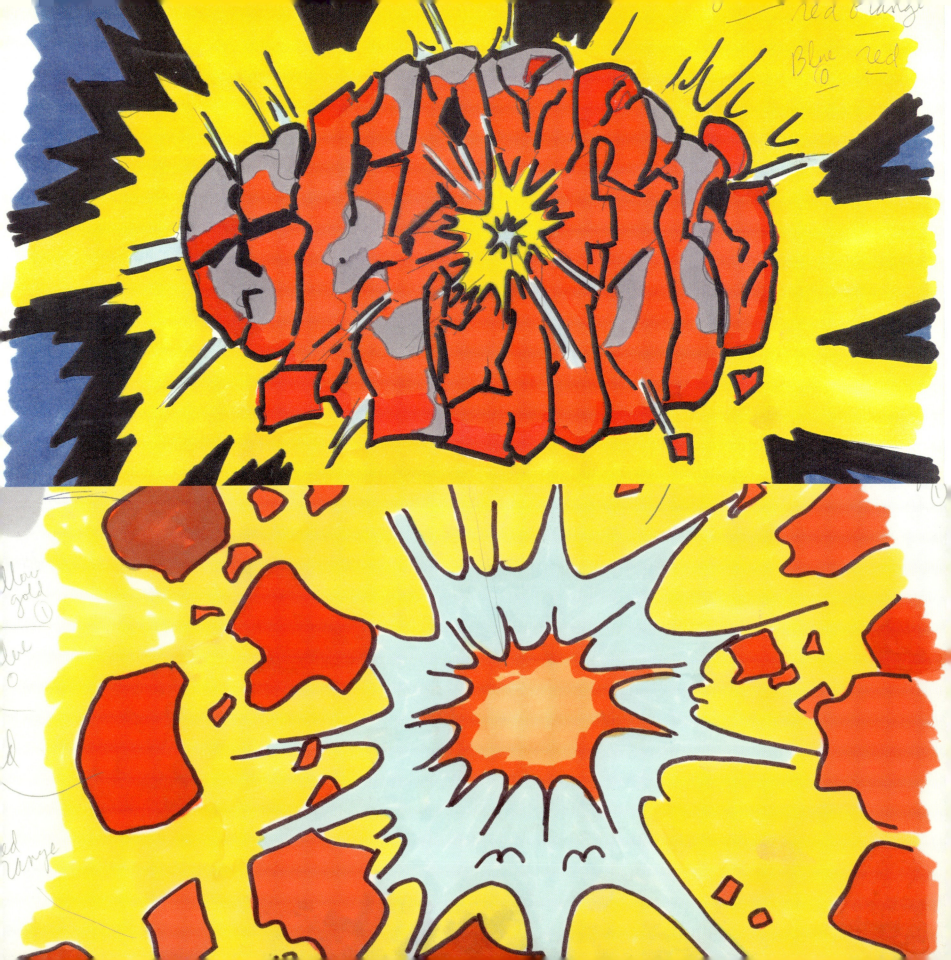

left: Animation study by Revolt 1982
right: Animation drawing by Zephyr 1982

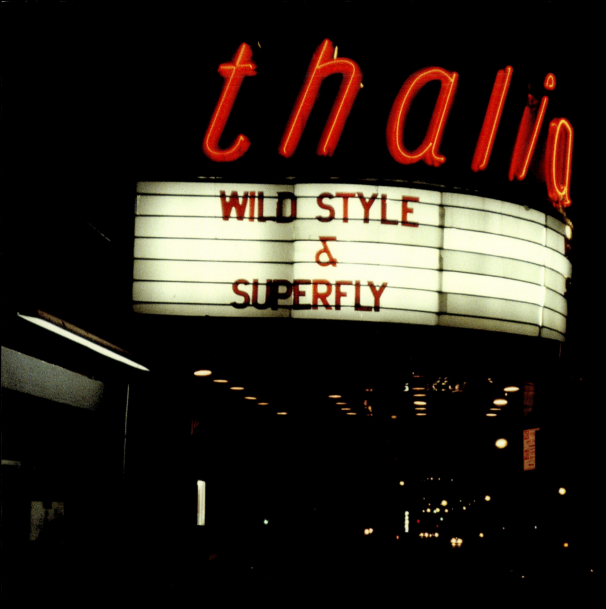

Thalia movie theater, New York,
photo by Charlie Ahearn

Part 3

The Release

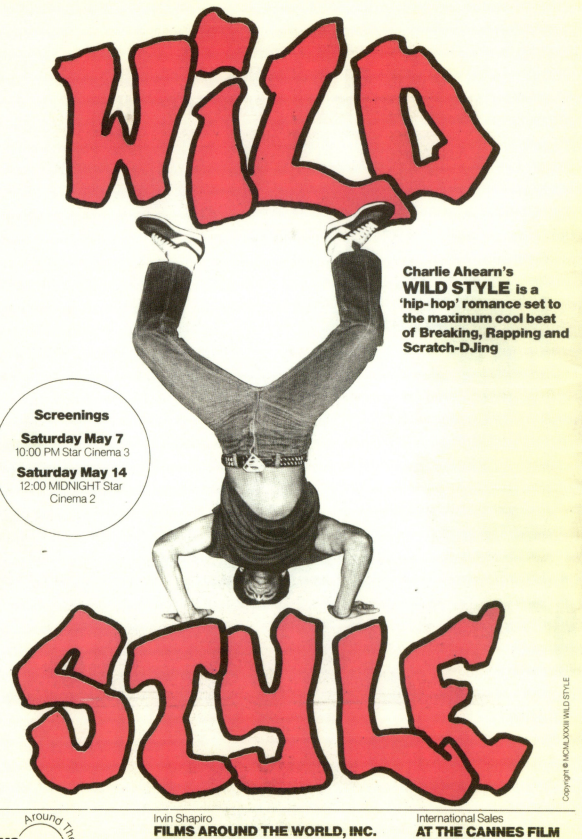

Advertisement for *Wild Style* screening at Cannes Film Festival, 1983

How the Movie Got Sold

The hardest part of making an independent film is getting it out into the world. By fall 1982 *Wild Style* was completed but had no distributor. I remember doing the final sound mix with editor Steve Brown and then carrying the freshly printed, unseen 16mm answer print across town from Duart Lab to a screening for the Fledgling Independent Film Market. This was years before Spike Lee or Sundance, and theatrical releases of independent movies were rare. There were nibbles from New Line Cinema and interest from First Run Features, a tiny company that mostly distributed 16mm progressive documentaries, but we sat out the rest of the year with no real offers on the table.

In 1983 I screened *Wild Style* for Irvin Shapiro at Films Around The World. He was this ancient, doddering character who knew the business and had a rep for taking chances with young directors. Irvin had just picked up an indie horror movie called *Evil Dead* and he made plans to bring both *Evil Dead* and *Wild Style* to the Cannes Film Festival that May.

After screening a fresh 35mm blowup to a packed theater off the Croisette (where all the red carpet events take place in Cannes), I was approached by Kaz and Fran Kuzui who had exciting ideas of bringing the movie and the whole damn *Wild Style* crew to Japan that fall.

The advertisement on the left was on the back cover of the Cannes Film Festival magazine. I remember seeing thousands of passersby holding this image while walking down the Croisette. The title "Wild Style" was just a frame from the animation. We had not yet made the final mural which became the movie's logo.

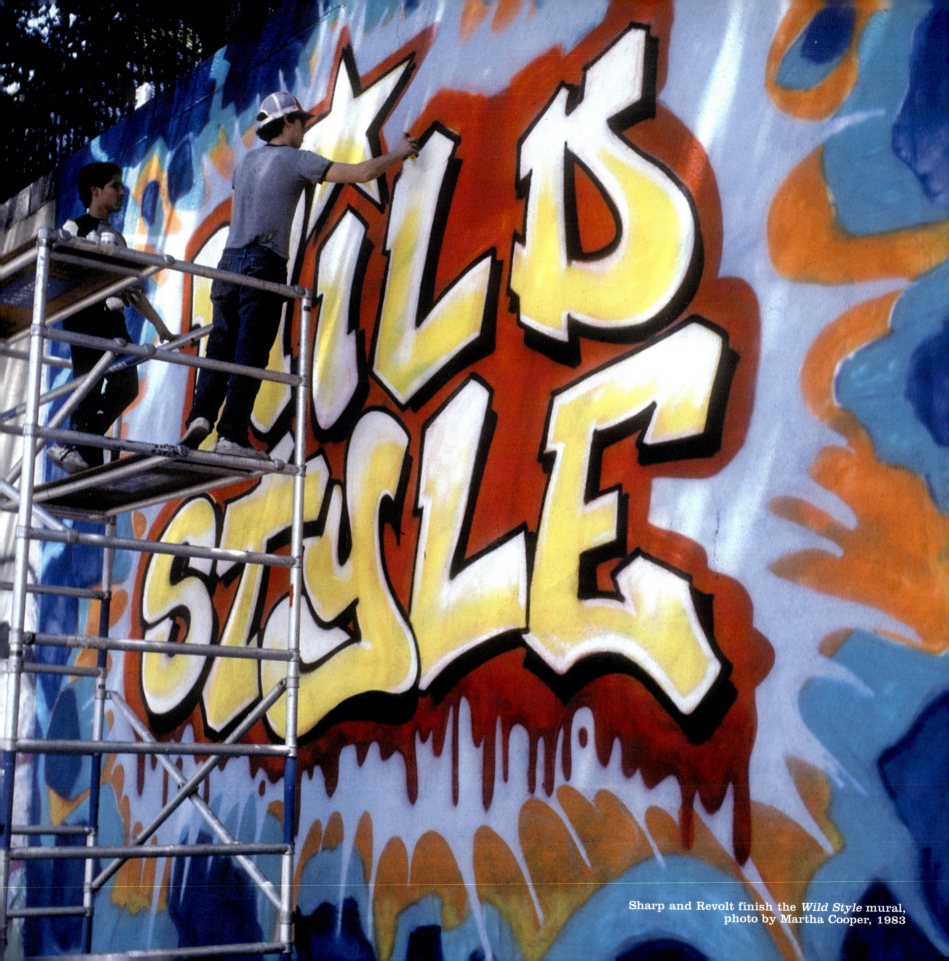

Sharp and Revolt finish the *Wild Style* mural, photo by Martha Cooper, 1983

The Wild Style Mural

During the launch of the film, we were toying with poster ideas. It seemed crucial to go back to the roots and create a real street piece that could represent the movie in a single image. We shifted through the animation and Zeph came up with a solid, readable "Wild Style" while Revolt kicked in some flashing, exploding wall flavor. We never bothered with permits; we just brought the scaffold to a huge wall along the West Side Highway where Zeph, Revolt, and their friend in crime, Sharp busted it out in the dark. Police cars cruised by but no one stopped. Marty Cooper, who had been shooting during the movie, came by to record the event as Patti, Fred, and Pink (where was Lee?) posed with Rock Steady royalty Frosty Freeze, Ken Swift, and Doze Green.

Sharp

As the night descended on Riverside Park, Zephyr, Revolt, and I, along with Charlie and Fab 5 Freddy went to the spot to paint the mural. Zephyr had spent the last few days fine-tuning the design and there were discussions about colors. Now was the moment. We took turns rolling out the wall as the night was falling and few were in the park. We assembled the scaffold and Zephyr sketched the outline, while Revolt and I kept an eye out for the cops as he painted.

A police car approached from a distance and, even though we had no permission, they never left the car. They eventually rolled off. As dawn was upon us and the wall was almost finished, Revolt and Ahearn decided it was time for victuals and libations. Martha Cooper arrived to take some photos of the semi-completed wall. I decided to roll the scaffold over to bust out a quick silver-and-black joint. Revolt returned with Ahearn and we finished the wall at about 9:00 AM. Ken, Frosty, Doze, Little Crazy Legs, Patti A, and Lady Pink showed up and we posed for the pictures. History was made.

Martha Cooper

The *Wild Style* mural shoot in Riverside Park was low-key and unplanned. Charlie called a day or so before and told me that some kids were going to be painting a mural in the park very near where I lived, and that it would be great if I could shoot it. I walked down to the park with a minimal amount of camera gear and took photos. I shot some stuff for me, and some for the movie. I did not foresee the very extensive and on-going use of the photos over the years. I didn't have a clue how *Wild Style* would turn out. Who knew??

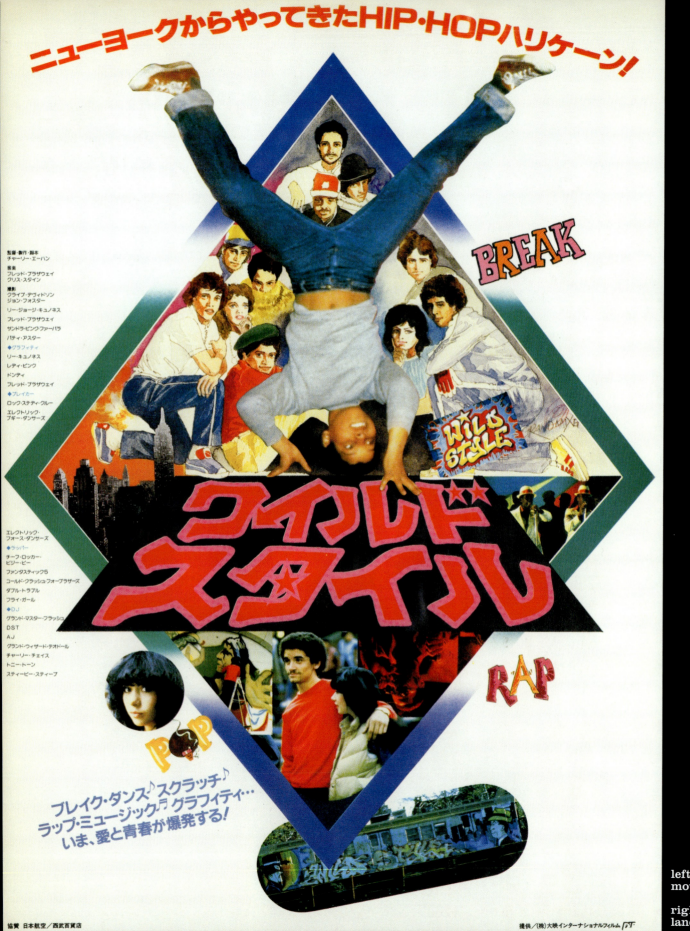

left: Japanese *Wild Style* movie poster, 1983

right: Futura and Dondi landing in Tokyo, 1983

Tokyo Rocks

Is it surprising that the world premiere was in Japan? Fran and Kaz Kuzui, who later brought us *Buffy The Vampire Slayer*, convinced Daiai, the distributor of Kurosawa movies, to bring this unknown independent movie to Japanese screens (months before it opened in New York) in the fall of 1983. Kaz was ready to do anything. A *Wild Style* book? He made two, crammed with Japanese characters and every hip-hop image he could get his hands on, all in a space of a few weeks. The Japanese tour rapidly expanded to include damn near everyone in the movie, somewhere around 36 people, including the Cold Crush, Rock Steady, Double Trouble, Busy Bee, D.St., Fred, Patti, Dondi, Zephyr, Futura, DJ Afrika Islam, Kool Lady Ruza Blue (with Rock Steady), my wife Jane, and yours truly. We came to shock, but the shock ran both ways. The white bus that pulled up on the runway to take us into Tokyo was instantly bombed with spray paint generously provided to us by the distribution company. The densely neon-lit Tokyo streets, emblazoned with Japanese characters, seemed supremely futuristic and alien to all of us—as if we were entering the metropolis from *Blade Runner*.

Busy Bee

When I got there it was amazing! I have fans in Tokyo! And you know where I come from—the Bronx. Oh my god, when I got off the plane, they said, "Busy Bee, we love you!" Yo, I've been doing this hip hop for a while. Hip hop has been doing me fine. I've got friends all across the world. Japan, Holland, France.

Crazy Legs, Busy Bee, Pink, and Japanese kids

One of the many culture clashes occurred when Fran brought our South Bronx crews out to Yoyogi Park near the trendy Harajuku section, where hundreds of Takenoko teens in 1950s rock-and-roll costumes danced in circles around their boomboxes. Rodney Cee, seeing the black leather jackets and greased back hairdos, thought maybe there was going to be trouble. Busy Bee, who had adopted his "Ayatollah of Rap" look was giving the White Fairies his "how ya like me now?" pose. We snaked through the park drawing a curious following until we made our own circle. Rock Steady began to do windmills into head spins and put those Takenoko kids in deep check. After four days, the Japanese were already picking up skills such as DJ scratching in the clubs, faster than Busy Bee could shout, "*Wa ta shi wa Tokyo ga ski* (I love Tokyo)."

 During the second week of the Japanese tour, we traveled by bullet train past Mount Fuji to the city of Osaka, which had a rep as a tough Yakusa town. After the first *Wild Style* event

Busy Bee, Fred, and DJ Stevie Steve with Tokyo rockers, photos by Charlie Ahearn, 1983

in one of the local clubs where the Japanese girls seemed very friendly, we settled back into our hotel. In the middle of the night I heard a pounding in the next room where Fred and Kay Gee from the Cold Crush were staying. There was some yelling and crashing. I slipped on my hotel kimono robe and padded barefoot down the empty hall. I came around the corner and encountered two (I swear this is true) guys dressed in black pajamas looking like movie ninjas with their black headwraps. They moved towards me, they flipped out their spring-action flexible metal clubs and whipped them in my face as they grunted in Japanese. I felt like Bob Hope in one of his "Road" movies, and all I could do was shrug my shoulders to say, "Hey, I don't speak Japanese." As soon as they backed away and disappeared around the corner, all the doors down the hall instantly cracked open and faces of Rock Steady peered out. They all began rolling in the hall laughing. Perhaps those girls in their hotel rooms were professionals and the Yakusa were not happy. We never found out.

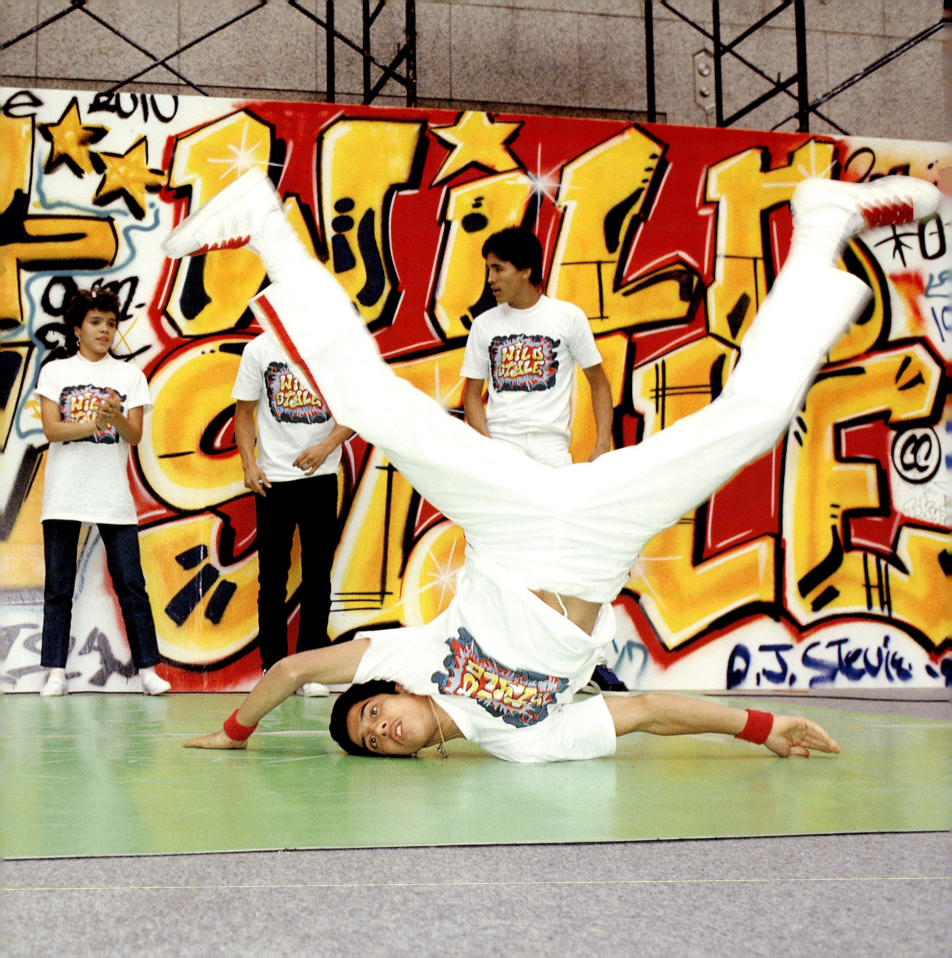

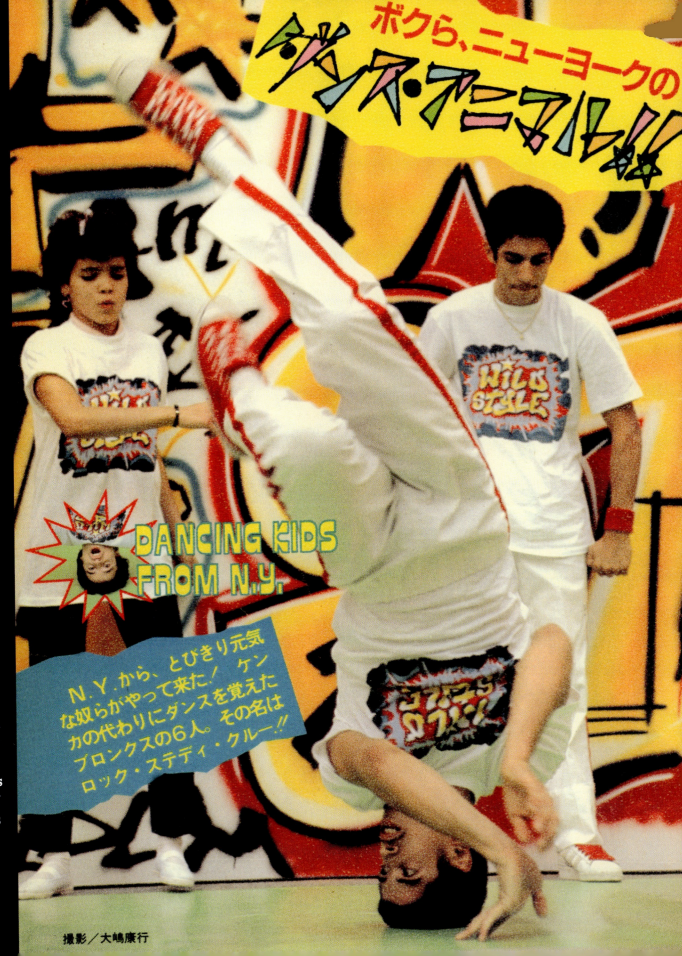

Since most of them were still minors, an evolving Rock Steady Crew, including Crazy Legs, Ken Swift, Doze Green, a new female member Baby Love, Buck Four, and Kuriaki, came on the Japanese tour with their manager Kool Lady Blue, who had spear headed hip-hop nights at the Roxy in New York. Only moments after we hit Tokyo, there was a huge publicity event held in an open plaza. Soon enough pictures were turning up in Tokyo teen magazines featuring members of the *Wild Style* tour as the new rock stars of the 80s.

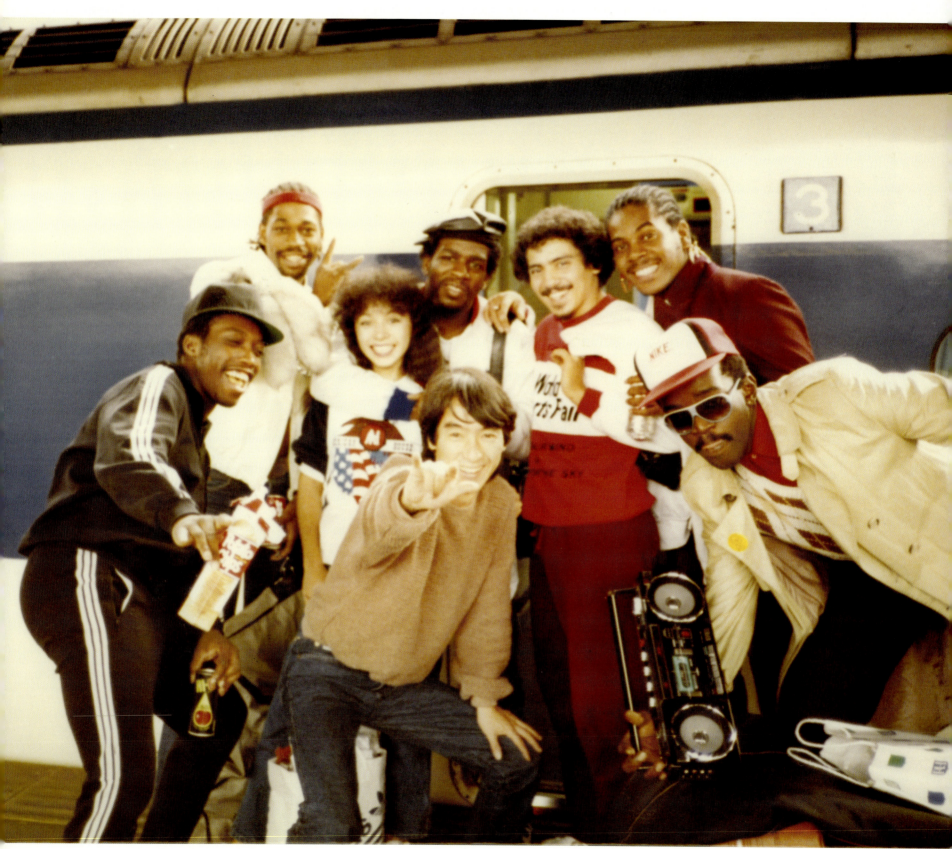
Kaz Kuzui with Pink, Fred, and the Cold Crush on a Tokyo subway platform, 1983

Lee

The film has come full circle in many ways. I've met all kinds of people who say, "That film changed my life." DJ Krush, world-renown DJ from Japan, told me through his translator, "Yo, Lee, if it wasn't for that film, you, and that character, I wouldn't be who I am today. The theory of the Samurai, to practice in darkness and in solitude, and then to come out busting ass—that film made it clear for me."

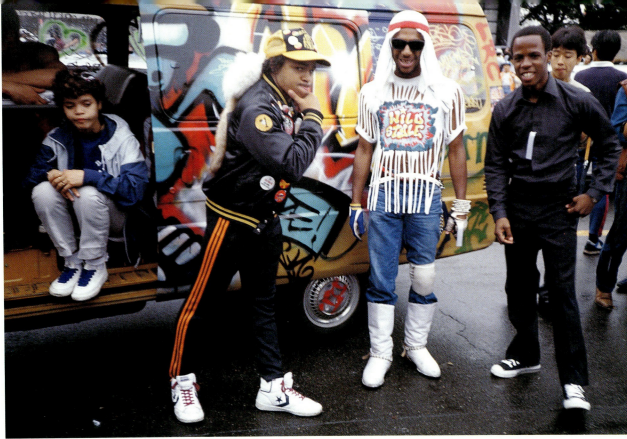

Wild Style tour bus with Baby Love, DJ Afrika Islam, Busy Bee, and KK Rockwell, photos by Charlie Ahearn, 1983

DJ Krush

Back in those days, I was probably hiding myself by wearing the armor of violence and evil. It was not conscious, but I wrapped myself in something radical and fronted. Maybe I was too young. I had a hard time finding something real, something I instinctively knew was "It."

All the things I did seem like something that my true self would frown on. I knew that I was living my life with ambivalence. For several years, I wasn't able to find things that I could truly devote myself to, but I continued to strut along Shinjuku and live a risky life.

It was at this time when I first saw *Wild Style* and discovered what I really wanted to do. From my childhood days, music was always my love. *Wild Style* made me want to express myself again through music. I chose to become a DJ. I chose music. If it had not been for this film, my life would have became very strange.

Many years have passed, and hip hop is now all over the world. It has crossed borders and inspired young kids with its innovative forms of expressions. *Wild Style* was there at the beginning, and like everybody else, I was struck by it. I still am—as a DJ flying around the world, devastated by music on a daily basis, and dedicating myself to music with sensation I am grateful for hip hop and *Wild Style* for showing me the path of life. If this film never existed, my life would be totally different. I will always remember it as the turning point in my life.

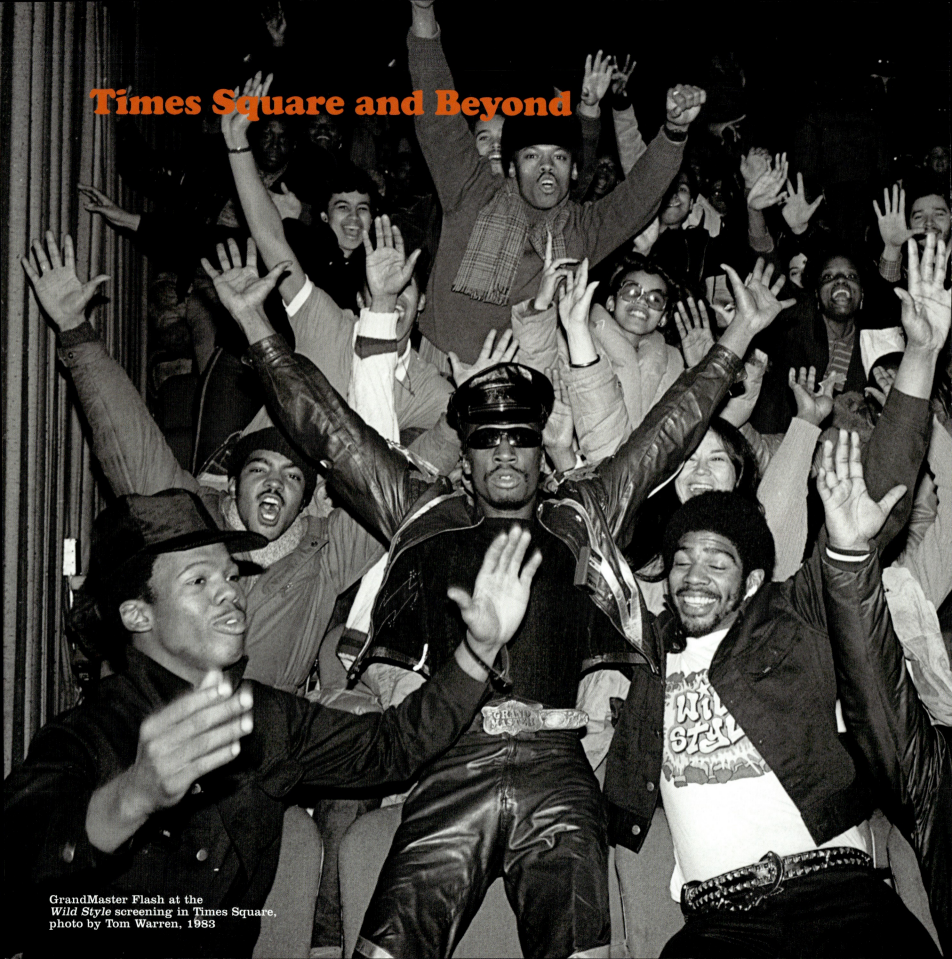

GrandMaster Flash at the *Wild Style* screening in Times Square, photo by Tom Warren, 1983

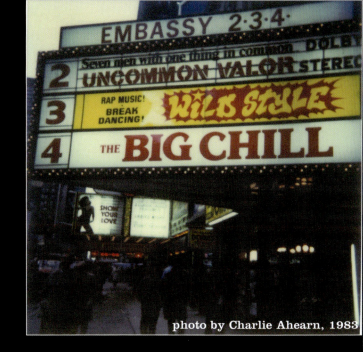

photo by Charlie Ahearn, 1983

When *Wild Style* opened in Times Square in November 1983, we had almost no promotional budget, but we had learned some lessons from Bronx rap promoters like DJ AJ. Kids came down from four boroughs to the First Run Features office to collect sacks of handbill flyers to pass out in front of their high schools on Friday afternoon.

The line at the theater, located on 47th Street and Broadway, ran around the block several weekends in a row, forcing them to put the movie on double screens. It broke all house records for attendance and was the second-largest gross in New York City (next to *Terms Of Endearment*).

A non-stop party inside the theater. People just wouldn't leave. Recognizing the hip-hop stars on the screen for the first time, kids were making a lot of noise. Others made a little cash selling reefer in the back rows. Kids were tearing shit up, literally. I got midnight threats from the theater owners, telling me that their seats were busted, that the rest rooms had been vandalized floor to ceiling, and that I was going to be personally held responsible because someone had broken the glass in the front of the theater to make off with a *Wild Style* poster.

The response in cities varied wildly. Philadelphia, where graffiti culture began back in the late 1960s, embraced the movie like cousins. Philly's then-Mayor Phillip Goode, who later had a hand in firebombing whole city blocks, saw the film as a threat and tried to squash it. But it ran there for months.

Chicago opened on the coldest Super Bowl Sunday in history. They were able to count tickets sold there on one hand. That city later kept hip hop alive with its underground DJ culture through the darkest days of the late 1980s.

Lee

"Zoro! Yo!" My first experience of it: The film was playing on 47th Street and Broadway. I came around the corner on my yellow Super Sport Nova and there was a line around the block. I was like, "Holy Shit!" It was mayhem. People were looking and some heads caught a glimpse of me. They yelled, "Zoro!" and I was like "Whoa!" I tore out of there sideways, burning rubber.

There it was, all of a sudden. It was like my character had been recognized after all these years. I was vividly in the limelight. It was so overwhelming for me at that time….

I met Mos Def for the first time on the street just the other day. He turned around and yelled, "Wild Style!" Over the years it has morphed from "Zoro, Zoro, Zoro," to "Oh, who's that guy?" and "Yo, I seen your face before."

Fred

At one of the first screenings in Times Square, I slipped in, I sat down, and watched the movie unseen by the audience. I had the biggest shock! People laughed so hard at so many of my scenes. I thought, but I wasn't trying to be funny. I wasn't trying to get laughs. I was trying to be cool. I was trying to be that guy I think is cool on the scene, but people laughed, and I didn't know how to take it. I would be like, "Scoobie Doo! Watch out for the third rail, baby, that shit is high voltage." People would crack up when I would say that stuff and I would think, man, are they laughing at me because I'm wack, or because I'm funny?

Lady Pink

If I recall, when the movie was first released, it played for eleven weeks on Broadway. That was pretty unprecedented. It was awesome. It inspired me to keep doing what I was doing. It was not some fluke, a momentary fad; I could do something with it.

I remember bringing my parents to see the film on Broadway. That was also the first time I saw it. Oh the language! Oh my god! I had no idea that I spoke like a little truck driver! I don't speak like that in front of my mother; she saw it on the big screen and was horrified! My parents don't speak any English, and the only word that they understood was "fuck," and there's "fuck this, fuck that," throughout the movie. Eventually I came to like it. Then I broke up with Lee and didn't want anything to do with him. I couldn't bear to see it. It was too heartbreaking.

Frosty Freeze

Before going to the after party at Danceteria following the movie premiere, we walked out of there saying, "D.St. is the ultimate." Even Theodore was like, "Whoa!" D.St. was way ahead of his time; this was before he did "Rockit" with Herbie Hancock.

Biz Markie

When it first came, out I saw it on 47th Street and Broadway which was right next to the Latin Quarter. The scene that really bugged me out was Flash in his kitchen on three turntables with Fab 5 sitting there. Flash was spinning, "watch out for the closing doors." I always wondered what else they shot that day.

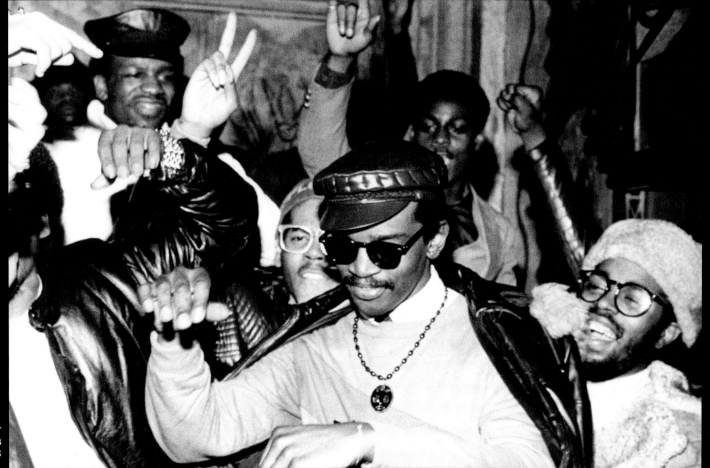

Tony Tone, AD, Fred, Rodney Cee, and JDL, after the Times Square premiere, 1983

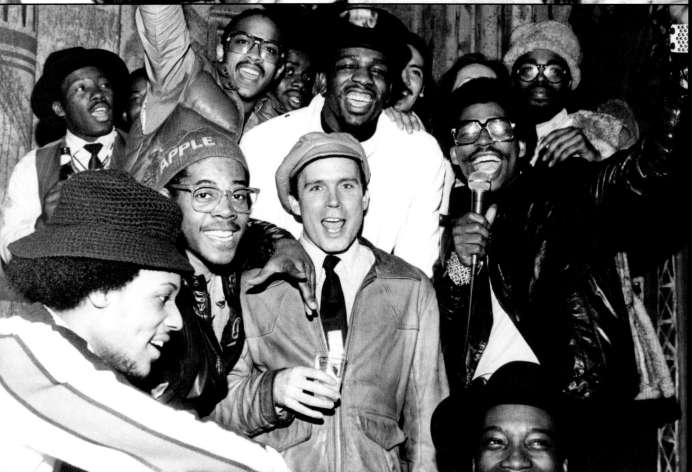

DJ Mean Gene, Kevie Kev, Tony Tone, JDL, Master Rob, AD, Charlie, and Caz, 1983

James "Koe" Rodriguez Bumrushing Wild Style in JC

My first recollection of Charlie A's seminal movie *Wild Style* was around 1983 or so. I was 13, living in Jersey City, NJ, a.k.a., Chilltown, JC and strung-out on hip hop. I experienced my first dose of *Wild Style* during auditions in the auditorium of P.S. 38. My friend, Felix Lopez copped the classic *Wild Style* soundtrack and proceeded to play it on the auditorium's cheesy phonograph. In all honesty, I had no idea what Felix was putting on. He lived in a predominantly white neighborhood and hung out with mostly white kids, so I thought he was gonna throw on some shit by Led-Zep or KISS. To my surprise, I heard Kevie Kev on the cut, "Fantastic Freaks at the Dixie." On cue, the rest of the crew chimed in, "And we're Fantastic 5 emceeee's".

All I remember was feeling the sudden urge to drop to the floor and start boogying! Listening to that incredible album and soaking up its fly artwork was more than an incentive to go peep the movie, which was a story unto itself.

During 1982, before *Wild Style* was even released, it had a crazy buzz in the streets—even across the Hudson in Jersey City. Every homeboy had an emphatic story of who was in it and what it was about, each report conflicting with the other. This flick was highly anticipated. I finally decided to see *Wild Style* one weekend with my older brother Bob and Pop, a respected cat off the Ave.

Pop was a cool dude and my brother's good friend. He was also down with the Little Demon Crew, a notorious crew of young hoods off Jackson Avenue. The Demons had two divisions: the Demons, who were the OGs, and the Little Demons, who were much younger and worse than their older counterparts. Going to peep *Wild Style* with Pop was a good move. Although my brother and I had a lil' juice, Pop's presence would no doubt ensure our safety at the flicks. Shit was hectic in the early 80s. You could've been vicked (robbed) riding the wrong bus, let alone going to a movie. In good ol' 82, relieving individuals of their personal possessions was definitely in vogue. "A to the K? K to the muthafuckin' Z!"

Once we arrived at the Loews Theater in Journal Square, the tension and excitement was palpable. Hoods and hip hoppers were in attendance. Movie theaters at that time were engaged in two ways: paid and unpaid admission. The latter was definitely our M.O. The Loews in JC was notorious for being bumrushed and backdoored. Others brazenly bogarted soft and elderly ushers to gain entrance.

After doing a bit of recon in the lobby, it was showtime! Pop proceeded to bumrush the lobby door. The theater had one particular usher, an older white gentleman with glasses and serious attitude to match. Homeboy was known for shutting kids down. Pop blew right threw this guy; my brother Bob and I were up next. In the past, I had bumrushed many a flick, but today I would come up short. On the day of the biggest movie of the year, my brother and I were stopped dead in our tracks by this old-ass usher. All I saw (as if in slow motion) was Pop looking back at us like, "C'mon y'all."

I can't front, I felt like crying. I wanted to see this movie more than I wanted to see Christmas!

Funny enough, I would meet Charlie Ahearn years later and become a filmmaker myself. I even attended the *Wild Style* 20th Anniversary Jam back in 2002 at the original Amphitheater. It was a great reunion and I felt proud to be there.

I'd be lying if I said I don't get amped whenever I hear "Freaks and Cold Crush at the Dixie." In fact, as childish as it might seem, I still get the occasional urge to bumrush a flick—but not at the Loews or State Theaters. Unfortunately, they've since closed their doors. The Loews reopened not too long ago as a non-profit arts and entertainment center. It sometimes shows classic movies like *The Godfather* and *The Wizard of Oz*. But let them get fly and bring back *Wild Style* for one night. I promise you, it'll be 1983 in Journal Square all over again! Hoods, hip hoppers, cheeba, and brew... "Scoo-b-Doo!"

photo by Martha Cooper, 1983

Fred

The main reason I got the call to be the host of *Yo! MTV Raps* was that the producers of the show saw me in *Wild Style*. They knew about my history as someone who was able to communicate to different kinds of people. I was credible on the street and in the 'hood, and had also made inroads downtown on the punk and new wave scene.

When *Yo! MTV Raps* happened I had just gotten to direct my first rap video—"My Philosophy" by KRS-One—without any idea that it would be seen on MTV. At the time MTV had not embraced black music. You just didn't see black folks on MTV.

In a sense I became Phade. It became like an alter ego. Basically that was the character I called upon to host *Yo! MTV Raps*. When I went to hip-hop parties I wasn't a rapper. Sure, I rapped a little, but I was not that on-the-mic, centerstage guy. I was very comfortable in the back observing things and taking notes. I wanted to be behind the camera, but I ended up in front of it as well.

Unpublished Posters

Poster, design by Crash, 1983

Poster, design by Charlie Ahearn, 1983

Event poster, design by Doze Green, 1983

USA Film Release Posters

USA Video release poster, 1985

First Run Features theatrical movie poster, 1983

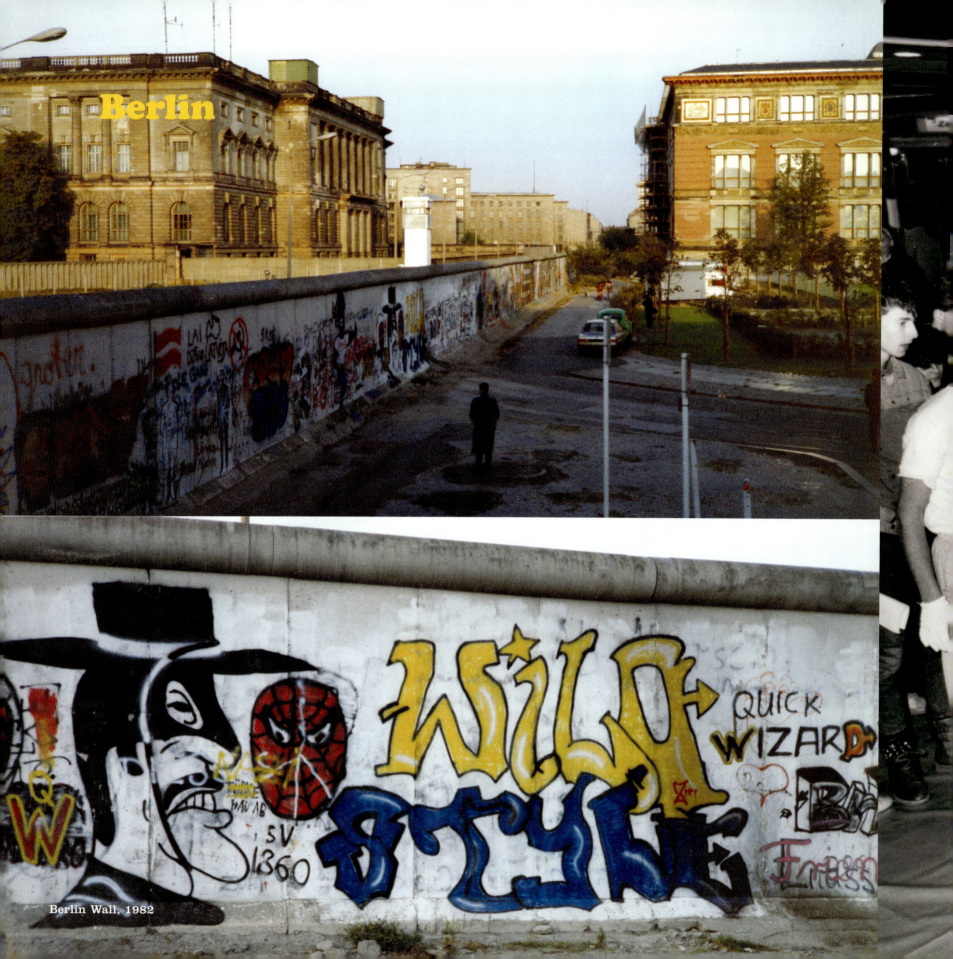

Berlin

Berlin Wall, 1982

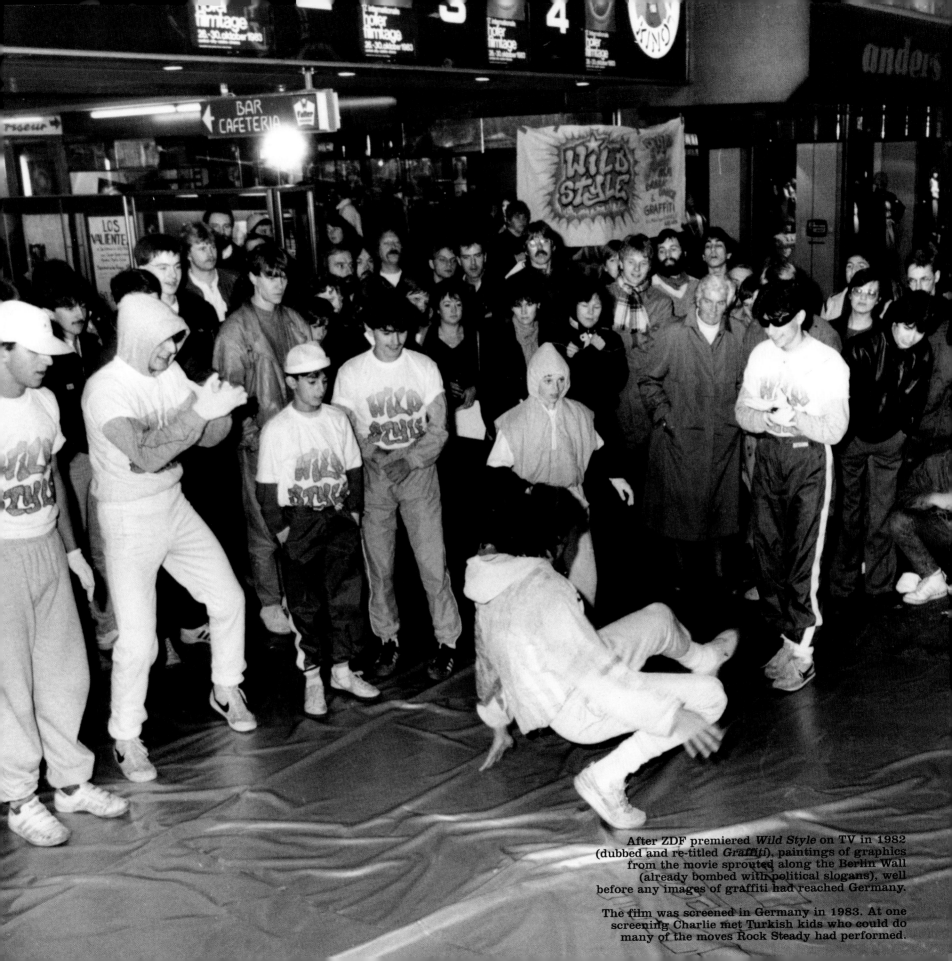

After ZDF premiered *Wild Style* on TV in 1982 (dubbed and re-titled *Graffiti*), paintings of graphics from the movie sprouted along the Berlin Wall (already bombed with political slogans), well before any images of graffiti had reached Germany.

The film was screened in Germany in 1983. At one screening Charlie met Turkish kids who could do many of the moves Rock Steady had performed.

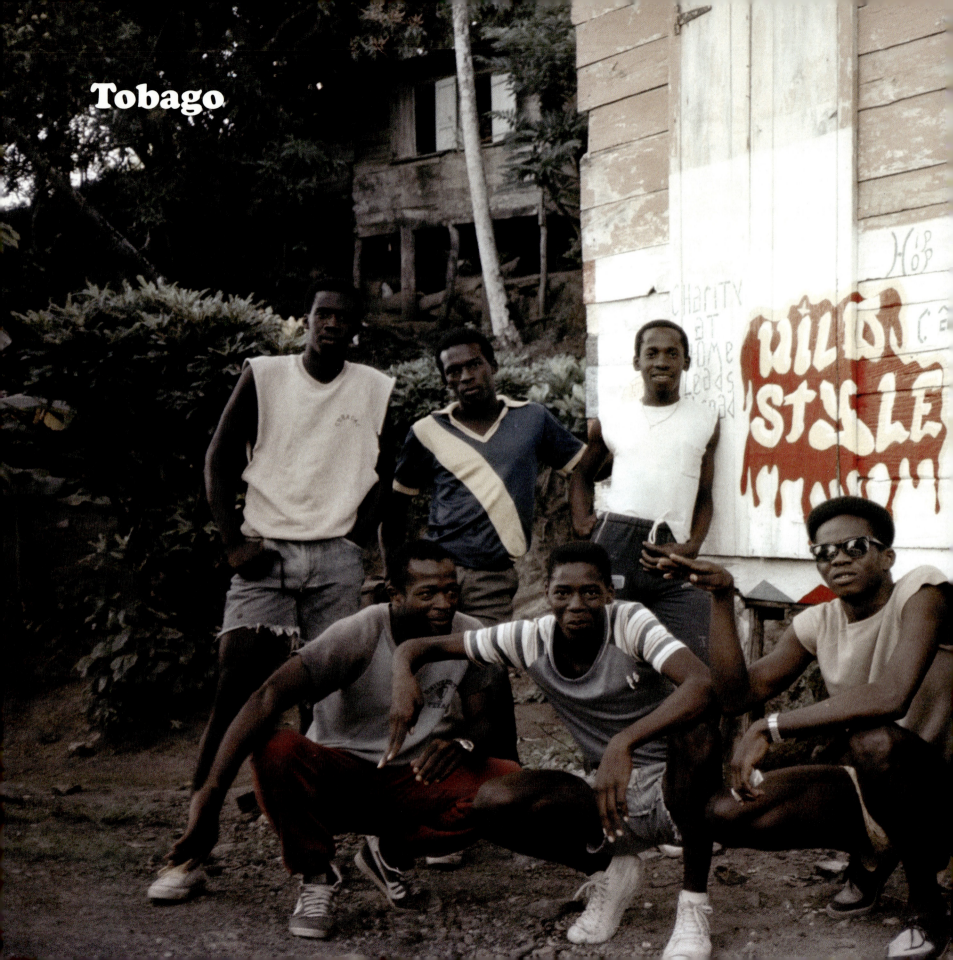

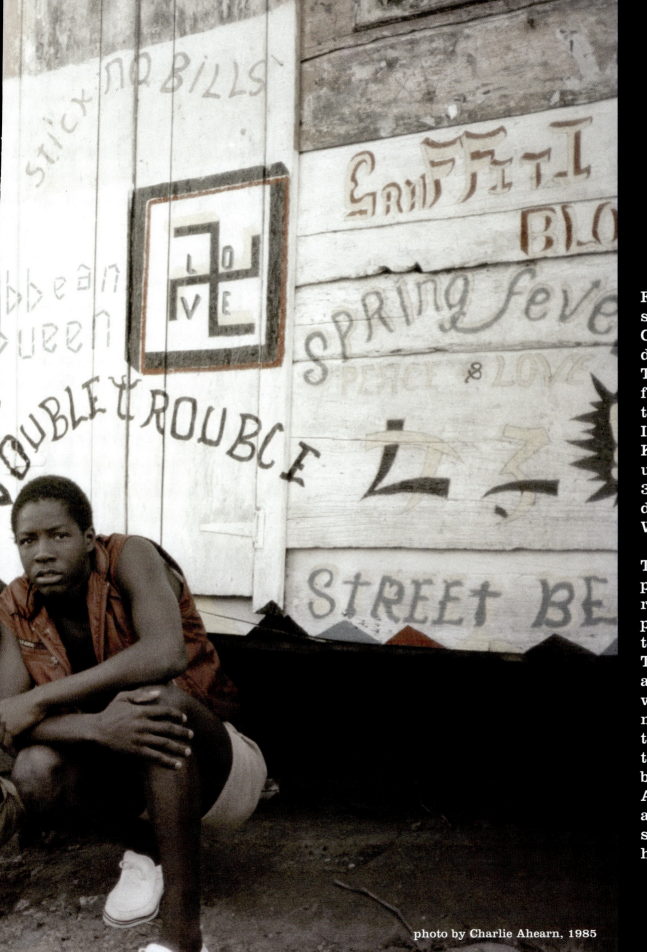

photo by Charlie Ahearn, 1985

Following the *Wild Style* screenings in Japan, Germany and U.S., our distributor, Films Around The World, continued to find fresh markets for the movie such as Spain, Italy, Denmark, and Korea. He also surprised us by selling a single 35mm print for theatrical distribution in the British West Indies.

While traveling in Tobago with my wife, painter Jane Dickson, riding on bus through a poor rural area, I shouted to the driver, "Stop!" There was a mud hut along the road decorated with images from the movie and I was excited to meet the budding teenage artists who had become fans of the film. As *Wild Style* went abroad, the culture spread, planting seeds of hip hop across the world.

Breaking in Italy & Switzerland

Paolo Capezzuoli The Movie Breaks in Italy

Nobody knew about hip hop in Italy in 1983. We only knew about breakdance videos. The best video was "Buffalo Gals" by Malcolm McLaren featuring Rock Steady and Dondi. The poster for the movie *Wild Style* was yellow and black and they added a florescent strip to the bottom: "Super Break Dance Movie!" The first time I saw the movie, I didn't like it so much. It was too raw and the whole scenario was different from what the media had spread about these candy-colored breakdancers with matching suits.

In *Wild Style*, they wore jeans and street clothes like anybody else. It was culture shock. It wasn't what we expected. But we watched it over and over again. It took us years to get it. I started with b-boying, but made my mark in Italy as a graffiti writer and later joined Rock Steady. *Wild Style* was my only visual reference for how to proceed.

Lady Pink

Walking down some street in Basel, Switzerland, I was followed by teenagers whispering my name. They told me *Wild Style* played Saturdays at midnight like the *Rocky Horror Picture Show* and they went to see it every weekend. The kids knew the dialogue, and copied the dancing exactly. This was in some little town in Europe: this is a cult movie; everyone knows it.

Say Ho! In Holland

photo by Charlie Ahearn, 2003

The Chief Rocker Busy Bee missed his flight out of Newark and everyone was upset because we had our opening party that night in May 2003 at the MU Gallery in Eindhoven, Netherlands—a photo exhibition with me and Jamel Shabazz. Only hours before the opening I got a call from Busy: he was in our hotel unpacking, but soon enough we were walking the streets, searching for those infamous smoke shops selling the finest weed from around the world. We walked into the Grasshopper, which was decorated with images of Jiminy Cricket (from Disney's *Pinocchio*) and Busy got busy rolling up. Later Busy rocked it at the MU. The following day we were making our way back through these narrow side streets, when suddenly a row of windows above us swung open. In each window was a blonde Dutch girl, waving down to us, "Oh, Busy Bee! Busy Bee!" Busy just looked up at the girls with a wide grin and gave them his funk salute with a "Ho!" I swear I witnessed it.

On and On

Obsessed with the origins of the culture, I began recording personal tales from the dawn of hip hop in the years before we made the movie. Later, I was fortunate to work with Jim Fricke from the Experience Music Project on a book called *Yes Yes Y'all: An Oral History of Hip Hop's First Decade*. The book and related events brought many of the artists from *Wild Style* to the public's attention, reminding fans that they can still rock a party.

www.ps1.org invited me to host a one-hour live internet show called "Yes Yes Y'all" with hip-hop pioneers Bambaataa, Rammellzee, Jazzy Jay, Super Natural, Blade, Fabel, and others.

Jeff Chang (author of *Can't Stop Won't Stop*), DJ Shadow (with album) and Charlie at the *Yes Yes Y'all* exhibition at Punch Gallery in San Francisco, 2003.

Charlie and Biz Markie during the "Yes Yes Y'all" internet radio show on www.wps1.org, 2005

Prince Whipper Whip and the Chief Rocker Busy Bee pose before their outfits on exhibit at the *Yes Yes Y'all* show at the Experience Music Project in Seattle, WA. Photos by Charlie Ahearn, 2003

Wild Style Reunion in LA

DJ Grandmaster Caz and the
Chief Rocker Busy Bee at reunion, 1998

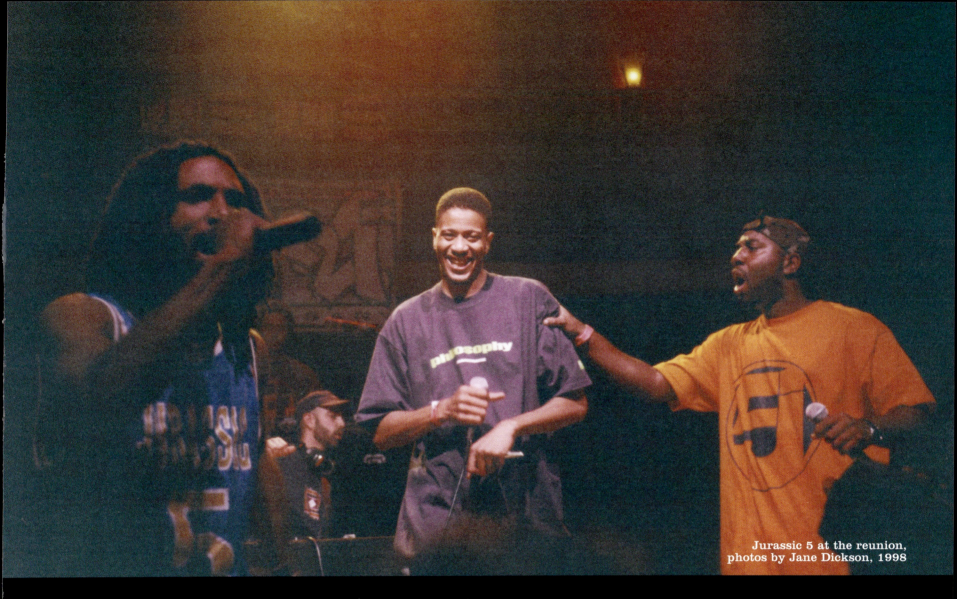

Jurassic 5 at the reunion, photos by Jane Dickson, 1998

⭐ Patti

When we produced the Wild Style reunion in Los Angeles, young DJ Nu-Mark from Jurassic 5 told me he had seen the movie 30 times! Jurassic got their name from their adulation of the classic groups Cold Crush and Fantastic Five. One of their girlfriends laughed and said, "Fantastic Five! You more like the Jurassic 5!"

⭐ Cut Chemist

Wild Style has been the old school reference point for me and my music for over twenty years. I often go back to this film to channel the spirit of true street and visual performance art. It is a product of its time: the early 80s, when bridges were crossed between genres and styles, between rich and poor.

Wild Style 20th anniversary
at the Amphitheater

Amphitheater Returns

Two decades after we had filmed at the Amphitheater, it continued to sprout weeds and fresh graffiti, and slowly fall apart. Then after the 9/11 attacks New York City painfully began to wake up to feel its bruised limbs and look around. On the TV show *Challenge America*, Erin Brockovich identified the Amphitheater as a downtown location in need and the response was immediate. Businesses rushed to donate money and materials to bring the place back to life. The rotting building with its classic cupola was torn down and the stage grew a pair of stainless steel arches. As part of a celebration for the refurbished facility, Soundlab hosted the *Wild Style* 20th Anniversary with a live concert featuring practically everybody in the movie, followed by a 35mm projection. I felt like I was in heaven as I sat in the back of the Amphitheater, watching scenes from 20 years earlier, as a full moon rose over the East River.

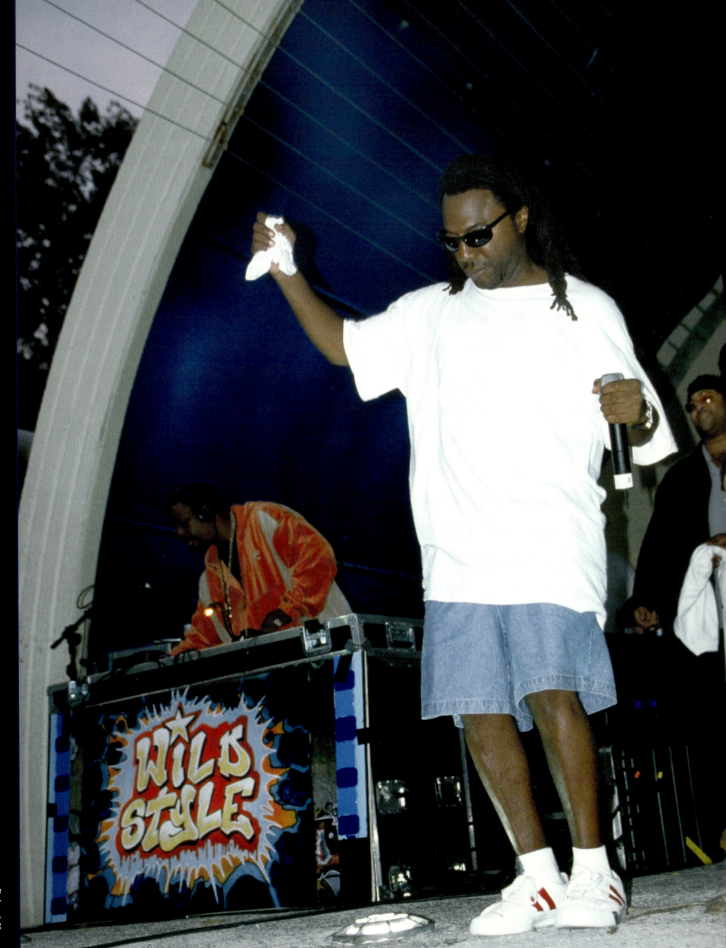

Caz and Busy Bee at the Wild Style 20th anniversary at the Amphitheater, photos by Akim Walta, 2002

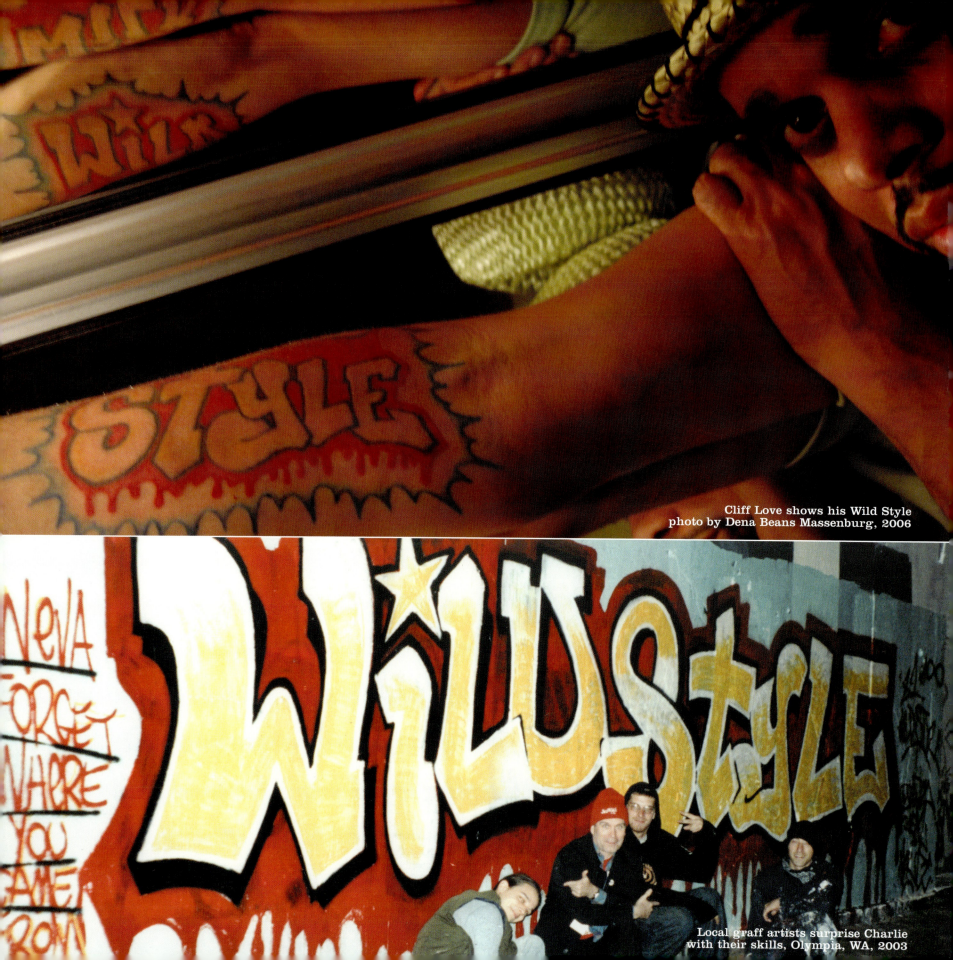

Cliff Love shows his Wild Style
photo by Dena Beans Massenburg, 2006

Local graff artists surprise Charlie with their skills, Olympia, WA, 2003

Fred

Over the years my performance in *Wild Style* has led many people to see me as that person who was there from the beginning. Because of the fact that everyone else in the movie was playing a character close to themselves, people assume that I was my character too—but in fact I wasn't.

When we were making *Wild Style*, we wanted to set the movie in the 70s. Because "Rapper's Delight" had already come out, MCs were making records, so we wanted to go back a few years earlier, and set it at a point when hip hop was completely underground, when the form was raw and pure.

Lee

It's wonderful to be a part of such a historic thing. Kids have taken hold of the culture and gone with it. They say every generation will create the art that it deserves. In the most innocent way this film vividly captured hip hop, and no other film could even compare. We were all innocent at that time and that's the beauty of it. There were no pretensions. There was no fictional script sensationalizing something that was sensational anyway. We were all in it to win it at that time. So there you go. You can't touch that!

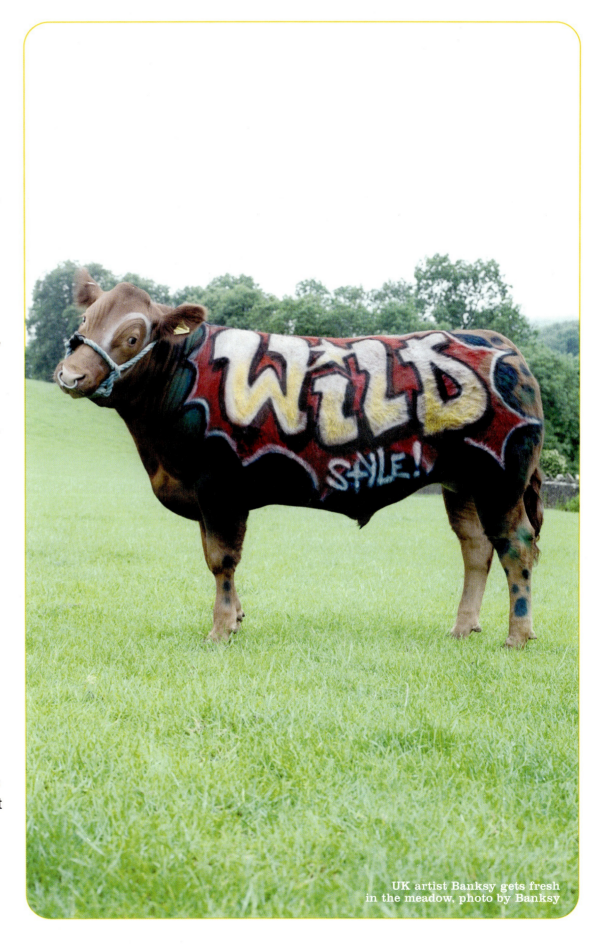

UK artist Banksy gets fresh in the meadow, photo by Banksy

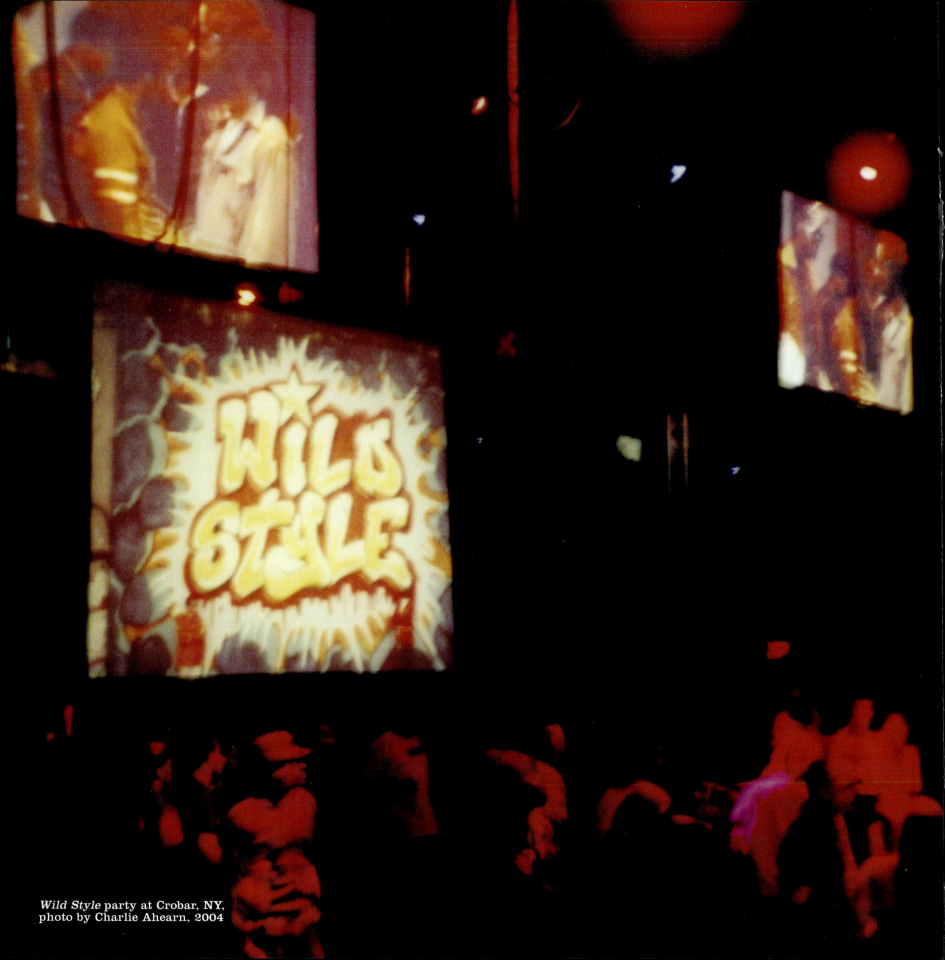

Wild Style party at Crobar, NY,
photo by Charlie Ahearn, 2004

Sacha Jenkins Sample Sale

Since the year nineteen hundred and seventy three, hip hop has been all 'bout swashbuckling ingenuity. About flipping the everyday. About revolutions; about remixing the who, what, when, where, why, and how and creating the superhuman, the super natural, the oh my God. This genius in the early days, of course, being a reaction to certain causes and effects: poverty begot the party people wanting to testify in the parks after dark, be it "yes, yes, y'all," "throw your hands in the air," or "broken glass everywhere." It's the same kind of combustion that inspired one of the greatest gangsta rap songs ever—ahem—"The Star Spangled Banner."

Hip hop: fresh, American-made culture, crafted by folks who were pretty much under the impression that they weren't really Americans. Ain't no picket fences in the South Bronx, dude. DJ Kool Herc didn't own a discotheque; his dance floor was cousins on the curb, his electricity rerouted from lampposts. Norman Rockwell didn't live Uptown—but our man KK Rockwell sure did (say hooooo!). Thankfully, artist, participant, documentarian, and filmmaker Charlie Ahearn recognized the real early on. He knew that there was a whole galaxy teaming with new languages and possibilities right here on Earth. He'd discovered Atlantis in the one place no one thought to look: the Boogie Down Bronx.

And what was committed to film—original b-boys and b-girls, graffiti writers, gun-toting thugs, club promoters, wide-eyed downtown gallery pubahs, cheeba-toking journalists, Zoros, Pink Roses, Chief Rockers, Grand Masters, and stray, itchy dogs in their natural habitat—would inspire and change the lives of troopers stationed around the world (these apostles being the kind of sleeper cells who would eventually go on to blow up spots with the same bombs that Afrika Bambaataa used to wreck shop in his hood.) Hence, 25 years later, we hip hoppers are still mesmerized by the celluloid shots that Señor Ahearn rang out with his nifty zip gun, BKA *Wild Style*.

Wild Style is a zip gun because it was handmade at a time when there was no such thing as Def Rowe Records; Warn A. Bros. Studios didn't offer up their classic New York set to set the stage for the action. There was no wardrobe budget or stylist on deck—talent came as they were. There was a script, but you know, cats took their liberties, free-styling some lines to make things a bit more natural. *Wild Style*: the zip gun that sang louder than every AK 47 on earth combined—the zip gun that (along with Henry Chalfant and Martha Cooper's *Subway Art*) helped to expand the territory of the young empire that scrapped its way out of the bowels of New York City only to conquer (and rock) the planet.

Everybody knows that rap music has been the most commercially successful, universally accepted component of hip-hop culture. Started out with heads just yappin' fly atop classics from various musical genres. A little call and response. There weren't any hip-hop movie soundtracks back in 83 because there weren't any hip hop movies yet (*Beat Street*—a complete *WS* rip off—no dis Mr. Belafonte—came a bit later) and only a handful of actual rap-based albums were around. We're talking way back in the culture's Stone Age here, and the *Wild Style* soundtrack is just that: stoned.

With Blondie's Chris Stein at the helm, the film is serenaded by a series of a moody, emotional, seemingly angel-dusted tracks (talkin' about that good dust). And what was recorded was recorded simply:

bass, drums, guitar, occasional synth, cowbells, and triangles—which speaks beautifully to that very moment in the movement's history: raw, pure, non-self conscious.

Like Jamaican dub plates (one-of-a-kind records made special order for sound clashes with opposing sucka mobile DJs) the *Wild Style* soundtrack was committed to wax and embellished upon live (meaning most of the vocal contributions to the record were committed live, in the moment, in the place to be, cuts and zigga-zigga-ziggas included). Hip hop, in truest form, is a seance. A ritualistic happening with a spiritual base in the tradition of so-called Negro spirituals. That's why so many recording artists have tapped directly into the veins of *Wild Style*: they're searching for that feeling of being touched by God. Or rather, they're looking for the confidence one has when one feels divinely guided. In the studio, a rapper can record and re-record vocals until they're convinced that they sound like Moses holding up two big ass tablets. Chief Rocker Busy Bee had one shot to rock and get it right. Grandmaster Caz, Prince Whipper Whip, GrandMaster Flash, DJ AJ—these cats went for theirs like they were on the guest list for the Last Supper.

Nasir "Nas" Jones is the MC who would go on one day to rap on wax—all I need is one mic. Nas is an artist who thirsts for that otherworldly connection; he respects the gifts of his elders, and so his legendary debut album, 1994's *Illmatic*, opens up with *Wild Style*'s "Subway Theme." Juxtaposed atop eerie keys and funked-out bass is dialogue from the film—the first voices heard on the LP. It's the conversation between Lee "Zoro" Quinones and the man who plays his older brother, who has returned from a stint in the military, looking neat and orderly and ready to buy into what America wants for him. Zoro climbs through a window and enters his bedroom. His brother has his gun drawn; once he realizes that the cat burglar is his little bro, a lecture ensues. "Stop fucking around and be a man," says Zoro's brother, who has no respect for the graffiti bomber lifestyle that his sibling subscribes to. Hip hop was uncivilized; the spray painted squiggles and letterforms all over Zoro's room proved that. But Zoro stands firm and announces to his brother—and the world—that he is somebody and there is something out there for him.

Lines and beats from *Wild Style* have popped up on countless hip-hop albums—so many, in fact, that name checking each and every one would be kinda like snitching (and we know how hip hop frowns upon finks!). The Beastie Boys—OGs in their own right—have gone to the *Wild Style* well more than once, copping nuggets. Like when Ad Rock drops "Where'd you get your information from?" (on "So Whatcha Want" off 1992's *Check Your Head*), he's lifting a line dropped by graff legend Andy "Zephyr" Whitten who played "Zroc." More recently, on 2005's *To The Five Boroughs*, the crew paid tribute to Double Trouble by singing, "If you want to know the real deal about the three, we're triple trouble y'all and we're doing it all for free!"

Kevie Kev screaming, "Soundman! Say turn it up!" is a favorite amongst DJs for good reason. The list is long, and can go on and on until the break of dawn: Biz Markie, Cypress Hill, De La Soul, Mobb Deep, Ghostface Killah, Shaquille O'Neil, Rakim, DJ Q-Bert. Truth of the matter is, Ahearn and posse have been fairly liberal and appreciative of those who have gone on to sample. Still, producers, don't get any slick ideas: it is your duty to come clean and cough up the loot because, well, if no *Wild Style* then probably no YOU.

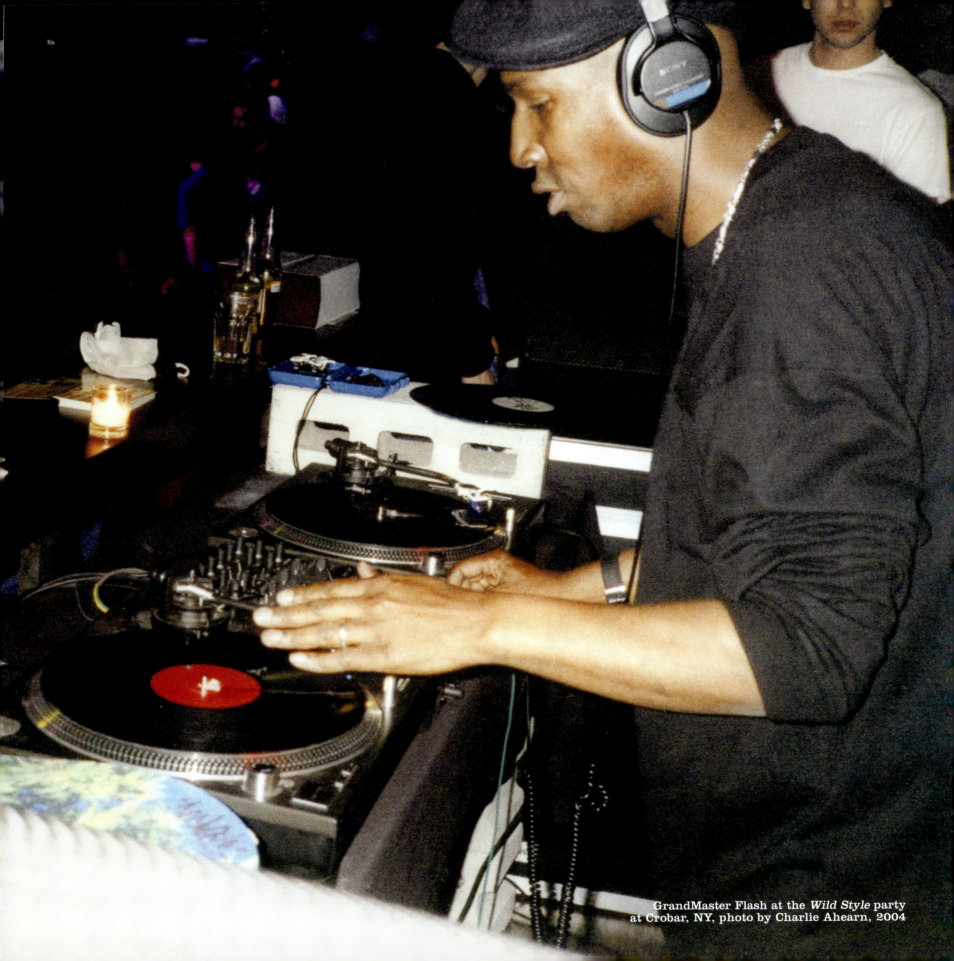

GrandMaster Flash at the *Wild Style* party at Crobar, NY, photo by Charlie Ahearn, 2004

Grandmaster Caz, DOA, Balozi Dola in Charlie's "Bongo Barbershop" video, 2005

Busy Bee rocks the bullhorn in Charlie's "Busy on the Beach" video, photo by Joe Ahearn, 2006

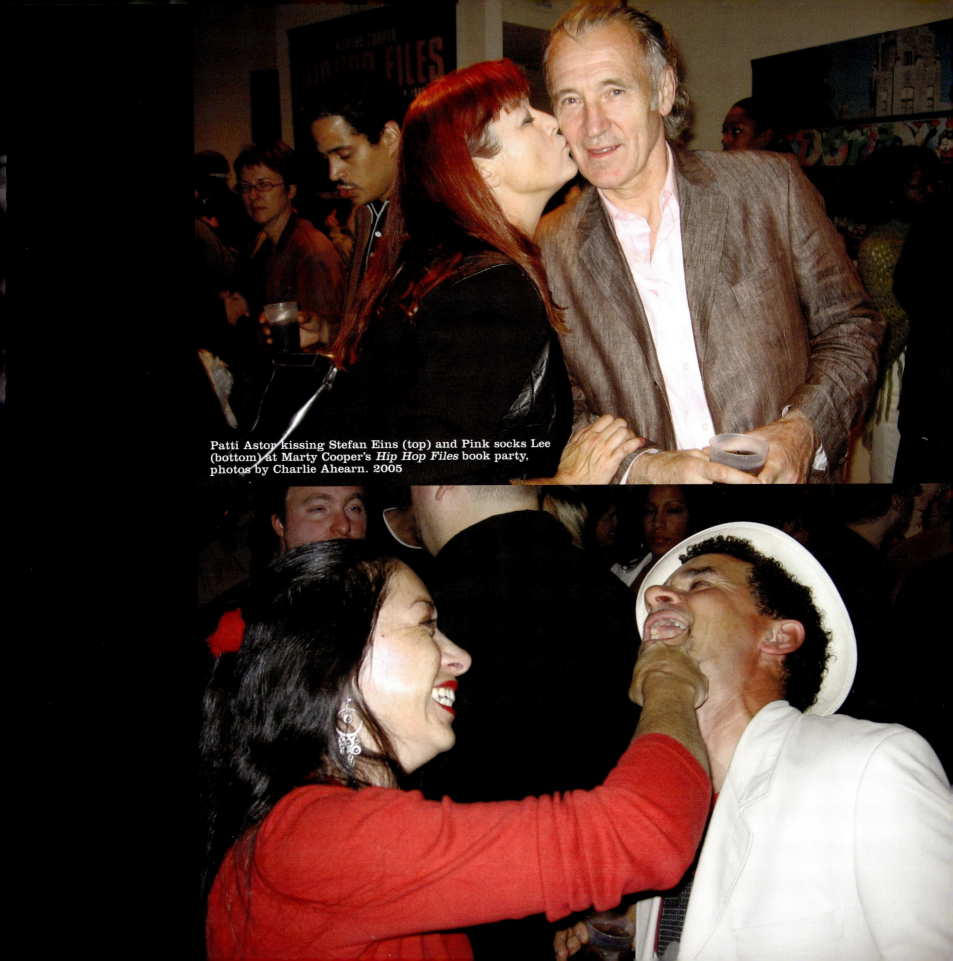

Patti Astor kissing Stefan Eins (top) and Pink socks Lee (bottom) at Marty Cooper's *Hip Hop Files* book party, photos by Charlie Ahearn. 2005

Rammellzee in The Battle Station.
photo by Charlie Ahearn, 2004

Carlo McCormick 'Til the Break of Dawn

While everyone assumed that it was merely a passing fad, just another bit of novelty for our disposable culture, the pioneers themselves were busy building landmarks that would not only last, but also continue to dominate our creative landscape to this day. *Wild Style* isn't just a glorious monument to the durability and destiny of hip hop, it is beyond the brief media hype of graffiti, the industry of rap and the commodified cooption of urban youth marketing, the only real narrative cinematic testament to the energies, inspirations, and ingenuities of New York's cultural underground of the late 70s. It delivered the beats that keep on rocking, the rhymes that still make us laugh, the art that inspired countless generations since, breaks we're still sampling and personalities in their prime who have subsequently become legends. It had the kind of casting that can only happen word of mouth and the authenticity that comes from being there.

Wild Style isn't just one of those must-have flicks you pack for those hypothetical stuck on a deserted island questions, it is quite simply required viewing for anyone who doesn't want to grow up as if they were themselves marooned on that island. Yes, it is a vital artifact of time and place, but it is more significantly a space unto itself. Charlie Ahearn brought such different elements of New York's urban polyglot to the same table and allowed, ever so briefly, the most amazing situation—in which the seemingly incompatible phenomena of hip hop, punk rock, and the downtown underground art scene found some unlikely commonalty. That's not a script or some gratuitous plot twist, that's a fact. It was the most rare of cross-pollinations that made everyone stronger, nourished adventure, and diversified experience. The old school bloom is now gone, but we're all still inhaling the fumes of this fertile foment and savoring the succulent sedulousness of its manifold mutant fruit.

Busy Bee and Caz at the Experience Music Project's *Yes Yes Y'all* opening party, photo by Charlie Ahearn, 2003

Grandmaster Caz

All in all I am thankful and appreciative for Charlie's vision and instincts. Say what you want about *Wild Style*, but it's the first and the best, and no Hollywood movie has been able to capture the realism, the times, and the energy that created this multi-billion dollar industry better. Peace.

Busy Bee

I was on tour with KRS-One in 2006, traveling around the world with The Temple of Hip Hop. I wasn't advertised so nobody had a clue I would be appearing and he'd bring me out certain nights: "How many of you seen the movie *Wild Style*?" He was playing in front of 17,000 people and everybody screamed, "Yo!" Then he'd say, "I brought a friend with me tonight and his name is the Chief Rocker Busy Bee." And the people lost their minds!

I keep doing my thing, rocking the house, because I get love. That's what it's all about. I'm in hip hop for the love, for the peace, and the unity. We're still having fun. That's what it's all about.

I mean love is love. Recognize hip-hop culture 'cause that's what we are doing. We're having fun with it. We spread love. There's no animosity. There's no prejudice. None of that. It's red, black, green, orange. We all in it. We come from Japan. You ever hear them rapping in Japanese? You ever hear them rapping in Swahili?

I want you to know Charlie Ahearn has done his thing. The cast of the movie, I love you all. We did our thing. We are history. *Wild Style* is all over the world.

Index

AD 116, 121, 124, 179
Ad Rock ... 200
Afrika Bambaataa 114, 190, 199
DJ Afrika Islam 169, 175
Ahearn, John 20-1, 51, 103, 118, 133
Ahlbum, Joey 154-5
DJ AJ 49, 51, 55, 62, 83, 142, 177, 200
Angie B/Angie Stone 104
Astor, Patti 68-9, 71, 81, 107, 110,
.................. 126, 129, 148, 167, 169, 193, 203
The B-52s .. 62
Baby Love 172, 175
Balozi Dola 202
Banksy ... 197
Basquiat, Jean-Michel 19-21, 63
Beastie Boys 2, 200
The Beatles 27, 85
Beckerman, David 84, 105
Billy167 .. 35
Biz Markie 2, 147, 178, 190, 200
Blade .. 32, 190
Blondie 19, 52, 59-63, 87, 199
Brokovitch, Erin 194
Brown, James 13, 20, 42, 155
Brown, Steve 105, 148, 165
Buck Four 172
Campbell, Cathy 104
Capezzuoli, Paolo 188
Caz Glover 91, 111, 128
Chalfant Henry 71, 81, 91, 93, 199
Chalie Tuna 150
Chandler, Ray 62
Chang, Jeff 190
Charlie Chase 83, 105, 117-8, 120-1,
... 123, 142
The Chief Rocker Busy Bee Starski 2-3,
.... 41-2, 45, 47, 50, 53-5, 77, 79-80, 85, 100,
.. 114, 123, 142-3, 145, 149-50, 169-71, 175,
..................... 189, 191-2, 195, 200, 206-7
DJ Clark Kent 45
Cliff Love 196
The Cold Crush Brothers 2, 45, 47,
.................. 55, 62, 85, 89, 116, 118, 120-4,
.................. 142, 145-9, 168, 171, 175, 193
Cooper, Martha 91, 167, 199, 203
Diego Cortez 21
Cowboy ... 147
Crash 80, 91-3, 102, 112, 182
The Crash Crew 55
Crazy Legs 70, 105, 136, 170, 173
Crime79 ... 27

Cut Chemist 193
Cypress Hill 200
D.St. 149, 169, 178
Davidson, Clive 80, 96, 120, 126, 149
Davis, Debbie 20
Daze 91, 93, 109, 111
De La Soul 200
Deak, Edit 69
Diaz, Raymond 15
Dickson, Jane 20, 116, 148, 155, 169, 187
DJ Disco Wiz 118, 146
DOA ... 202
Doc .. 32
Dondi 32, 35, 37, 91, 93,
........................... 128-31, 155, 169, 188
Dota Rock 125
Double Trouble 110-1, 142, 145, 149, 169
Doze Green 167, 172, 182
DJ Easy Lee 143
Esposito, Giancarlo 91, 93
Esses, Sam 81
DJ EZ Mike 56
Fab 5 Freddy 2, 18-9, 21-5,
.... 27, 38-9, 42, 45, 47, 51-2, 59, 61-3, 69-71,
... 74-5, 77, 80-1, 83-9, 91, 100, 105, 108, 110,
.... 115, 117, 123, 126, 129, 133-4, 142-3, 146,
........ 148, 167, 169-71, 175, 178-9, 181, 197
Fabel ... 190
Fantastic Romantic Freaks 2, 47-8, 51,
............................ 66-7, 114, 118-121, 123,
............................ 125, 142, 147, 180, 193
Ferrari, Lenny 62, 83
Fitzgibbon, Colleen 145
Foster, John 130-1, 149
Fricke, Jim 190
Frosty Freeze 70, 108, 136-7, 150, 167, 178
The Funky Four Plus One 42, 67, 85,
.. 87, 110-1
The Furious Five 58-9, 67, 69, 85, 87, 118,
........................... 134, 142-3, 145, 147, 149
Futura 28-9, 32, 53, 70, 93, 169
Gardner, Tanya 83
Ghostface Killah 200
Goldstein, Richard 21
Grand Wizzard Theodore 51, 83, 105,
............................ 118, 123, 142, 152-3
Grandmaster Caz 55, 57, 116-8, 120-1,
........ 124, 146-7, 179, 192, 195, 200, 206-7
GrandMaster Flash 2, 5, 52, 58-9, 62,
............... 67, 83, 87, 89, 108, 134-5, 142-3,
..................... 145, 147, 149, 176, 178, 200-1

Hammons, David 20
Haring, Keith 19-21
Harpur, David 83
Harry, Debbie 19, 59-63, 69, 87
Heart ... 34, 92
High, Becky 154-5
Icaza, Gabriel 129
Ingram, Nathan 13, 15, 104, 129
Iz the Wiz 104, 129
Jarmusch, Jim 81
Jazzy Jay 190
Jazzy Jeff 40
JDL 55, 110, 116-7, 121, 124, 146, 179
Jenkins, Sacha 199-200, 202
Jurassic 5 2, 150, 193
Kase2 ... 77, 89
Kay Gee 55, 116, 121, 124, 171
Kel1st 28-9, 92-3
Ken Swift 71, 136, 167, 173
DJ Kevie Kev Rockwell 152
King2 .. 35
Kislac, Niva 132-3
KK Rockwell 40, 110-1, 142-3, 175, 199
DJ Kool Herc 45, 51, 124, 199
Kool Lady Ruza Blue 169, 172
Kool Moe Dee 55, 149
KRS-One 181, 207
DJ Krush 173
Kuriaki ... 172
Kuzui, Fran 165, 169-70
Kuzui, Kaz 165, 169
LA Sunshine 149
Lady Pink 2, 70, 74, 90-5, 101,
........................... 112-3, 128-9, 139, 148-9,
........................... 167, 170, 175, 178, 188, 203
Lee, Spike 81, 165
Letts, Don 148
Lewis, Joe 124
Lil Markie C 107, 110
Lisa Lee 114, 120
Little Crazy Legs 167
Loose Bruce 143
Lovebug Starsky 54-5
Mare139 92-3
Master Rob 179
McCormick, Carlo 205
McNulty, John 125
DJ Mean Gene 179
Melle Mel 56-8, 147
Mercedes Ladies 62
Mitchell, Eric 81

Mobb Deep	200
Moth	34
Nares, James	81
Nas	2, 200
Noc167	35, 108
Obe	111
O'Brien, Glenn	19, 62, 132-3
O'Neal, Shaquille	120, 200
Otterness, Tom	20
Papp, Joseph	100
Paulie G	143
Peanut2	35
Phase2	50-1, 78-9
Mayor Phillip Goode	177
Poe, Amos	81
Pookie	126-7
Presweet	27
Prince Whipper Whip	119, 125, 191, 120
Public Enemy	125
DJ Q-Bert	200
Quinones, Lee	2, 13, 18, 21-2, 24-5, 28-32, 38-9, 60, 63, 70-1, 74, 84, 90-3, 98-105, 113, 115, 126, 129-30, 132, 139-41, 144, 148-9, 158, 167, 175, 178-9, 200, 203
Rakim	200
Rammellzee	34, 72, 108, 145, 149, 190, 204
Revolt	27, 155-6, 160, 166-7
Ricard, Rene	69
Rice, Bill	133
Richie T	45
Rock Steady Crew	2, 53, 70-2, 105, 136-7, 145, 149, 169-71, 185, 188
Rodney Cee	41-2, 55, 77, 104, 108, 110-1, 123, 142-3, 170, 179
Rodriguez, James "Koe"	180
The Rolling Stones	27
Rubie D	119, 125
The Salsa Twins	141
Scharf, Kenny	20-1
Scorpio	58
Seen	32
Sha Rock	43, 85-7
Shabazz, Jamel	189
DJ Shadow	190
Shapiro, Irvin	165
Sharp	166-7
Silver, Tony	81
Smiley149	76
Special K	149
Spoonie Gee	80, 84
Sput	110
Stein, Chris	19, 59, 62-3, 83, 87, 117, 199
Stelling, Bill	69, 203
DJ Stevie Steve	171
The Sugarhill Gang	67
Super	34
Super Natural	190
Take One	70, 136
The Talking Heads	62
Tony Tone	83, 116, 121, 123-4, 145, 179
Tracy168	35
The Treacherous Three	55, 83, 142, 149
Voice of the Ghetto	27
Warhol, Andy	38, 133
Waterbed Kevie Kev	66-7, 114, 119-20, 125, 179-80, 200
Zephyr	26, 32, 37, 80-1, 91, 93, 129, 155-9, 161, 167, 169, 200
Zulu Nation	45, 114, 147

Performers

DJ GrandMaster Flash

The Chief Rocker Busy Bee with DJ AJ

The Cold Crush Brothers:
Grandmaster Caz
JDL (Jerry Dee Lewis)
The Almighty Kay Gee
Easy AD
DJ Charlie Chase
DJ Tony Tone

The Fantastic Romantic Freaks:
Waterbed Kevie Kev
Master Rob
Prince Whipper Whip
Dota Rock
DJ Grand Wizzard Theodore

Double Trouble:
Rodney Cee
KK Rockwell
with DJ Stevie Steve

Rammellzee and Shockdell

DJ D.St.–DXT

Rock Steady Crew:
Crazy Legs
Frosty Freeze
Ken Swift
Mr. Freeze
Take One

Pop O Matics:
Loose Bruce and Paulie G

Electric Force:
"Lil" Sput
"Lil" Markey C
Easy Al
Stevie Steve
Sable

Cast

Raymond, ZORO .. LEE George Quinones
Rose, LADY BUG .. Sandra LADY PINK Fabara
PHADE .. Fred Brathwaite
Virginia ... Patti Astor
ZROC ... Andrew ZEPHYR Witten
Hector (Raymond's brother) ... Carlos Morales
Chico (boy with broom) ... Alfredo Valez
Art patroness .. Niva Kislac
Television producer ... Bill Rice
Museum curator ... Glenn O'Brien
ZORO double .. DONDI White
The Union Crew ... Johnny CRASH Matos
.. Chris DAZE Ellis
... Fred CAZ Glover
... Edwin "Obe" Ortez
Community Organizer ... Joe Lewis
Graffiti Detectives Michael IZ THE WIZ Martin
.. Nathan Ingram
Fly Girls ... Lisa Lee
.. Henrietta Henry
... Pamela Smith
.. Diane Parker
.. Lillian "Cookie" Brown
The Chief Rocker ... David "Busy Bee" Parker
Stick-Up Kids .. Vernon "Pookie" McDaniels
.. Kennedy Lee Howard
Street kids .. "Lil" Markey C
... "Lil" Sput

Film Credits

Director, Producer, Writer ... Charlie Ahearn
Original Idea ... Fred Brathwaite, Charlie Ahearn
Associate Producer Fred Brathwaite, Jane Dickson
Directors of Photography Clive Davidson, John Foster
Editor .. Steve Brown
Sound Editor ... Kevin Cloutier
Assistant Editor .. Nathalie LeGuay
Script Supervisor .. Cathy Campbell
Production Managers Clive Davidson, Carole Turley
Assistant Directors Colleen Fitzgibbon, Rex Piano
Sound Recordist ... Bernie Nobel, Larry Scharf
Graffiti Murals by .. LEE, DAZE, CRASH, DONDI
Camera Operators John McNulty, Robert Chappell
Assistant Camera Charles Blackwell, Sekou Shepard,
... Dennis Hann, Chorine El Khaden
Key Grip .. David Lee Beckerman
Production Assistant Gabriel Icaza, Alfredo Valez
.. Charles Lum, David Koch
Set Construction .. Tom Otterness, Uli Rimkus
Musical Director .. Fred Brathwaite
Original Music ... Chris Stein
Synthesized Guitar .. Chris Stein
Bass Guitar ... David Harpur
Percussion ... Lenny Ferraro
Animation Joey Ahlbum, Andrew ZEPHYR Witten,
... Daniel REVOLT Scott, Becky High
Still Photography Cathy Campbell, Martha Cooper

Acknowledgments

To begin at the beginning: meeting Fab 5 Freddy in 1980, I felt as if making this movie with him would be a snap—or as Rodney Cee would say, "Nothing to it, but to do it!" Lee Quinones' struggle to create his art inspired me to work harder as a filmmaker. We were all hip-hop artists struggling to take this culture to the next level. Who knew that Fred would dazzle on screen or that Lady Pink would be so intense on film? Hell, she isn't acting! Busy Bee grabbed me at my first MC jam, got the part, and I am grateful for 25 years of Busy Bee. And I am so thankful to Grandmaster Caz, Grand Wizzard Theodore, Waterbed Kevie Kev, Rodney Cee, and all those who invited me to their parties and welcomed me into their homes.

After I had written a few essays for powerHouse Books, Miss Sara Rosen sidled up to me at one of their events and asked me if I wanted to publish a book with them; without hesitation I said, "Wild Style The Sampler." In the two years since that conversation I would often picture Sara dressed in a cheerleader's outfit, shaking her pom poms from her desk, shouting, "Great! Great! Yeah great!" Sara's cheers and book designer Kiki Bauer's eye really helped get this book made. I want to especially thank Daniel Power and Craig Cohen for letting us do this fun project under powerHouse's roof. Thanks to Yasmin Ramierez, my brother John Ahearn, and my wife Jane Dickson were especially patient and insightful in crucial moments when I needed guidance with this project.

My gratitude to Sacha Jenkins for giving *Wild Style* his full laptop blessing during his hectic *The (white) Rapper Show* schedule and to Carlo McCormick for serving up that generous tasty essay; I thank you both. Thanks to Fred, Lee, Lady Pink, Busy Bee, Zephyr, Koe Rodriguez, Caz, Theodore, Melle Mel, Waterbed Kevie Kev, Frosty Freeze, Revolt, Sharp, Cathy Campbell, Marty Cooper, Patti Astor, Glenn O'Brien, Biz Markie, Paolo Capezzuoli, DJ Krush, and Cut Chemist for generously sharing your memories.

The visual richness of this book owes much to the beautiful photography of Cathy Campbell, who toiled on the movie's hard working skeleton crew. Marty Cooper, who snapped the images people most associate with *Wild Style*, uncovered some fresh photos for me and I am grateful to her as well as to Henry Chalfant and Joe Conzo for their iconic photographs. I want to thank Tom Warren, Teri Slotkin, Uli Rimkus, Akim Walta, Jane Dickson, Lee Quinones, Lady Pink, Banksy, Jonathan Wenk, and many others for donating pictures from their personal files. For all those not mentioned who offered ideas, stories, and images to this project, I am supremely grateful and proud of your support. Rock on!

Wild Style The Sampler

© 2007 powerHouse Cultural Entertainment, Inc.
Artworks and photographs © 2007 the artists and photographers
Text © 2007 the authors

All rights reserved. No part of this book may be reproduced in any manner in any media, or transmitted by any means whatsoever, electronic or mechanical (including photocopy, film or video recording, Internet posting, or any other information storage and retrieval system), without the prior written permission of the publisher.

Published in the United States by powerHouse Books,
a division of powerHouse Cultural Entertainment
37 Main Street, Brooklyn, NY 11201-1201
telephone 212 604 9074, fax 212 366 5247
e-mail: info@powerHouseBooks.com
website: www.powerHouseBooks.com

First edition, 2007

Library of Congress Cataloging-in-Publication Data:

Ahearn, Charlie.
 Wild style : the sampler / by Charlie Ahearn. -- 1st ed.
 p. cm.
 ISBN 978-1-57687-364-9
 1. African American youth--Attitudes. 2. Popular culture--United States--History. 3. Hip hop--United States. 4. Rap (Music)--Social aspects. 5. Documentary films--United States--History. I. Title

 HQ796.A337 2007
 791.43'72--dc22

 2006052936

Hardcover ISBN 978-1-57687-364-9

Printing and binding by Pimlico Book International, Hong Kong

Book design by Kiki Bauer

Page 1 and back cover photos by Martha Cooper
Busy Bee on the cover photo by Charlie Ahearn

A complete catalog of powerHouse Books and Limited Editions is available upon request; please call, write, or rock our website.

10 9 8 7 6 5 4 3 2 1

Printed and bound in China